HOME

Managing editor for GoodPlanet: Olivier Blond

Editorial team: Olivier Blond, Olivier Milhomme, Anne Jankéliowitch,

Sabine de Lisle, Céline Cros, Julien Leprovost, Yves Sciama

Editorial coordinator: Isabelle Delannoy

The GoodPlanet team would also like to thank Yann Godeluck

UNEP

The publishers would like to thank **UNEP** for granting permission to reproduce in this work nine previously unpublished posters, designed for the occasion of the 25th Session of the Governing Council / Global Ministerial Environment Forum, held in Nairobi, Kenya, in February 2009.

HOME

A HYMN TO THE PLANET AND HUMANITY

A project by Yann Arthus-Bertrand and GoodPlanet

ABRAMS, NEW YORK

INVENTING A NEW WORLD

This book is not a spin-off from the film of the same name. It is a supplement, a companion piece, an extension of the film.

Every day, we are assailed by bad news: hunger is growing, the climate is affected, species are dying out, resources such as water, oil, and metals are dwindling, and we are on the brink of a worldwide economic crisis. And yet most of us have not changed at all. We read the many reports from the scientists and economists, but still we continue down the same path as if we were suddenly struck by some inescapable intellectual blindness. It is as if, although we know about it, we just don't want to believe it.

Perhaps what we need is some good news. All over the world, entrepreneurs, local authorities, and associations are moving into action, coming up with new technology, new trades, new relationships between humanity and nature. Their creativity is moving forward into a new century that is cleaner and fairer, more natural and at the same time more human.

This is the international overview that is captured in this book. It appraises the threats that our current lifestyles have created, but at the same time reveals the amazing heritage that four billion years of evolution have given to humanity. It also celebrates the many projects that have been launched to usher in a new era, in which the human spirit has dreamed up new ways of living and thinking that are more in tune with our planet. A world that no longer regards the Earth as a supermarket, but as a home.

All the experiments and experiences described here are simply examples, but they show us the path toward a new mode of existence, based on moderation, intelligence, and sharing. They are an invitation for us to change. Change can be a good thing when it means working for a better future. I see evidence of this every day, when I meet people who are working toward this new world.

It is too late for pessimism. We are now well aware that solutions exist. We all have the power to change things. What are we waiting for?

Yann Arthus-Bertrand

We 6 billion human beings are not the only inhabitants of this planet. We share it with billions and billions of animals, plants, and single-cell organisms. And it is not merely a case of cohabitation: our very existence depends on our close links with these other organisms. Albert Einstein once predicted that if the honey bee disappeared, the human race could only survive for four years: without bees to pollinate their flowers, the majority of plants would fail to reproduce and would die out, along with all the animals that depend upon them for food, and that includes mankind.

All living organisms, including humans, are part of a complex web of relationships that connects them with one another and with their environment. This interdependence relates to the food chain, to the balance of populations, and to natural cycles. As a result of these relationships, all the basic elements circulate and are exchanged between living beings and the environment in a process that is constant and universal, occurring through us and all around us.

ALBERT EINSTEIN ONCE PREDICTED THAT IF THE HONEY BEE DISAPPEARED, THE HUMAN RACE COULD ONLY SURVIVE FOR FOUR YEARS

Carbon dioxide is collected from the air by plants which are eaten by animals or humans, and then one day returns to the earth or the air when the body of these living beings decompose. Oxygen, given off by plants in photosynthesis—the process whereby plants synthesize organic compounds from solar energy, carbon dioxide, and water—is breathed in by animals or humans. Exertion will cause these to perspire and this perspiration will contain molecules of water that may previously have been present in the sky, in the river, in the soil, in a fruit, in our brain... Understanding these relationships is the objective of what we call ecology.

What differentiates us from all other species is our awareness of this interdependence between all living things and of the processes that sustain life. As Albert Jacquard put it, the nature of mankind is to "be aware that tomorrow will exist and that I can act upon it."

Millennium Ecosystem Assessment (MEA)
www.millenniumassessment.org

Pink lapacho tree on the slopes of Mt. Kaw, French Guiana (4°30'N–52°00'W) A native of damp tropical forests from Mexico to Argentina, *Tabebuia impetiginosa* loses all its leaves before flowering in spectacular fashion. This pink lapacho, flowering in isolation amid an ocean of green, demonstrates the low density of the species. Unlike the temperate forests, in which homogenous populations of a single or just a few species of tree are common, the forests of the tropics contain thousands of plant species.

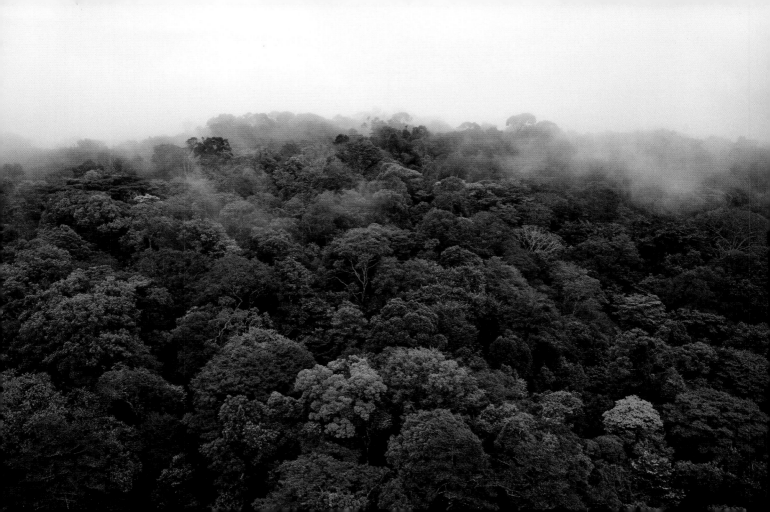

The miracle of life occurs within a context of awesome dimensions. Firstly, in terms of time: the universe itself is some 14 billion years old, the first mammals appeared almost 200 million years ago, and humankind has existed for around 200,000 years. Secondly, in terms of space: we still do not know whether there is life elsewhere in the universe; since 1995, however, we have been aware of the existence of planets that revolve around stars in a similar way to our own solar system, and it is possible that the universe contains many such planets and suns.

The birth of the Sun, approximately 4.5 billion years ago, brought about a chain of events that established all the conditions necessary to life. It was around this phenomenal source of energy that the eight planets of our solar system were formed. Venus is closer than the Earth to the Sun and is a furnace, whereas Mars is located further from the Sun and is icy cold. The Earth, on the other hand, is located at just the right distance to be able to support life.

ITS MASS, ITS METALLIC CORE, AND THE EFFECTS OF GRAVITY EQUIP PLANET EARTH WITH A MAGNETIC SHIELD AND AN ATMOSPHERE THAT BLOCK THE DEADLY COSMIC RAYS

But this is not all. Its mass, its metallic core, and the effects of gravity equip Planet Earth with a magnetic shield and an atmosphere that block the deadly cosmic rays, retain the Sun's energy in the form of heat, and protect the planet from being bombarded by meteorites. Finally, with the formation of water on Earth, a cradle for life was created. Environmental conditions, and the intensity of solar energy, subsequently remained stable for a sufficient period of time for life to continue and pass from a primitive form to that which we know today—a process that took 3.8 billion years.

Thanks to our mastery of the world, we have a tendency to relate everything back to ourselves and to evaluate everything on a human scale—that of the few decades of our individual lives, or the few thousand or million square miles of the country we inhabit. But will we ever take in the bigger picture? Will we ever learn to take care of the planet we inhabit, of its limited and precious resources, so that we can hand it on in good condition to our descendants?

Millennium Ecosystem Assessment (MEA)
www.millenniumassessment.org

Lake Holmsarlon, near the Myrdalsjökull glacier, Iceland (63°51'N–19°53'W) The landscape of Iceland was formed by volcanos and glaciers. In 2006, hydraulic and geothermal power represented 70.6% of Iceland's energy. More specifically, geothermal power provides domestic heat and electricity, while dams produce electricity destined in large part for the hydrometallurgical industry and in particular the extraction of aluminum.

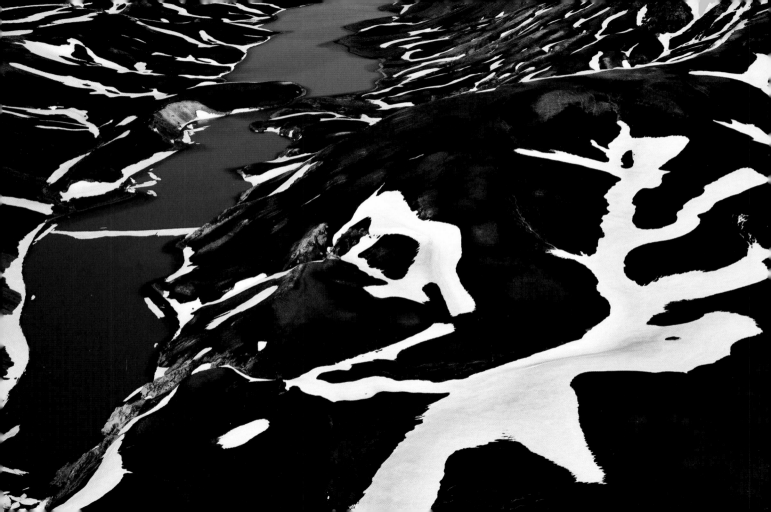

The biosphere is made up of a series of natural habitats together with the living organisms that populate them, and it covers the surface of the Earth with a thin film not unlike the skin of an apple. But in this case the apple is full of movement, from its core to its surface. We live on a planet that is active and dynamic, whose features are constantly changing.

Continental drift, caused by movements in the Earth's crust over billions of years, has shaped our current map of the world. The shifting of the continental plates near the surface is perceptible to us as tremors and earthquakes or volcanic eruptions, which frequently destroy human constructions. However, we often remain unaware of the effects of these movements over hundreds of millions of years, during the course of which mountain ranges are created, oceans are formed and recede, and continents change position.

It is in its crust that the Earth's memories of the past are stored. When wind or water erode the soil, they present a chapter of the Earth's geological history for us to read. The rocky strata of the Grand Canyon—the oldest of which, exposed at the base of the cliffs, date back almost 2 billion years—reveal that the whole region was in fact covered by sea water at several different points in the past.

The minerals to be found on Earth take us even further back in time. The majority of elements were created by nuclear reactions occurring billions of years ago at the core of stars like our Sun. They are the dust of stars, relics of the infancy of our world, when it was no more than an accumulation of dust and gases which gradually agglomerated.

The result of 4.5 billion years of geological history is a rich and fertile world full of resources necessary to life, of minerals, and energy sources. In search of these minerals and resources, mankind digs ever deeper into the soil, leaving ever deeper scars. Sometimes we even resort to dynamiting mountains. But despite their profusion, the Earth's resources are not boundless. Today we are beginning to realize that they have to be used sparingly.

Millennium Ecosystem Assessment (MEA)
www.millenniumassessment.org

> THE MAJORITY OF ELEMENTS WERE CREATED BY NUCLEAR REACTIONS OCCURRING BILLIONS OF YEARS AGO AT THE CORE OF STARS LIKE OUR SUN

The Maelifell volcano, near the Myrdalsjökull glacier, Iceland (63°51'N–19°13'W) This volcanic cone in southern Iceland, composed of solidified ejecta and ash, was created by one of the many eruptions that occurred beneath the icecap before the Myrdalsjökull glacier receded. Freed from the glacier some 10,000 years ago, the Maelifell is now bathed by the glacial streams that flow from it. Its perfect cone rises 650 feet (200 meters) above the plain and is covered with grimmia, a moss that commonly grows on cooled lava flows, varying in color from silver-gray to brilliant green depending on the level of humidity in the ground.

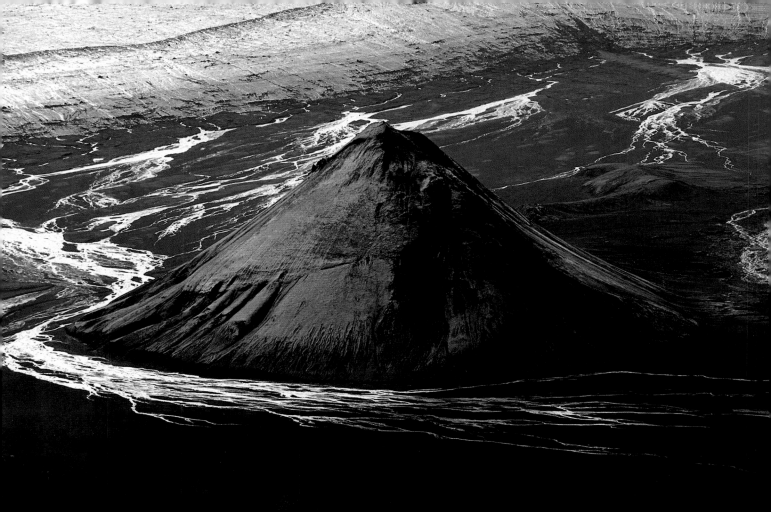

The advent of life on Earth had a considerable impact on the planet. More than 4 billion years ago, Earth's atmosphere was unbreathable: it contained no oxygen but a significant quantity of greenhouse gas, being 85% water vapor and 10 to 15% carbon dioxide (as opposed to 0.03% today). In time, a primitive form of algae known as cyanobacteria appeared in the waters of the ocean, and photosynthesis was born. Oxygen was released into the atmosphere as a byproduct of photosynthesis and the concentration of oxygen gradually increased until it reached today's level of 21%, remaining stable for around 550 million years.

The phytoplankton (tiny algae) in our oceans plays the same role today, renewing the oxygen in the atmosphere and storing carbon dioxide. Its biomass is considerably greater than that of the continental forests. Sixty to 70% of the oxygen that we breathe comes from our oceans, so it is the oceans, not the forests, that are the planet's "lungs."

For some decades now, another life form has been considerably modifying the Earth's atmosphere: mankind itself. Our industrial activities have been releasing compounds that destroy ozone—a gas that forms naturally from oxygen and is therefore also a product of photosynthesis. Ozone is responsible for filtering the Sun's damaging ultraviolet rays. In southern Chile and southern Australia, the "hole" that has been opened up in the ozone layer exposes the population directly to these rays, with the result that cases of retinal damage and skin cancer are increasing in these regions. The Montreal Protocol, signed in 1987, banned the use of gases that damage ozone—fortunately for us, because they could have wiped out all trace of life on Earth.

Today, it is greenhouse gases that we are releasing into the atmosphere in excessive quantities. These gases are responsible for climate change, increasing the mean temperature of the planet and threatening its ecosystems. The composition of the atmosphere is not fixed, therefore. Human beings and all living organisms, in particular chlorophyll-bearing plants, are part of this process. We need them if we are to preserve an atmosphere that we can continue to breathe in.

The Ozone Resource Page, NASA
www.nasa.gov/vision/earth/environment/ozone_resource_page.html

> ## 60 TO 70% OF THE OXYGEN THAT WE BREATHE COMES FROM OUR OCEANS, SO IT IS THE OCEANS, NOT THE FORESTS, THAT ARE THE PLANET'S "LUNGS"

White Haven beach at high tide, Whitsunday, Queensland, Australia (20°17'S–148°59'E) White Haven beach, with its fringe of mangrove swamps, is exceptional for the quality of its sand, composed of 98% silicate and regarded as the purest in the world. A handful of bathers share the waters with manta rays, crocodiles, turtles, and schools of dolphins. The site belongs to the Great Barrier Reef marine park, a UNESCO World Heritage Site, which extends along the coast of Australia over a distance of 1,400 miles (2,300 kilometers).

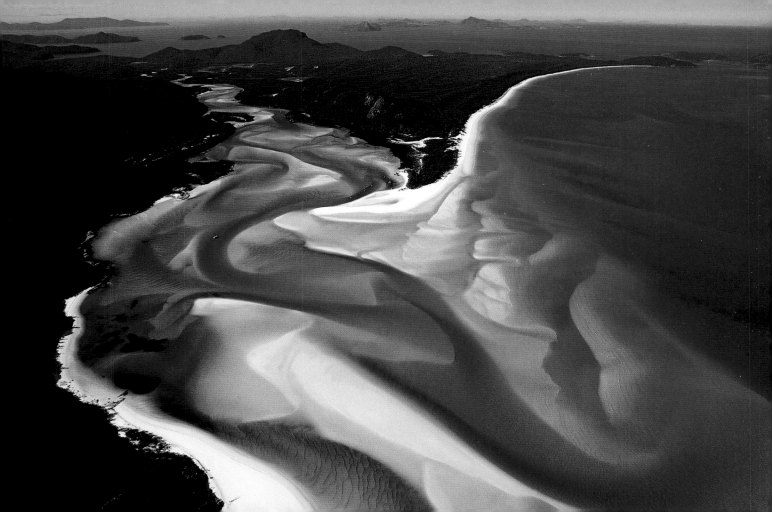

All cells—plant or animal, bacterial or fungal—function according to identical mechanisms, deriving as they do from the same early life forms that appeared 3.8 billion years ago. Having conquered every habitat, from the iciest, deepest waters of the ocean to the hottest desert wastes, they populate both earth and air, forming organisms that can be anything from a few micrometers to several dozen meters long. The diversity of the living world is immense and biologists today estimate the existence of something between 5 and 100 million species—still only a tiny fraction of the total number of species that have succeeded one another in the life of the planet.

Every year, advances in science uncover a little more information regarding the profound relationships between the species. Humans and chimpanzees share 99% of their genetic inheritance, but the common fruit fly shares 40% of its genes with us and the sea urchin, a marine creature with no head or limbs, 70%! This genetic proximity is mirrored in a compositional proximity—all living organisms being formed of the same basic molecules. This explains how one species can feed off another: in the process of digesting, the first re-uses the elements of the second, rearranging them in its own fashion.

The similarities go even further and explain the effects of numerous molecules used by mankind. Thus, morphine, produced by the poppy, a plant with large, brightly colored flowers, alleviates pain in the human body, causes digestive disorders, and procures intense feelings of pleasure. This action is possible because certain human cells themselves synthesize a form of morphine similar to that of the poppy, and because other human cells recognize and respond to it.

In the same way, the majority of medicines used today are taken from nature. To quote just two examples, aspirin is derived from the willow, and vinblastine—used in the treatment of cancer—comes from the Madagascar periwinkle. Today, almost 80% of the world's population makes direct use of plants for medicinal or cosmetic purposes.

> HUMANS AND CHIMPANZEES SHARE 99% OF THEIR GENETIC INHERITANCE, BUT THE COMMON FRUIT FLY SHARES 40% OF ITS GENES WITH US AND THE SEA URCHIN, A MARINE CREATURE WITH NO HEAD OR LIMBS, 70%!

Millennium Ecosystem Assessment (MEA)
www.millenniumassessment.org

Grand Prismatic Spring, Yellowstone National Park, Wyoming, USA (44°31'N–110°50'W) The yellow and orange colors of the spring derive from the presence of *Archaea*, one of the most primitive life forms: different species develop depending on the water temperature, which is very high at the center of the basin, and lower at the periphery.

We have a truncated vision of the living world. The plants, animals, and insects that we see or know represent in reality only an infinitesimal part of life on Earth. The bulk of it is concealed underground. More than 50 billion microscopic organisms teem in a tablespoon of forest soil, and more than 1,000 species of invertebrates can be recorded over a square meter. It is the earth that harbors almost 80% of the continental biomass (weight of living matter) of our planet, a large part of it consisting of earth worms, which aerate and fertilize the soil—a fact that led Darwin, in 1881, to compare them to mankind's invention of the plow.

A whole array of creatures—worms, centipedes, ants, mites, algae, molds, and bacteria—are busily engaged in the task of recycling living matter: decomposing dead plants and animals and transforming them into humus, from which the roots of new plants draw their nutrients in order to create fresh living matter.

THE HUMAN BODY CONTAINS TEN TIMES MORE BACTERIA THAN IT DOES CELLS

Another location where bacterial life is abundant is the human intestine. The human body contains ten times more bacteria than it does cells. We do not see these bacteria and rarely give them a thought, and yet they directly influence our health, aiding our digestion and helping us to fight against invading germs.

The animals we tend to feel most drawn to are large mammals whose appeal lies in their expressiveness or their beauty. The giant panda, the Asian tiger, and the polar bear are no more important than earth worms or mites. Their popularity, however, promotes an awareness that is crucial in safeguarding the great pageant of biodiversity, which includes not only the large and the beautiful, but also the minuscule, invisible, repugnant, and fearsome, together with all those other elusive species not yet recorded or described by science.

Millennium Ecosystem Assessment (MEA)
www.millenniumassessment.org

Elephants in the swamplands of the Okavango Basin, Botswana (19°25'S–23°14'E) African elephants (*Loxondonta africana*) travel for many miles in search of the 220 to 440 lb (100 to 200 kilograms) of vegetable matter on which they feed each day. They follow the dominant female, in single file, communicating with movements of the trunk or the ear, through smell or touch, or a whole range of low-frequency sounds inaudible to the human ear. These animals have been intensively hunted for their ivory and are at risk of extinction. Their numbers declined from 2.5 million in 1945 to 500,000 in 1989, when trading in ivory was finally banned.

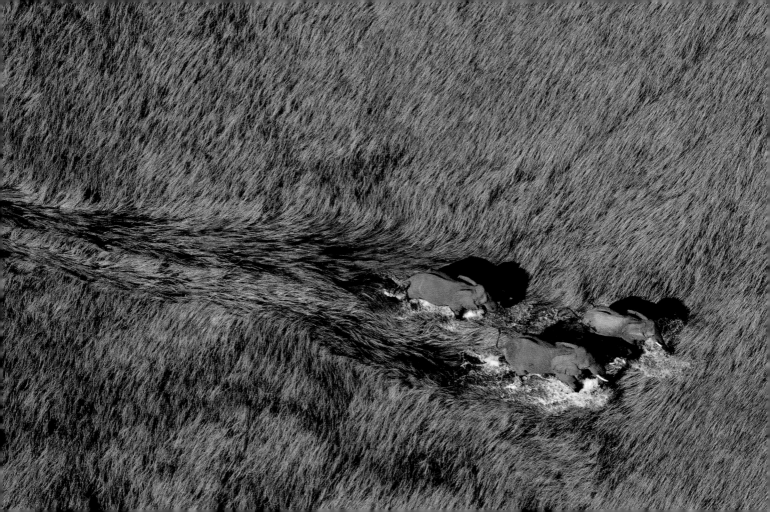

We often talk about the "law of the jungle," a phrase that conjures up a violent image of each individual out for himself and in conflict with others. But this is not a true vision of life in the wild. The living world is no idyll, certainly, but cruelty and injustice play no part in it.

Living organisms are all engaged with one another in complex food chains. Virtually all these chains start with some form of plant life (plants, algae, phytoplankton) capable of manufacturing its own organic substances. These ecosystems function, therefore, as a result of solar energy, which is crucial to a plant's survival. Each link in the chain is food and then predator in turn. When one organism dies, it keeps another organism alive. Predation also plays a regulatory role that benefits the species by eliminating weak or sick individuals which serve as easy prey. The cycle continues until the organic matter becomes waste, or a cadaver, at which point it decomposes, through other links in the chain, into mineral elements that are reincorporated into plants once more.

There is still a great deal we do not know about the relationships between species, not all of which are related to food.

EACH LINK IN THE CHAIN IS FOOD AND THEN PREDATOR IN TURN. WHEN ONE ORGANISM DIES, IT KEEPS ANOTHER ORGANISM ALIVE

Species can also depend upon one another for shelter, protection, movement from place to place, and reproduction. Plants need insects to convey their pollen from flower to flower while feeding on their nectar. Others rely on animals to scatter their seeds, either by swallowing and disseminating them in their excrement, or by transporting them on their coats. The clownfish shelters inside the sea anemone, having evolved a natural immunity to its stinging tentacles. Corals harbor inside their bodies a type of microscopic algae essential to their growth.

These complex relationships demonstrate that if we wish to safeguard the existence of any particular species, we can only do so within its natural habitat, since it is here that it fulfills its role relative to the other species present, and to humankind. A hippopotamus isolated in a zoo is no good to anyone. A hippopotamus in Lake Edward, in Africa, fertilizes the waters generously with its excrement, so benefiting the fish, which are present in large numbers for humans to catch.

Millennium Ecosystem Assessment (MEA)
· www.millenniumassessment.org

Pelicans in the Senegal River Delta, near Saint Louis, Djoudj National Park, Senegal (16°15'N–16°19'W) The White Pelican (*Pelecanus onocrotalus*) has white plumage, dark wing tips, and a large yellow beak with a heavy pouch. "Pelican Island" in Djoudj National Park is home to some 5,000 of these birds. The park is a wetland zone of considerable size, one of the first resting places for nearly three million migratory birds after they have flown across the Sahara. The third largest bird sanctuary in the world, it owes its name to a branch of the Senegal River, the Djoudj, which waters this humid savannah ringed by desert, providing refuge to a great variety of species.

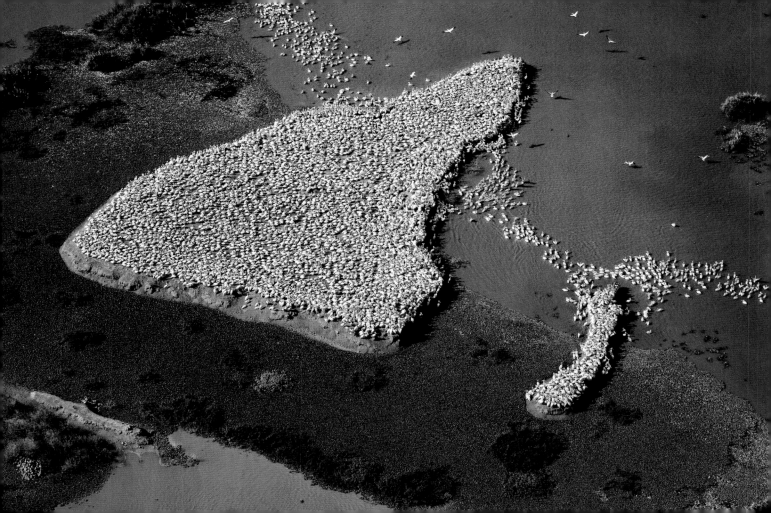

Why should we protect the natural world? Because it is beautiful, and because it relaxes us and inspires us. And because it is our duty, and to do so makes us better human beings. There are a great many answers to this question. And the experts have added another: because it is in our own interests. They have proved the fact by listing all the services provided by the planet's ecosystems, entirely gratis, for the benefit of humanity.

The list is laboriously long. Take a forest, for example: it produces wood, stores carbon dioxide, releases oxygen into the atmosphere, purifies water through filtration, prevents erosion by keeping the soil in place, averts flooding by saturating the ground like a sponge, is home to a variety of rare plants and animals, and provides walkers with the benefits of recreation and relaxation. Or take a coral reef, which protects our coastlines (acting like a breakwater), functions as a breeding ground and a nursery (a major factor for fish stocks), and contains various molecules of potential benefit to medicine.

What is all this worth? The European Commission is financing a major study relating to The Economics of Ecosystems and Bio-diversity (TEEB), in an attempt to calculate the significance of these benefits in monetary terms. Preliminary figures for the forested area of the Masoala National Park, in Madagascar, alone show its value as 11,000 billion US dollars. If we consider the destruction of the planet's forest ecosystems, the toll is equivalent to 5% of the world's annual GDP.

IF WE CONSIDER THE DESTRUCTION OF THE PLANET'S FOREST ECOSYSTEMS, THE TOLL IS EQUIVALENT TO 5% OF THE WORLD'S ANNUAL GDP

Trapped within our short-term vision, we sometimes forget just how precious the natural world is; this is one of the reasons why we accept its destruction. But it can be extremely profitable to consider the value of the services that ecosystems render us. When, for example, New York City decided to improve its water supply, it chose the option of reforesting the surrounding hills instead of building a water purifying plant. The result was naturally purified water obtained for ten times less than the projected cost of the plant (8 billion US dollars). Can the language of cost-benefit analysis produce a response from us where all else fails?

The Economics of Ecosystems and Biodiversity (TEEB)
ec.europa.eu/environment/nature/biodiversity/economics/pdf/teeb_report.pdf

River branch in the Okavango Basin, Botswana (18°58'S–22°29'E) Schoolchildren learn that "all rivers flow to the sea," but the Okavango seems to be the exception that proves the rule. The journey's end for this river is a sea of sand: the Kalahari Desert. Rising in Angola, where it is known as the Cubango, the river flows across Namibia before draining away into a vast inland delta, 5,800 square miles (15,000 square kilometers), in Botswana. By the time it deposits its rich cargo of sediments in the delta, it has flowed for 900 miles (1,450 kilometers), watering and replenishing the lands along its route.

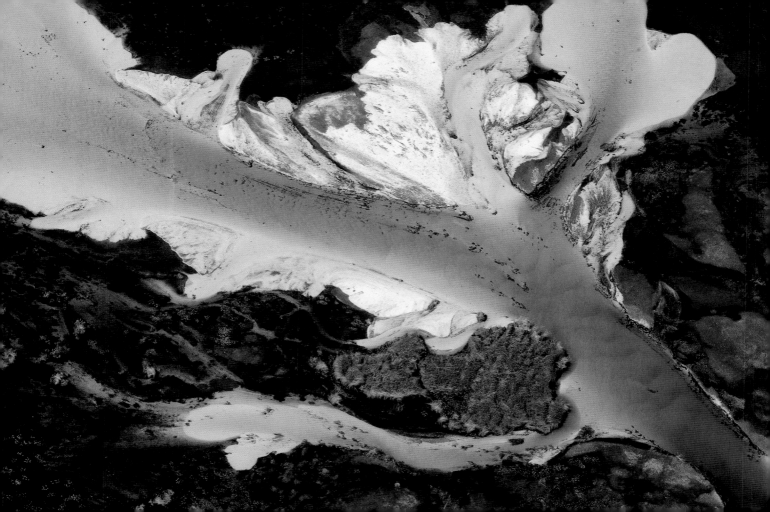

Today's landscapes bear the imprint of mankind and the marks of our economic growth: areas under cultivation, infrastructures, hydroelectric dams, urban sites, pollution. What is the impact of such damage, beyond the visual evidence?

Certain consequences are immediately apparent. Hydroelectric dams, for example, which impede the flow of over half the planet's major rivers, prevent migrations and permanently affect pre-existing living conditions for many species. Similarly, highways carve up natural habitats, imprisoning living creatures on one side or the other of an insuperable barrier. Other effects are less direct. With the spread of urban areas and infrastructures, the earth is blanketed in concrete, making it impermeable to rainfall. Surface water increases, feeding streams and rivers and giving rise to more frequent and more serious flooding.

Invisible chemical pollutants are even more insidious. They are carried far and wide by air and sea currents, turning up as far away as Greenland, for example, where they accumulate in the fat of marine animals. Studies carried out in the 1970s revealed the presence of a pesticide, DDT, in the bodies of seals and polar bears, and of mercury in white whales. These toxic substances are described as "persistent" because they accumulate and contaminate the entire food chain from plankton to fish to seals, right up to the Inuit who hunt the seals. The breast milk of some Inuit women is so heavily contaminated that it could be classified as toxic.

STUDIES CARRIED OUT IN THE 1970S REVEALED THE PRESENCE OF A PESTICIDE, DDT, IN THE BODIES OF SEALS AND POLAR BEARS, AND OF MERCURY IN WHITE WHALES

Humanity puts great strain on the natural world. But what role does each of us play in this? We now have a tool that can measure it: we can calculate what is known as our "ecological footprint"—the necessary surface area of the planet for the production of our food, the manufacture of the objects we rely upon, and the absorption of our waste products. The average ecological footprint, taking humanity as a whole, is 4.4 acres (1.8 hectares), but the average for a European is 11.8 acres (4.8 hectares). The overall resources used by human beings already exceed the planet's capacities for regeneration by 30%. If our consumption continues at the same rate, by 2030 we will need the equivalent of two planets to maintain our way of life.

Millennium Ecosystem Assessment (MEA)
www.millenniumassessment.org

Seta valley devastated by fire in August 2007, Euboea, Greece (38°32'N–23°56'E) This landscape of cultivated valleys and forested slopes was ravaged by fire in 2007. Fanned by strong winds, some hundred fires—probably the work of arsonists—destroyed almost 500,000 acres (200,000 hectares) in late August 2007 from the north of the country down to the Peloponnese. A state of emergency was declared throughout Greece.

The last large-scale mass extinction of animal and plant species, which wiped out the dinosaurs 65 million years ago, also had positive consequences: it was followed by the expansion and diversification of mammals and, subsequently, by the appearance of human beings. It was as if the old branches had been lopped off the tree to make way for the new shoots. Why, then, should we regard the current reduction in biodiversity as a source of alarm?

Our planet has already experienced five similar large-scale episodes, caused by natural catastrophes, climate change, or the impact of meteorites. The most extreme, at the end of the Primary Era, some 250 million years ago, wiped out more than 80% of species then in existence. Each time, after millions of years, biodiversity re-establishes itself and is enriched with a whole array of new families and genera.

In between two crises, a natural cycle occurs involving the appearance, evolution, and extinction of living species. It is estimated that one vertebrate species will disappear in this way every 50 to 100 years. In the course of the last 400 years, however, 151 species of higher vertebrates have become extinct—in other words, one species every 2.7 years. Today, one bird in eight, one mammal in four, and one-third of all amphibians is at risk. If we look at the living world as a whole, the extinction rate is some 1,000 times faster than we would naturally expect. The problem is not that certain species are disappearing: it is the speed at which this is happening.

IF WE LOOK AT THE LIVING WORLD AS A WHOLE, THE EXTINCTION RATE IS SOME 1,000 TIMES FASTER THAN WE WOULD NATURALLY EXPECT

This is why it is thought that the planet has now entered its sixth large-scale mass extinction of plant and animal species. Unlike previous extinction events, which have occurred over thousands or even millions of years, this one is taking place over decades or centuries; the process is so rapid that ecosystems are becoming incapable of adapting to it.

The other difference is that this particular event can be attributed to one single species—human beings. Unlike the dinosaurs, however, mankind also possesses the means to counteract this phenomenon.

Bungle Bungle National Park, Kimberley, Australia (17°31′S–128°20′E) A series of columns and domes, some 650 to 980 feet (200 to 300 meters) high, form a labyrinth of gorges over an area of almost 300 square miles (770 square kilometers) in this national park. These rocks are composed of solidified sediments, and their orange and black colors are the result of the alternation of layers rich in iron oxide and permeable layers in which lichen can grow.

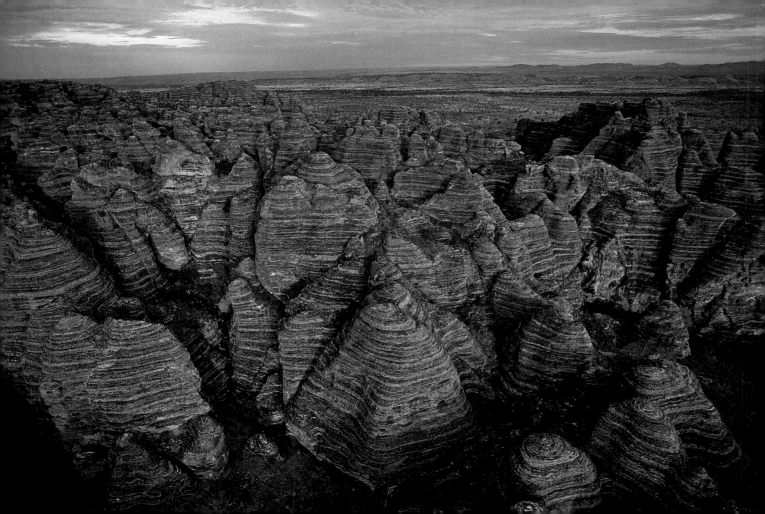

PROTECTED AREAS
ECOSYSTEM MANAGEMENT

What are the benefits of protected areas?

Source: Secretariat for the Convention on Biological Diversity, 2008. *The Value of Nature: Ecological, Economic, Cultural and Social Benefits of Protected Areas.*

Provide coastal protection

$300,000

Amount of money saved per km of coastline due to protection by mangroves.

$9 billion

Money saved globally every year due to storm protection by coral reefs.

Provide jobs

1,200

Number of jobs created by establishment of South Luangwa National Park in Zambia. In 2004 the park cost $1.2 million, but raised $4.1 million in tourism and had a total value of $16 million.

Preserve freshwater sources

875,000 households

Number of rural rice-farming households in Madagascar that depend on fresh water from protected areas.

Regulate global warming

4.43 gigatons

Amount of carbon sequestered in Canada's national parks.

20–25%

Percentage of greenhouse gas emissions resulting from conversion of forests and other ecosystems.

Improve fisheries

10-fold +
Increase in fish catches in areas surrounding Apo Island MPA in the Philippines.

300 kg
(660 lb) Increase in monthly fish catches for local communities, almost double the previous amount.

Improve local income

35%
Increase in local incomes due to a tripling of fish catches in a locally managed marine protected area in Fiji.

What are some of the threats to protected areas?

Climate change • Poaching • Conflict • Unsustainable use due to population pressure • Illegal logging • Fossil fuel extraction • Pollution • Invasive species • Fire • Natural and anthropogenic disasters • Unregulated tourism

Produced by UNEP/DEWA/GRID-Europe, Feb. 2009

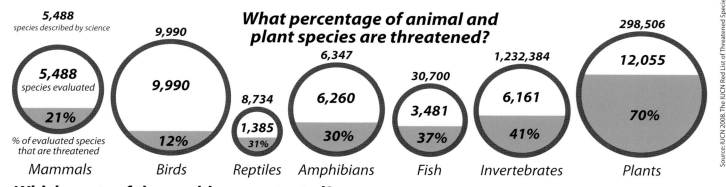

What percentage of animal and plant species are threatened?

5,488
species described by science

5,488
species evaluated

21%

% of evaluated species
that are threatened

Mammals

9,990

9,990

12%

Birds

8,734

1,385

31%

Reptiles

6,347

6,260

30%

Amphibians

30,700

3,481

37%

Fish

1,232,384

6,161

41%

Invertebrates

298,506

12,055

70%

Plants

Source: IUCN 2008. The IUCN Red List of Threatened Species

Which parts of the world are protected?

IUCN National Protected Areas, Categories I-VI and Unclassified Areas

North-East Greenland National Park (est. 1988)
97,200,000 ha
(240 million acres)

Franz Josef Land Zakaznik (est. 2004)
4,200,000 ha (10 million acres)

Northwestern Hawaiian Islands Marine National Monument (est. 2000)
34,136,200 ha
(84 million acres)

Great Barrier Reef Marine Park (est. 2004)
34,781,500 ha
(86 million acres)

Galapagos Marine Reserve (est. 1996)
13,300,000 ha
(33 million acres)

Qiangtang Nature Reserve (est. 1990)
29,800,000 ha
(74 million acres)

12%
of land on earth is protected.

0.5% of oceanic area is protected.

Namib Naukluft National Park (est. 1979)
4,976,800 ha
(12 million acres)

Source: UNEP GEO Data Portal, compiled from UNEP-WCMC

The invention of agriculture was the first revolution. Appearing almost simultaneously around 10,000 years ago in different world regions—the Middle East, China, the Andes, and New Guinea—it progressively modified the relationship between human beings and nature. It ended the uncertainty of the hunter-gatherer way of life and ushered in the technological age; it permitted humans to settle and establish the first towns. The invention of agriculture is also known as the "Neolithic Revolution."

Humans quickly domesticated certain species of animals, essential for agricultural work. Later, poorer quality soil and lack of water led to the invention of other techniques such as irrigation. Through agriculture and livestock rearing, humans molded and tamed nature.

Agricultural techniques and productivity developed slowly. Over the centuries more land was cleared for cultivation in order to increase yields. But the 1950s saw a new agricultural revolution with the advent of mechanization, the use of synthetic fertilizers, pesticides, and the selection of higher-yielding crop varieties. Nowadays, farmers in the developed world can produce 200 times more than they could before mechanization.

Today, agriculture and livestock rearing account for 99% of human calorie consumption. They are also the primary source of revenue for almost half of the world's population: 2.6 billion men and women depend on them for their survival. However, this agricultural model is now in crisis. The land is exhausted, as is the environment. To the north and south, the countryside is facing a catastrophe. Global economic relations are being strained by agricultural exports and hundreds of millions of people are starving—even though trade agreements and food distribution policies are playing a crucial role. We need to find another system!

> FARMERS IN THE DEVELOPED WORLD CAN PRODUCE 200 TIMES MORE THAN THEY COULD BEFORE MECHANIZATION

United Nations Food and Agriculture Organization (FAO)
www.fao.org

Masai village enclosure, near Kichwa Tembo camp, Kenya (1°13'S-35°00'E) For the Masai, a family's wealth is measured in head of cattle, while land ownership is completely irrelevant. In a country where 75% of the population is employed in agriculture, there is an increasing trend among the Masai to settle, particularly following the droughts of 1999 and 2000. But this change in lifestyle is putting heavy pressure on the land.

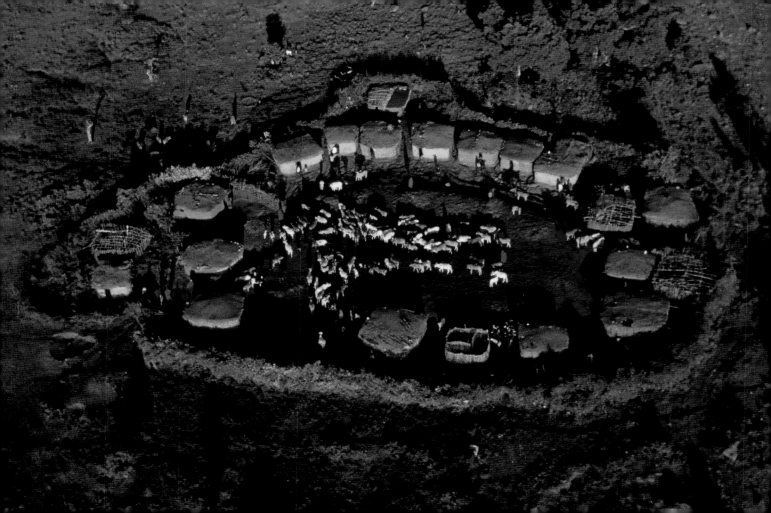

Today more than 900 million people are in danger of starvation. The grain market is at the mercy of the harvests: poor results place millions of lives at risk, as in 2008 when there was widespread famine across many countries. By 2050 the population will have reached 9 billion—what then?

Modern agriculture is struggling just when we need it most. The 20th-century agricultural revolution increased yields at a rapid rate. However, growth has since slowed down. According to the United Nations Food and Agriculture Organization (FAO), productivity rose by 2.3% per year from 1961, but this figure is set to fall to 1.5% between now and 2030, and to 0.9% between 2030 and 2050. Methods developed in the 20th century to increase productivity have revealed their limitations. Intensive farming, irrigation, fertilizers, and pesticides have damaged the soil, water, and life itself, in short, the entire ecosystem farmers rely on for production.

Ecofriendly agricultural practices are possible, and can take several forms. Organic farming is the best-known example. Different systems respond to different specific needs. The challenge for the 21st century is to combine green methods with sufficiently high levels of productivity to feed the entire planet and bring about a "Doubly Green Revolution," in response to the first Green Revolution of the 1950s.

Conservation agriculture is leading the way in this area. It successfully harnesses the dynamics of our ecosystems. By creating minimal soil disturbance it promotes microbial activity, and it employs crop rotation to minimize the need for fertilizers and pesticides. According to the FAO, the returns match those of traditional intensive farming methods. Since it eliminates the need for plowing, farmers' workloads are halved. Lower input also means that it is cheaper, saving up to 70% of fuel costs. Introduced some twenty-five years ago, it is now practiced on 250 million acres (100 million hectares) around the world, and is promoted by the FAO on a global scale.

United Nations Food and Agriculture Organization (FAO)
www.fao.org

> THE CHALLENGE FOR THE 21ST CENTURY IS TO COMBINE GREEN METHODS WITH SUFFICIENTLY HIGH LEVELS OF PRODUCTIVITY TO FEED THE ENTIRE PLANET

Plowed fields near Hlatikulu, Kingdom of Swaziland (26°56'S–31°21'E) The region of southern Swaziland is dominated by subsistence farming, practiced on small parcels of land by village communities. The succession of prolonged droughts and high temperatures in 2006-2007 devastated the corn crops, resulting in the worst annual harvest on record: 60% down on the previous year.

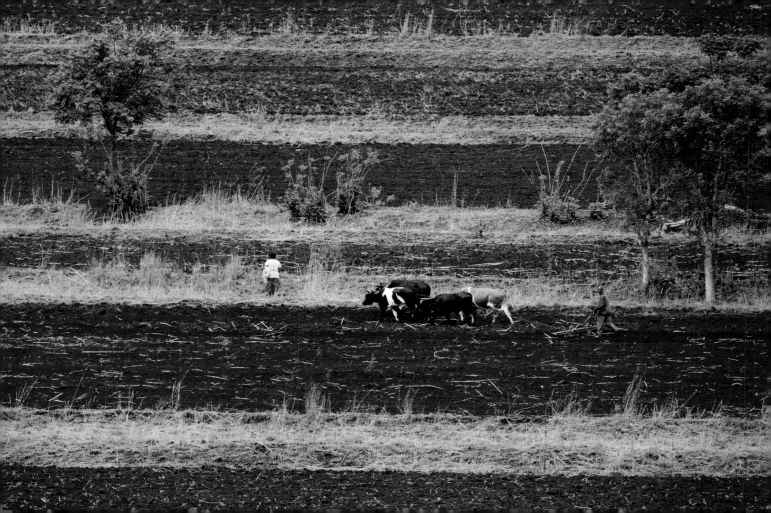

In the USA, the world's leading agricultural power, there are almost three million farmers, making up around 1% of the population. Each of them can farm several hundred hectares and produce thousands of tons of grain. But this is not a representative image of world farming. Nearly 80% of farmers farm by hand. And globally, agriculture is still the majority occupation: it employs 47% of the active population.

Today, conditions vary widely from one region to another, but all over the planet, the world of farming is in a state of crisis. A farmer in the Midwest of the USA can produce 2,000 times more than a poor farmer in Rwanda. But in order to do this, hundreds of thousands of dollars must be spent on equipment, getting the farmer into debt. To pay back this debt, the farmer must then follow an endless path toward maximum productivity. In the farmlands of India, farmers also get into debt to pay for pesticides, and sometimes one bad harvest can lead to disaster—suicides among farmers are on the rise in the country.

GLOBALLY, AGRICULTURE IS STILL THE MAJORITY OCCUPATION: IT EMPLOYS 47% OF THE ACTIVE POPULATION

In many countries, particularly those in South America, the majority of farmers work as employees on large corporate farms called *latifundios*. In Brazil, for example, 1% of landowners own 54% of farmland. Social conditions are hard, wages are minimal, and violence is endemic. The Landless Workers' Movement (MST) is demanding agrarian reforms which are long overdue.

In the poorest places, the fall in food prices is making it increasingly difficult for farmers to survive. Farmers may sometimes own their own land, but women, who make up a large proportion of the workforce, often have no ownership rights over the lands that they farm. Millions of people are leaving the countryside and moving to big cities, where too often they end up in shanty towns.

Farming is nonetheless an honorable job, built around a close relationship with nature. There is a need to find a way to give it a status that befits the importance of its role: feeding the human race.

United Nations Food and Agriculture Organization (FAO) www.fao.org

Women carrying buckets in Dogon country, near Bandiagara, Mali (14°20'N–3°37'W) Since the 10th century, the Dogon people, traditionally sedentary farmers, have lived in the southwest of the Niger River bend. They first settled by the cliffs of Bandiagara, near Mopti, in order to avoid conversion to Islam. Dogon men and women both work in the fields, but women also grind the millet and look after the children. In Africa, 80% of women work on the land.

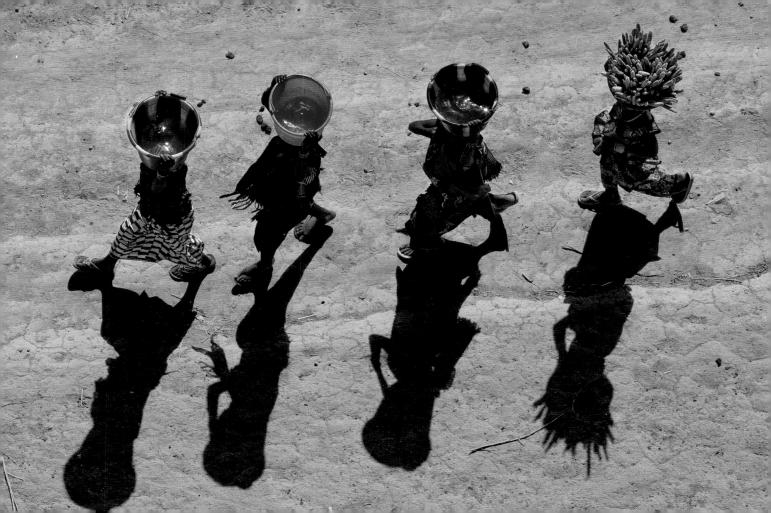

Was the Green Revolution successful? The term refers to the extensive modernization of agriculture in developing nations following the Second World War, particularly during the 1960s and 1970s. On the positive side, the selection of more productive varieties and the use of synthetic pesticides resulted in significantly increased yields. The great famines which had ravaged these countries became a thing of the past.

On the negative side, the cost to the environment has been very high. The pesticides contaminated the ground water through to the water table. The dangerous side-effects of these chemicals are now continually being re-evaluated. Pesticides can interfere with the endocrine system and cause cancer, particularly among the farmers who are most exposed. Although some chemicals have been banned in developed countries, all too often they continue to be used in poorer countries.

The Green Revolution also reversed an old principle. For centuries, farmers adapted varieties to their own terrain—notably permitting the development of local varieties whose quality could be controlled and certified. The new agriculture does the opposite: it takes hyperproductive varieties created in the laboratory and adapts the soil to them via the liberal use of fertilizers. But these fertilizers alter our ecosystems and, for example, promote the growth of algae and bacteria, which can spread to become pollutants.

PESTICIDES CAN INTERFERE WITH THE ENDOCRINE SYSTEM AND CAUSE CANCER, PARTICULARLY AMONG THE FARMERS WHO ARE MOST EXPOSED

There are two consequences to this last point. Farmers of smallholdings must now buy large quantities of fertilizers and pesticides in order to grow these varieties. They go into debt, and the slightest shortfall in their harvest is disastrous. Moreover, they no longer use the seeds selected over generations and kept from the previous harvest, but purchase them from seed cultivators. They become dependent on them rather than on their traditional techniques, which are subsequently lost. The challenge is to enable smallholders to reappropriate their own seed varieties. Several organizations are working to achieve this, but their operations are highly localized and unfortunately sometimes go unnoticed.

Intergovernmental Forum on Chemical Safety, www.who.int/ifcs

Pesticides are sprayed on a carrot field in Jeju-Do, South Korea (33°27′N-126°34′E) Jeju-Do is an island located 56 miles (90 kilometers) south of the Korean peninsula. The land is extremely fertile, permitting cacti, mandarins, pineapples, and carrots to be cultivated. The farmworkers' equipment suggests that the chemicals they are using are highly toxic. In 2000, Korea ranked ninth in the world with a total consumption of 8,665 tons (1 ton = 2,205 lb) of fungicides and pesticides.

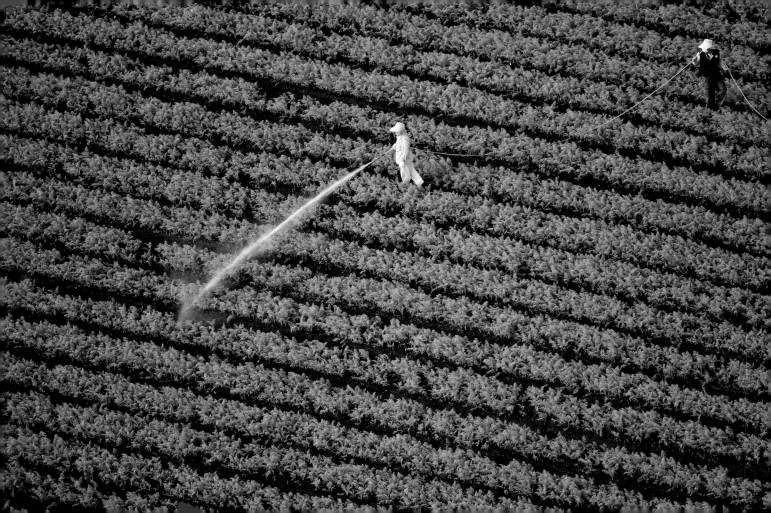

The farming world is too often thought of as an opposition between two groups: the subsidized farmers of the West and the poor farmers from developing countries. But for some twenty years, there have essentially been three groups, because a new category has arisen in the form of the Cairns Group—a group of nineteen countries including Argentina, Australia, Brazil, and Indonesia, who practice large-scale farming on huge areas of inexpensive land, using cheap labor, and modern production methods that are not subsidized. This group promotes liberalization of global trade in agricultural produce, through the abolishment of export subsidies.

Trade subsidies are certainly a major issue. The European Union's Common Agricultural Policy (CAP), for example, takes up more than 40% of the EU budget (45.36 billion euros in 2008). It is controversial for a number of reasons. Firstly, because many Europeans would prefer the EU to spend its budget on research, health, or education. Secondly, because the system favors the largest producers at the expense of smaller competitors, and harmful production methods instead of those that respect local ecosystems. And lastly, because it discriminates against farmers from non-EU countries. So what should be done?

Today, getting rid of the CAP would not be enough to save both small farmers and the environment. Moreover, the liberalization promoted by the Cairns Group is not socially and ecologically based—far from it. According to some studies, the abolition of the CAP could even have harmful effects on poor farmers, particularly in Africa, because they cannot compete with those from the Cairns Group. In addition, 60% of agricultural exports from Africa (excluding South Africa) are made up of cacao, coffee, tropical fruits and vegetables, and cotton: products that complement rather than compete with the agricultural products of Europe, and which are therefore not affected by the CAP. The problem is not with subsidies themselves, but the types of subsidies, to whom they are available, and why. If financial aid was given to support ecologically and socially sustainable agriculture, that would certainly not be a bad thing.

THE EUROPEAN UNION'S COMMON AGRICULTURAL POLICY TAKES UP MORE THAN 40% OF THE EU BUDGET

World Trade Organization, www.wto.org

Cotton harvest near Banfora, Burkina Faso (10°48'N–3°56'W) Burkina Faso is Africa's leading cotton producer, with three million people employed in the cotton industry. Cotton represents a quarter of the country's GDP and 60% of its exports, which makes the economy vulnerable to fluctuations in the world market. After having rejected GM cotton for some years, the Burkina Faso authorities officially authorized its introduction in 2008, in order, they claim, to guarantee regular crops.

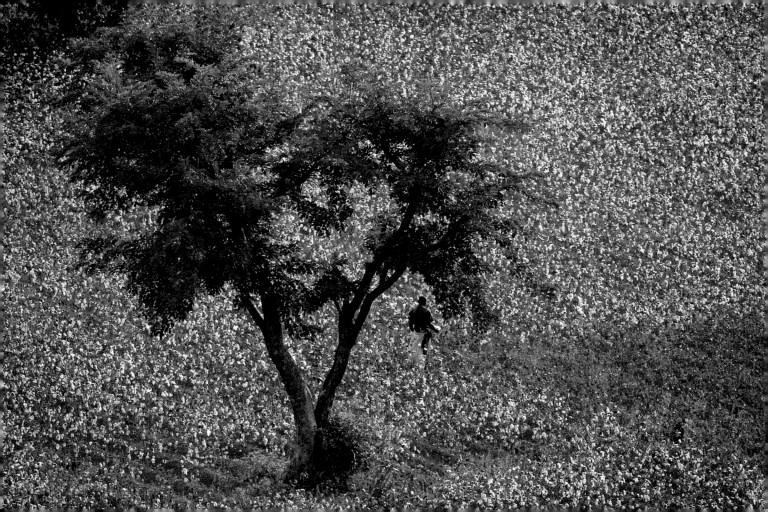

Our lives all depend on a layer just a few dozen centimeters thick: the topsoil that covers our planet and enables us to farm. This shallow layer is disappearing as it is stripped of its nutrients. Fertile land is being transformed into barren plains, arid terrain, and desert.

Today almost 40% of the Earth's arable land has been degraded in one way or another. The causes are numerous, including deforestation, overgrazing, and "unsuitable" farming practices, often associated with intensive methods or poorly regulated irrigation systems which increase the soil's salinity. Once damaged, the land is eroded by wind and rainwater until the shallow fertile layer disappears altogether. In a few short years, humans have destroyed soil which has often taken millennia to form through the slow fragmentation of rocks blended with humus, providing a fertile base for plants to grow in.

Over the centuries, agricultural productivity has risen by extending the surface area utilized. But today, most of our arable land—or the best-quality land, at least—has already been used. There is nowhere left to go. We must therefore not only preserve the land we have, but also farm it differently.

Countries such as China, Haiti, Mali, and Algeria, which are suffering from soil erosion and desertification, are already engaged in this task. Experts have identified numerous ways to prevent erosion such as tree planting and terracing, minimal plowing, and combating deforestation. A newer technique, *terra preta* ("black earth" in Portuguese) involves mixing charcoal obtained from organic waste matter into the soil. This porous material creates a soil base in which micro-organisms can thrive, and nutrients necessary for plant growth can accumulate. The soil's productivity thus increases two- or threefold.

As this example illustrates, changing agriculture is within our reach. It need not require state-of-the-art technology or heavy financial investment.

TODAY ALMOST 40% OF THE EARTH'S ARABLE LAND HAS BEEN DEGRADED IN ONE WAY OR ANOTHER

World Soil Information (ISRIC), www.isric.org

The Mahajilo River crossing the eroded plateaux to the east of Miandrivazo, Madagascar (19°31'S–45°28'E) The plateaux are scarred by deep grooves scooped out by flowing rainwater. These ravines, or *lavakas*, carry laterite, a red sediment scoured from the hills by erosion, into the river. There are no longer any trees to retain the loose earth as the forest has disappeared, cleared by slash-and-burn farming and overgrazing.

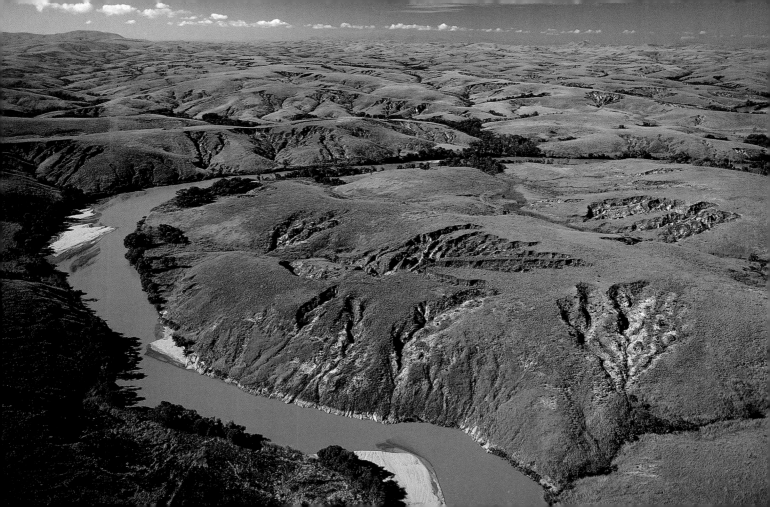

Most of our "natural" landscapes are not natural at all: they have actually been shaped by humans over the course of centuries. In order to cultivate crops over ever larger areas, humans have cleared vast expanses of forest and turned plains into fields and pastures. In time, many wild species have adapted to these landscapes, resulting in the development of ecosystems modified by humans and teeming with life. Agriculture has thus fostered biodiversity.

Agricultural land is surrounded by semi-wild habitats such as pastures, prairies, and hedgerows which are home to large numbers of animals and plants, sometimes as many as, or even more than, those found in certain natural ecosystems. These habitats even support numerous endangered species: across the cultivated fields of Europe, three in four mammals, two in three birds, and almost one in two butterflies live in the hedgerows.

But modern agriculture now plays an opposing role. The homogenization of crops and practices has caused heavy losses in domestic biodiversity: in the course of a century, three quarters of the plant varieties created by humans over millennia have disappeared. Today, 90% of the world's agricultural production has been reduced to around thirty plant species and fourteen animal species. This loss of domestic biodiversity weakens our resources and places global food security under threat. Moreover, the synchronization of farming activities (dates for harvesting, plowing, etc.), the disappearance of semi-wild habitats, and the extensive use of chemical fertilizers and pesticides are seriously harming the flora and fauna which live in the fields and surrounding areas.

There are many ways to protect this biodiversity, one of which is championed by movements such as Slow Food, whose goal is to help people rediscover the taste of good food and different products. "Defend biodiversity by eating it," say its supporters. In effect, encouraging smallholders to cultivate or breed original varieties is a means of assuring their continued survival. It also promotes a varied, and therefore healthy, diet.

Slow Food International, www.slowfood.com

TODAY, 90% OF THE WORLD'S AGRICULTURAL PRODUCTION HAS BEEN REDUCED TO AROUND THIRTY PLANT SPECIES AND FOURTEEN ANIMAL SPECIES

Rice harvest near Mopti, Mali (14°23'N–4°21'W) In the interior of the Niger Delta, water floods tens of thousands of hectares of land each year. Over time, as the water levels rise and fall, the same plains support livestock breeders, fishermen, and farmers. Red rice, millet, sorghum, and corn are all cultivated here. A million people live in the delta, which represents an oasis in this drought-ridden region of the Sahel.

We not only practice farming to feed ourselves. An increasing quantity of land is now used to produce non-edible goods such as paper, clothes, or fuel. Cotton fields, for example, comprise 2.5% of the world's farmland, yet absorb 25% of all pesticides used. As for eucalyptus, the area devoted to its cultivation has multiplied fivefold in fifty years, as paper consumption has risen. It grows rapidly but requires a lot of water, and few birds and plants are able to adapt to the presence of this tree, imported from Australia.

Tea, coffee, and cacao are other export products that are not subsistence crops, but they bring in taxes for the governments and income for farmers, and so have been encouraged. They often take up the best land and their growth, which is linked to booming populations, turned some countries that were formerly self-sufficient into food-importing nations over the course of the 20th century.

COTTON FIELDS COMPRISE 2.5% OF THE WORLD'S FARMLAND, YET ABSORB 25% OF ALL PESTICIDES USED

Even grain crops are not always used to feed mankind: more than half of those that are exported are used to feed livestock or turned into biofuels. They are cultivated on deforested land or in areas where subsistence crops could potentially be grown. In order to put an end to this competition for land, between plants used to feed people and plants used to feed engines, specialists are working to develop what are known as second-generation biofuels. These use the non-edible parts of subsistence crops, such as straw, and could be grown on the poorest of land, but they are still at an experimental stage.

If all available land was used to grow subsistence crops, the planet would have plenty to eat. But farmers would still need to be guaranteed a decent income, and a way of sharing out this food and transporting it to those in need would have to be found.

United Nations Food and Agriculture Organization (FAO)
www.fao.org

Wheatfield near Lamar, Colorado, USA (38°32'N-102°55'W) Colorado ranks fourth among the US states for winter wheat production. Despite the sophisticated techniques that are now used, harvests nonetheless fluctuate considerably from one year to the next. Ground humidity and spring temperatures are still major factors.

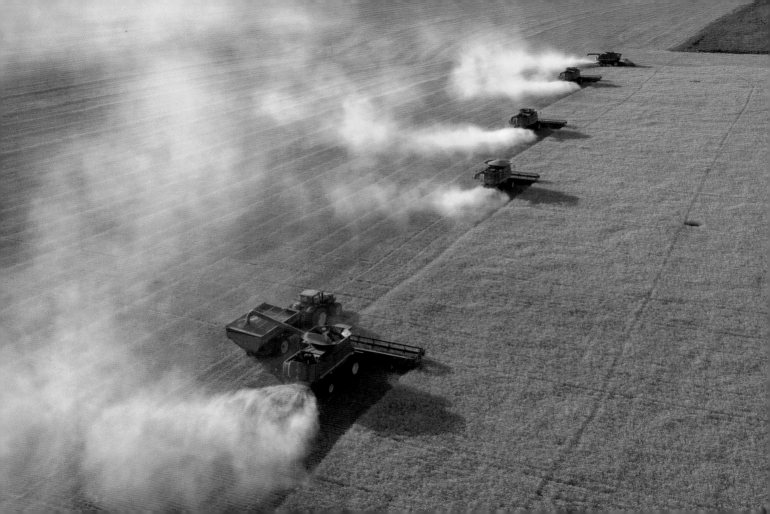

Nowadays, we eat oil. Most of the fertilizers essential to modern agriculture are produced by the petrochemical industry. But it doesn't end there. In the West, the food industry is based on a system of imports and distribution networks that is reliant on transportation.

Intercontinental imports of fresh produce are a case in point. Transporting food into Europe by air creates the equivalent of four to five times the food's weight in carbon emissions! Moreover, the system of major retail chains, which functions on economies of scale to keep costs low, is completely dependent on heavy-duty hauliers to supply supermarkets with food around the clock. It is not unusual for a food to be produced in one country, packaged in another, and sold in a third. One study calculated that the ingredients used to make a single pot of fruit yogurt may have traveled a total of 5,600 miles (9,000 kilometers). This type of agriculture is disconnected from its traditional geographical base and can relocate to those areas where wages are the lowest, bringing about a sharp fall in workers' pay.

In the same way, crops cultivated within this system are disconnected from the natural rhythm of the seasons, and grown in hothouse environments. For example, in Almería in southern Spain, millions of tomatoes are grown all year round in wooden boxes, on rockwool enriched with minerals, nutrients, and water. They are packaged daily and distributed around the world.

The solution is to "relocalize" food by reducing the distances it travels. This means reforging links with local producers, re-establishing "short cuts" between producers and consumers without passing through the intermediary of the major retail chains, and, of course, favoring seasonal produce. Producers' cooperatives, many of them organic, are multiplying around the globe, creating jobs and enabling agricultural areas—some fallen into disuse—to be cultivated again.

> ## THE INGREDIENTS USED TO MAKE A SINGLE POT OF FRUIT YOGURT MAY HAVE TRAVELED A TOTAL OF 5,600 MILES

United Nations Food and Agriculture Organization (FAO)
www.fao.org

Greenhouses in San Agustin, near Almería, Spain (36°42′N–2°44′W) This gigantic mosaic of 30,000 greenhouses in the desert of Almería in southern Spain has become Europe's vegetable garden. Stretching out as far as the eye can see, this metropolis supports 100,000 people, with hundreds of heavy-duty vehicles transporting its produce abroad each day. In this arid plain bordered by mountains, overpopulation and intensive farming are aggravating the problem of water shortage.

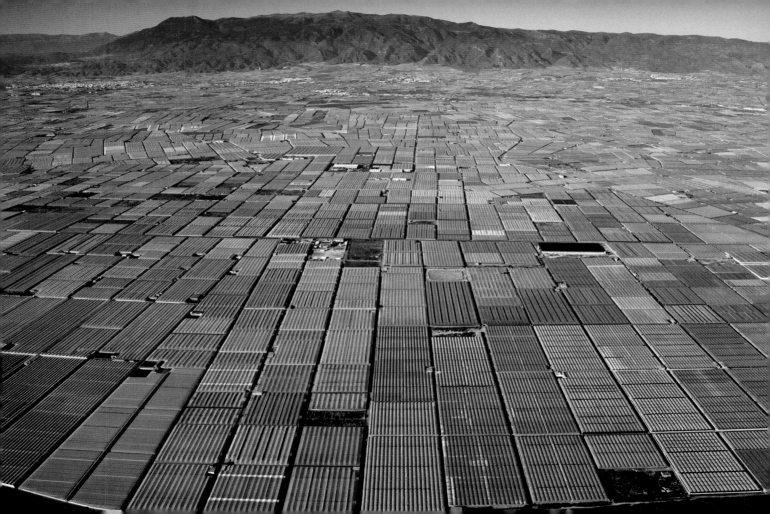

Will genetically modified organisms (GMOs) help feed the world? It is one of the principal arguments put forward in favor of their use in agriculture. As with most of the claims made about GMOs (and there are many), it is hard to prove.

The first difficulty is created by the sheer diversity of GM seed varieties. There are hundreds of modified forms for major crop types such as corn or soya. Agricultural production can vary dramatically from one year to the next, and from one field to the next. Few serious studies have been made on the subject, and no two have reached the same conclusions.

At best, GM foods increase returns by just a few percentage points. But controversial issues such as the impact of GMOs on health and the environment, the potential for widespread diffusion of modified genes, and the impossibility of reversing this process are the source of heated debate. Besides, dealing effectively with food shortages is more a question of distribution than of agricultural production.

IN 2008, GM CROPS COVERED A TOTAL OF 309 MILLION ACRES IN TWENTY-FIVE COUNTRIES

Given the uncertainties surrounding GMOs and the relatively modest advantages they bring, most opponents have been lobbying for governments to be cautious and wait before using them. They protest against existing GM crop cultivation and criticize the lack of public debate on the subject. Strong opposition movements are being formed across the globe, for example in France, led by José Bové, and in India, led by Vandana Shiva.

This has not stopped the spread of GM crops. In 2008, they covered a total of 309 million acres (125 million hectares) in twenty-five countries. In response, international measures have been put in place by the Convention on Biological Diversity, focusing principally on the labeling and traceability of products that contain GMOs. For some, these measures don't go far enough, but at least they ensure that consumers who disapprove of GMOs can avoid them.

Convention on Biological Diversity
www.cbd.int

Crop circle in a GM corn field, Grézet-Cavagnan, France (44°23'N–0°07'E) On July 27, 2006, Greenpeace activists created this crop circle, visible from the air, to protest against a French court ruling banning them from revealing the location of GM corn fields. This symbolic act served as a reminder that European law requires transparency on the cultivation of GM crops by obliging municipalities to indicate their presence on the land.

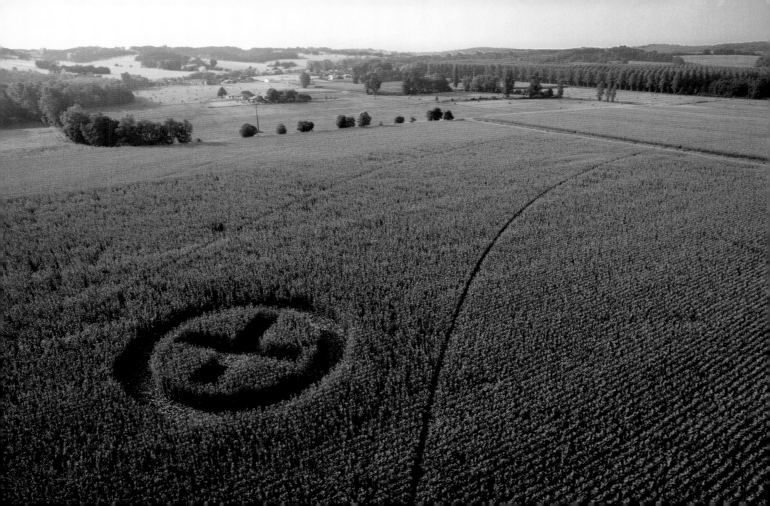

We are eating more and more meat. Why? Firstly, because there are simply more of us. Secondly, because more of us are able to buy meat. This last point is obviously good news, since it means that we are eating a more balanced diet. However, it also has negative consequences.

In effect, livestock farming is expanding to satisfy the growing demand for meat. Grazing animals require space, which is often reclaimed from our forests. Animals reared intensively on factory farms—in reduced, confined spaces—need huge quantities of fodder and cereals: it takes 15 lb (7 kilograms) of soya or corn to produce 2 lb (1 kilogram) of beef, as opposed to just 4 lb (2 kilograms) to produce chicken. Much of the land used for soya crops used to be part of the Amazon rainforest. Deforestation releases large amounts of greenhouse gases. If you include the emissions directly produced by the animals and farms, livestock rearing is responsible for 18% of greenhouse gas emissions.

IF YOU INCLUDE THE EMISSIONS DIRECTLY PRODUCED BY THE ANIMALS AND FARMS, LIVESTOCK REARING IS RESPONSIBLE FOR 18% OF GREENHOUSE GAS EMISSIONS

Intensive livestock farming has other harmful effects on the environment. It takes between 260 and 530 gallons (1,000–2,000 liters) of water to produce 2.2 lb (1 kilogram) of wheat, which means in turn that it takes more than 2,640 gallons (10,000 liters) of water to produce 2.2 lb of beef. Antibiotics and hormones are also added to the animals' feed, modifying their environment. Finally, the animals are often reared and killed in terrible conditions, thus raising ethical concerns.

For people who eat meat several times a week, reducing meat consumption is therefore an easy and effective way of saving the planet. Failing this, choosing free-range rather than factory-farmed meat, preferably labeled, is better both for the environment and for the welfare of the animals. Switching from beef to meats that create less pollution, such as poultry, is another strategy. Protecting the environment also means protecting yourself: consuming too much meat can contribute to a range of health issues such as obesity, cancer, and heart disease.

United Nations Food and Agriculture Organization (FAO)
www.fao.org

Feedlot on the outskirts of Bakersfield, California, USA (35°19′N–120°16′W) The USA is the world's number one beef producer. Livestock farming takes place in the western US regions, which specialize in breeding, and in the central Great Plains (Iowa, Nebraska, northern Texas, and Colorado) where cattle are force-fed in factories called feedlots or "fattening farms."

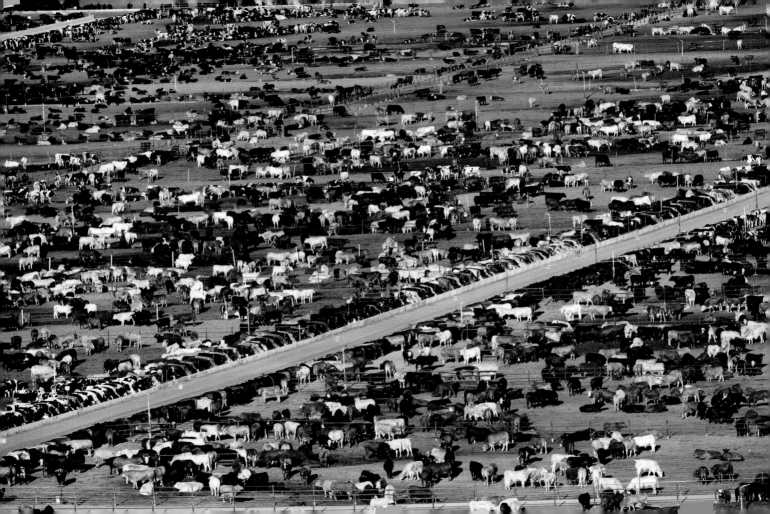

WASTE MANAGEMENT AND RECYCLING
RESOURCE EFFICIENCY

How do different wastes compare in terms of production and recycling efficiency?

Glass
- Recycled glass melts at a lower temperature, so the recycling process uses less energy.
- Can be recycled indefinitely; 1 kg of old glass bottles produces 1 kg of new glass bottles.

Paper
- Can be recycled 5–7 times before cellulose fibers break down.
- Small amounts of new fiber are often added to maintain quality, but new products can be made from 100% recycled material.

Aluminum
- Melting down scrap aluminum uses much less energy than making new aluminum.
- Can be recycled indefinitely.
- The average aluminum can contains 40% recycled material.

Plastic
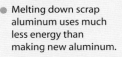
- Lighter than other materials, so it can save energy on transportation.
- Many different types, all of which must be recycled separately.
- Is down-cycled to make other products rather than new bottles.

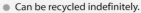

Sources: Swiss Federal Office for the Environment, 2008. *Waste management facilities: Recycling*; US EPA, 2008. *Common Wastes and Materials.*

Comparison of amount of material needed to make new and recycled products

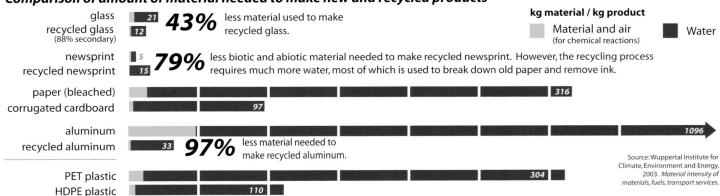

kg material / kg product
- Material and air (for chemical reactions)
- Water

glass — 21
recycled glass (88% secondary) — 12
43% less material used to make recycled glass.

newsprint — 5
recycled newsprint — 15
79% less biotic and abiotic material needed to make recycled newsprint. However, the recycling process requires much more water, most of which is used to break down old paper and remove ink.

paper (bleached) — 316
corrugated cardboard — 97

aluminum — 1096
recycled aluminum — 33
97% less material needed to make recycled aluminum.

PET plastic — 304
HDPE plastic (thicker, more durable plastic) — 110

Source: Wuppertal Institute for Climate, Environment and Energy, 2003. *Material intensity of materials, fuels, transport services.*

Produced by UNEP/DEWA/GRID-Europe, Feb. 2009

What are the most common types of waste?

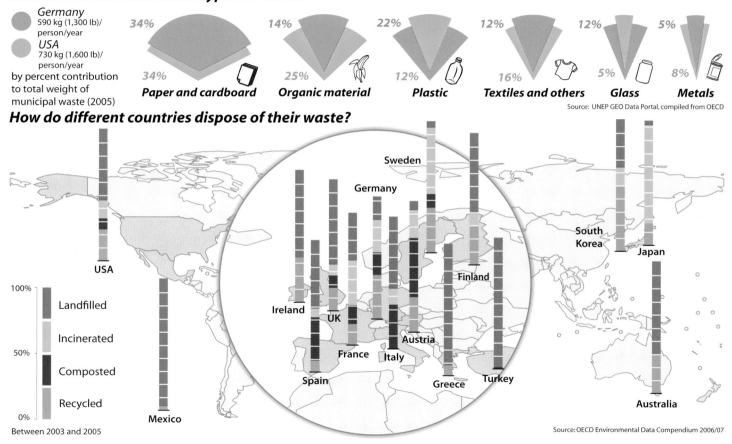

Germany
590 kg (1,300 lb)/
person/year

USA
730 kg (1,600 lb)/
person/year

by percent contribution
to total weight of
municipal waste (2005)

34% / 34% **Paper and cardboard**

14% / 25% **Organic material**

22% / 12% **Plastic**

12% / 16% **Textiles and others**

12% / 5% **Glass**

5% / 8% **Metals**

Source: UNEP GEO Data Portal, compiled from OECD

How do different countries dispose of their waste?

USA

Mexico

Ireland

Spain

UK

France

Italy

Germany

Sweden

Austria

Greece

Finland

Turkey

South Korea

Japan

Australia

100%

50%

0%

Landfilled

Incinerated

Composted

Recycled

Between 2003 and 2005

Source: OECD Environmental Data Compendium 2006/07

The world's population quadrupled over the course of the 20th century and now stands at 6.7 billion. Since 2000 it has increased by 700 million, which is equivalent to the entire population rise in the 19th century. In the 18th century, it rose by a mere 200 million. As their numbers have grown, human beings have gravitated increasingly toward cities, which have also grown as a result. Since 2007, more than one in two of us live in a town or city.

There are more people in some of the bigger cities—such as Tokyo, with its population of 35 million—than in some countries as a whole. In developing countries, urban growth can occur at a rate that is simply mind-boggling. Dhaka, the capital of Bangladesh, had a population of 300,000 in 1950, whereas today the figure stands at more than 15 million: a fiftyfold increase in fifty years. Boom towns such as Dhaka face immense problems in terms of infrastructure including electricity, drinking water, and waste disposal.

Nevertheless, this demographic explosion and the urbanization linked to it seem also to hold part of the solution. Birth rates have been shown to be decreasing over a great many parts of the globe, particularly in urban areas. The current average stands at

DHAKA, THE CAPITAL OF BANGLADESH, HAD A POPULATION OF 300,000 IN 1950, WHEREAS TODAY THE FIGURE STANDS AT MORE THAN 15 MILLION: A FIFTYFOLD INCREASE IN FIFTY YEARS

2.6, with significant regional disparities. In many Western countries, it has even fallen below 2.1, the threshold for population increase. The world population is shrinking and ageing. Whereas earlier projections for the coming decades envisaged a global population of 12 billion, the estimate has fallen and it is now thought that the population should stabilize at around 9 billion by 2050.

This seems to be due to the fact that city-dwellers generally have better access to education. For many women, in particular, this signifies access to information and to methods of contraception. It also means that these women are often able to work in addition to having a family. Having children becomes a choice, to be balanced against a career, for example. Urban life, moreover, changes people's behavior and living requirements: couples have fewer children than those living in the country since they no longer need help in the fields. This reduction in the birth rate responds to one of the major challenges of the century: that of population control as a means of successfully feeding the world and saving the planet.

UNFPA, State of World Population, www.unfpa.org/swp

Blocks of flats on Seoul's south bank, South Korea (37°29'N-126°57'E) The metropolitan area of Seoul, capital of South Korea, has a population of more than 10.7 million, making the city the world's eleventh largest. In 1955, following the Korean War, only 24.4% of the population lived in urban areas. In 2007, the figure stood at 81.3%. This lightning growth has had a profound impact on the fabric of the city, whose landscape is now essentially one of tower blocks and austere concrete façades.

When their focus shifted away from mere survival, human beings began to create towns and cities for themselves. This led to the development of culture, commerce, and politics: all the trappings of civilization. Crafts were developed and goods were traded. The concentration of human beings in one place facilitated exchanges both of merchandise and of ideas; it also made some kind of power structure necessary. It is in today's cities that virtually all the world's economic and cultural activities are concentrated: New York and Tokyo each have an annual GDP in excess of a trillion US dollars.

Towns and cities are also places of passage, where people of very different origins come together. But this diversity is only partial: the urban model has no space for other models, such as the nomadic or the indigenous way of life. It is also highly stratified, in both social and spatial terms, and city-dwellers tend to only mix with people from a similar background or class. Above a certain size, large urban concentrations dehumanize social relationships. But by grouping people together, they also enable them to organize themselves and they make politics possible. The 1992 Earth Summit in Rio de Janeiro was already postulating that the best way to treat environmental questions is to ensure the participation of all the citizens concerned, at the appropriate level.

The model of participatory democracy practiced in the Brazilian city of Porto Alegre is frequently cited as an example of an alternative form of organization and government. The city set up local councils which enabled the residents to become involved in making any decisions that affected them directly; these councils were allocated a percentage of the city's budget, so that they also had the means to carry out the decisions taken—many of which related to tackling social inequalities and protecting the environment. There were criticisms of this administration, particularly as its participants were drawn from only one section of the population; since it was not necessarily representative of the whole, it risked promoting individual interests. However, the Porto Alegre model was simply one form of representation among the many currently practiced in the world, all of which have both advantages and disadvantages.

THE BEST WAY TO TREAT ENVIRONMENTAL QUESTIONS IS TO ENSURE THE PARTICIPATION OF ALL THE CITIZENS CONCERNED, AT THE APPROPRIATE LEVEL

State of the World's Cities 2008/2009, Harmonious Cities
www.unhabitat.org/pmss

Village near Mopti, Niger Delta, Mali (14°42′N–4°09′W) The towns and villages along the Niger are home to cattle farmers, fishermen, and crop growers. They are renowned for the mosques that have come to form the heart of these Mali communities, which are now 90% Muslim. These buildings, said to be of the "Sudanese" type, look like impregnable fortresses. A combination of unbaked brick and fine clay plaster produces a daring style of architecture and a freedom of forms.

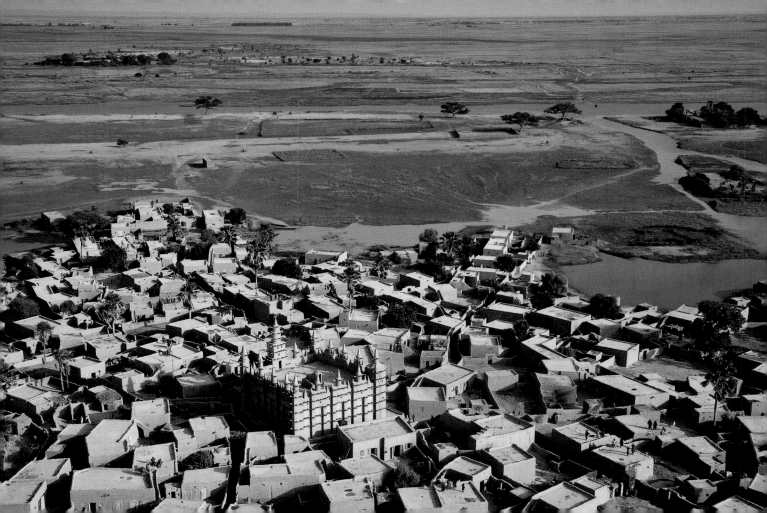

An urban center is an artificial environment in conflict with the natural environment. The natural surface of the soil is plastered over with concrete or asphalt. Air pollution, continuous light emissions, noise, vibrations, and a warmer and drier climate (thanks to air conditioning and the wind-break effect of buildings) together create a very particular kind of universe. And yet plants and animals (and not just cats and dogs) manage to thrive in this environment, which fosters a special kind of biodiversity. The green areas and patches of waste ground are home to a number of wild creatures: rats and cockroaches, for example, are prolific in urban areas, but so too are foxes and birds of prey. In some parts of Zurich, for example, the density of foxes is ten times greater than in the countryside.

A great many towns and cities have been built in defiance of the natural environment to some extent—as if to demonstrate the resourcefulness of humanity. Skyscrapers climb ever higher, land is reclaimed from the sea, and cities spring up in the desert despite the shortage of water. Brasília and Naypyidaw, the capitals of Brazil and Burma respectively, were built from nothing—in the midst of savannah, on the one hand, and jungle on the other.

IN SOME PARTS OF ZURICH, THE DENSITY OF FOXES IS TEN TIMES GREATER THAN IN THE COUNTRYSIDE

Our towns and cities actually occupy less than 5% of the planet's continental land masses. Urban expansion eats up the countryside, however, and natural habitats are carved up by road networks. Our food and construction materials and the energy we consume in travel and transport require the use of agricultural lands, mines, etc. A city such as Los Angeles gets its drinking water from the Colorado River, 240 miles (390 kilometers) away. And as a result of world trade, the impact of an urban center extends far beyond its immediate environment.

Paradoxically, the concentration of human beings in a city, though directly responsible for pollution and other negative effects, actually limits our ecological footprint. It reduces the need for transport, while apartment blocks use less energy for heating and lighting. By contrast, a suburban or semi-rural lifestyle leads to the urbanization of further areas of countryside (due to road building and the extension of water and electricity supplies), and is generally accompanied by an increase in travel and transport and higher energy costs.

State of the World's Cities 2008/2009, Harmonious Cities
www.unhabitat.org/pmss

The Palm Jumeirah, an artificial island, Dubai, United Arab Emirates (25°07'N–55°08'E) Fifty years ago, Dubai consisted of a handful of adobe huts, a souk, and a port serving the dhows that crisscrossed the waters of the Sea of Oman. Thanks to its oil reserves, Dubai has undergone massive development and has launched a construction program for a series of artificial islands. The Palm Jumeirah, in the shape of a palm tree, is the smallest of these.

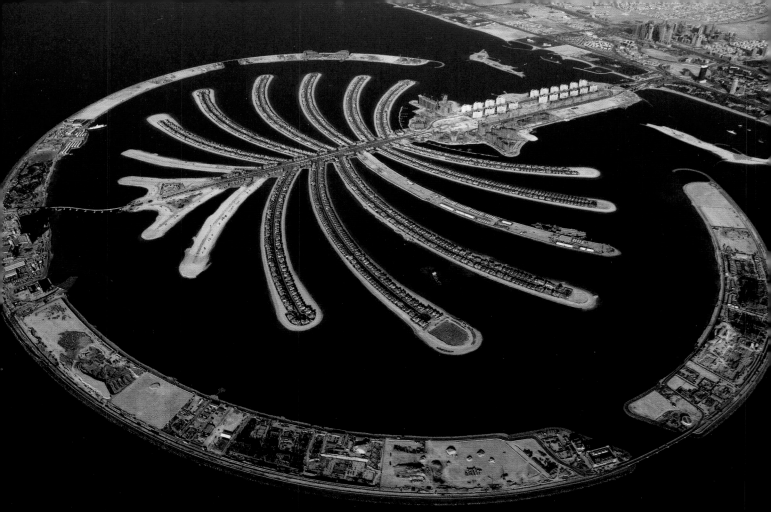

It is possible to make cities more environmentally friendly, as a number of local initiatives demonstrate. The German city of Freiburg, traditionally a supporter of green measures, typifies a more ecological approach to city living: 13,000 of its residents live in sustainable districts, the best known being Vauban, created on the site of a former military base. The development is characterized, among other things, by low energy consumption; it relies on solar power and has car-free zones designed to promote travel on foot, by bicycle, or by public transport. Other examples are found in Curitiba, in Brazil, and Malmö, in Sweden, where the emphasis is on recycling, rainwater collection, and the development of green spaces—including rooftops—and genuinely mixed communities.

Buildings play an important role in the energy stakes: they are responsible for approximately 40% of Europe's energy consumption and a percentage of greenhouse gas emissions. Most of these can be avoided: well-designed buildings consume so little energy that they can rely entirely on renewable energy sources—a phenomenon known as "passive" housing.

WELL-DESIGNED BUILDINGS CONSUME SO LITTLE ENERGY THAT THEY CAN RELY ENTIRELY ON RENEWABLE ENERGY SOURCES

Today, a great many cities are taking steps to tackle climate change and promote sustainable development. They have grouped together around a number of initiatives such as the C40 Climate Leadership Group (C40 for short), an association of forty of the world's largest cities committed to tackling global warming, and the International Council for Local Environmental Initiatives (ICLEI).

Nevertheless, comprehensive initiatives are isolated cases and are conceived on a modest scale. Cost is not generally the determining factor: governments frequently offer subsidies and, in any case, the longer-term savings rapidly compensate for the initial outlay. The main problem is that urban development is a slow process. It is easier to create a sustainable district from nothing than to convert existing homes and an existing urban space. This is why the most ambitious projects—and those that get the most media coverage—are the current new developments such as Dongtan, in China, and Masdar, Abu Dhabi.

ICLEI, www.iclei.org

Solar-powered houses in Vauban, a sustainable district of Freiburg, Germany (47°58'N-7°50'E) The site of a former French military base was occupied by squatters for several years before being transformed into a sustainable district with the cooperation of its residents at the end of the 1990s. More than 5,000 people currently live there. Solar panels on the roofs of the houses provide the residents with the energy they need.

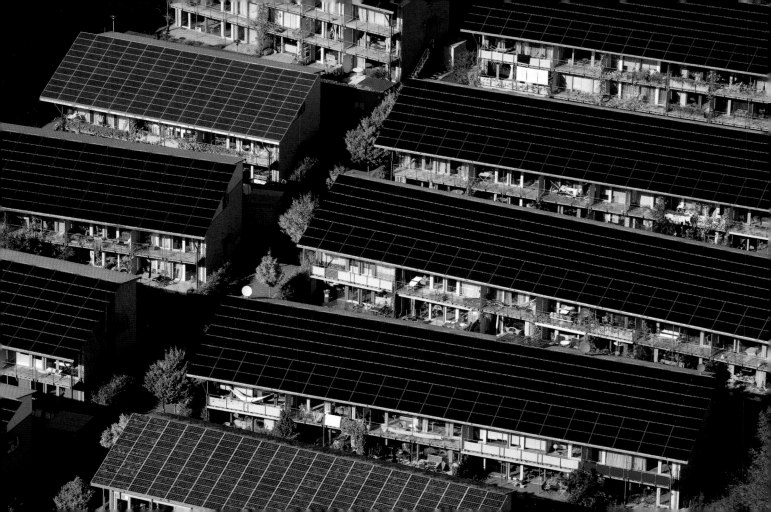

The motor car has become a victim of its own success: there are now almost a billion vehicles on the road worldwide. True, a privately owned car is a very convenient means of travel, and in areas where other infrastructures are scarce it may be the only one available. But cars tend to cause congestion on urban streets and their progress is hampered by traffic jams. Ivan Illich, a German philosopher, calculated that when you add together the working time necessary to purchase a car and the time wasted sitting in traffic jams, taking the car is in fact no quicker than walking.

Moreover, road transport is the principal cause of air pollution and greenhouse gas emissions in the West (accounting for almost 25% of France's emissions). Road traffic accidents are also responsible for more than a million deaths in the world each year, while road building, the extraction and refinement of petroleum, and the disposal of used tires are all linked with damage to the environment.

None of this is inevitable. The towns of northern Europe, for example, still have pleasant, narrow streets, refusing to bow to

ROAD TRAFFIC ACCIDENTS ARE ALSO RESPONSIBLE FOR MORE THAN A MILLION DEATHS IN THE WORLD EACH YEAR

the need for a "car at all costs," and promoting the bicycle as an alternative means of getting about on a day-to-day basis. And Bogota, in Colombia, has put in place an extensive network of fast and efficient bus services. The aim in all these cases is not to do away with the car, but only to use it when it is genuinely the best solution (while developing greener alternatives as well as encouraging car sharing). One possibility is to combine different forms of transport, driving to a station or a bicycle park, for example—a system known as intermodal transport.

The problem is that the majority of today's towns and cities are designed around the car. When people live in suburbs several miles away from their work place, or from the nearest shopping center, and when public transport is poor, there is genuine need for a car. To create real change, it is not enough to suggest that everyone rides a bicycle; what needs to change is the city itself. We may have to throw out the blueprint and start again.

Worldwatch Institute
www.worldwatch.org/node/1480

Suburb of Denver, Colorado, USA (39°35′N–105°04′W) These rows of identical houses looping back on themselves are typical of the suburbs that have grown up around the cities of North America. The growth of these suburbs was a consequence of the post-war economic expansion that encouraged home ownership. This kind of urban sprawl is typified by a network of low-density residential suburbs that rely entirely on the use of the car.

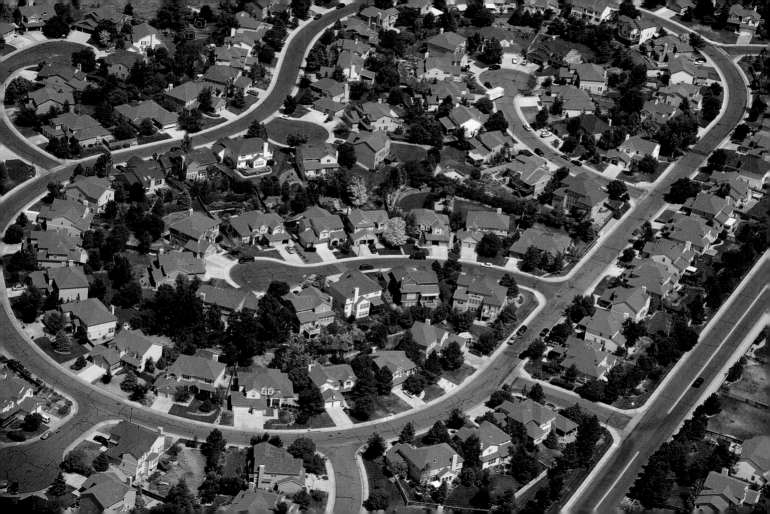

Air pollution causes cardiac, respiratory, and reproductive problems and is responsible for 2.4 million deaths each year. In the industrialized countries, the emissions of a great many pollutants—though not all—have decreased significantly as a result of industrial slowdown and tighter controls. In Europe, sulfur dioxide (SO_2) emissions have dropped by 85% compared with the 1980s, and lead emissions have fallen by more than 96% since the 1990s, thanks to the introduction of unleaded fuel. In developing countries, however, the reverse is true. China has thus become the world's main polluter, largely due to rapid industrialization and the use of coal-fired power stations.

Nevertheless, it is air pollution inside buildings that is responsible for the majority of deaths—a fact that has only recently come to light. Cooking methods are the principal source of this type of pollution: wood, leaves, coal, and cow dung all release toxic substances and particles when they are burned.

IT IS AIR POLLUTION INSIDE BUILDINGS THAT IS RESPONSIBLE FOR THE MAJORITY OF DEATHS— A FACT THAT HAS ONLY RECENTLY COME TO LIGHT

Reductions in air pollution are possible through a few simple measures, such as the use of engines that adhere to pollution standards, chimney filters, and improved cooking methods. But human beings often only react in response to a catastrophe. London's "Great Smog" of 1952—which was responsible for more than 4,000 deaths in a matter of days—led to the introduction of the first laws against air pollution (the Clean Air Act). This incentive was taken up in the USA and in the majority of Western countries. The Americans also introduced the idea of the pollution permit, a market mechanism that has proved very effective in reducing sulfur emissions (which are also responsible for the acid rain that ravages forests and lakes). This mechanism prefigured the more recently created trade in greenhouse gas emissions. Air pollution has since become the classic example of an area where the authorities can intervene, in one way or another, without needing to mobilize public support.

World Health Organization
www.who.int/topics/environmental_pollution/en

São Paulo, Brazil (23°32'S–46°37'W) Brazil's largest city—covering an area of 3,000 square miles (8,000 square kilometers) and with a population of 26 million—started life as a tiny mission founded by the Jesuits in 1554. Single-story houses gave way to apartment blocks, then to high-rises and, more recently, skyscrapers. An inevitable corollary of such high-density living has been an increase in the number of cars in the city and in levels of air pollution.

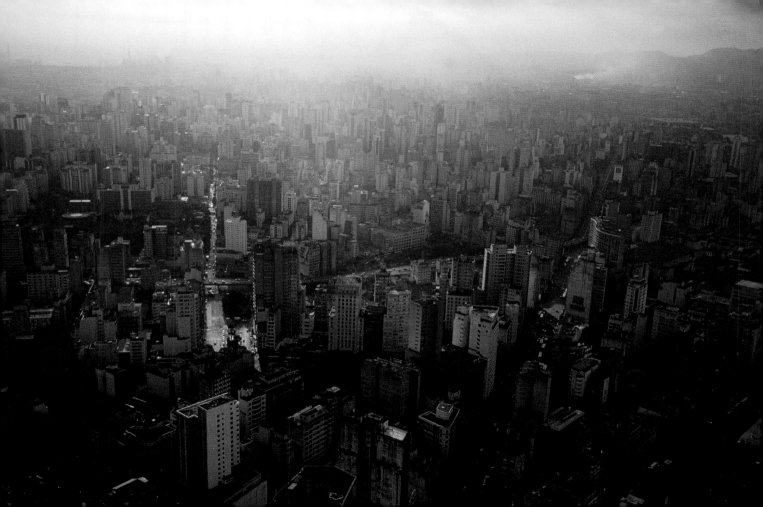

In 2001, almost a billion people were living in shanty towns, and by around 2030 this figure will have doubled. In the world's poorest countries, as many as 80% of the population are confined to these deprived areas. But wealthy countries are not exempt from the phenomenon either: they too have ghettos where poverty and social exclusion are endemic.

Poverty and lack of access to basic services are the characteristics of these overpopulated districts. They have no infrastructure, no houses built of stone or concrete, no access to health services, and no transport services to and from the city. The terrain itself can often be dangerous due to subsidence or the proximity of garbage dumps containing toxic substances.

Built without any kind of planning, wherever there is available space, shanty towns are capable of disappearing as fast as they sprang up, since the inhabitants rarely have any rights of ownership. Sometimes all it takes is a building project for an apartment block, and the bulldozers move in. Sometimes it is the authorities themselves who seize the initiative to destroy a shanty town and expel its inhabitants—maybe because the latter are often perceived as a source of instability, despite being the victims of circumstance. But the expulsion of these people only moves the problem on. It even exacerbates it, increasing levels of poverty by making it more difficult for those who had jobs in the city to continue to work.

Experts suggest a very different approach—one that enables these communities to settle properly in their districts and aims to combat poverty: by helping people to acquire their own pieces of land, or promising them a fair and fixed rent; by giving them access to microcredit so that they can furnish their homes comfortably; and by giving them a role and a voice. Nevertheless, such measures can only be fully effective if they form part of a coherent political commitment backed up by significant investment.

THE EXPULSION OF THESE INHABITANTS OF SHANTY TOWNS ONLY MOVES THE PROBLEM ON. IT EVEN EXACERBATES IT

United Nations Program for Human Settlements
www.unhabitat.org

Makoko shanty town, opposite Lagos island, Lagos, Nigeria (6°30'N–3°24'E) The population of Lagos is thirty times what it was in 1950. This is a city where inequalities are rife. The wealthy live in areas segregated from the rest of the population, while the poor are confined to shanty towns that spring up next to one another. There is no town planning of any kind and these dwellings are simply thrown up, with no access to electricity or running water.

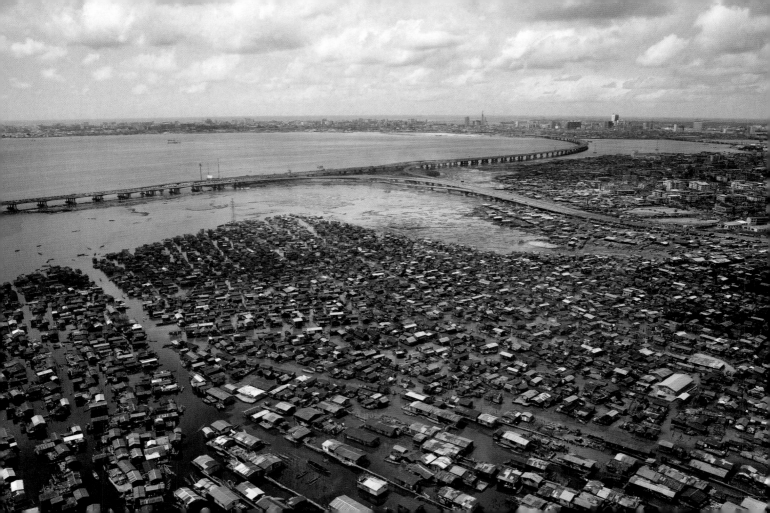

For better or worse? What is the impact of information technology on our planet, and in particular on the three pillars of sustainable development—the environment, the economy, and society? To date at least, the rise of the virtual economy is not proving as significant for the environment as was originally predicted. Doing one's shopping on the internet is more environmentally friendly than going to the supermarket, but there are still the energy costs of delivery and transport, etc. And the internet itself uses up vast reserves of energy. Indeed, the data-processing centers and the servers each of us use—sometimes without even knowing it—when we request information from a search engine or download a video are greedy consumers of energy. Globally, the IT industry is responsible for the same level of greenhouse gas emissions as the aeronautics industry. And the electrical components are often high polluters.

In economic terms, IT is a very useful tool, including in those countries where infrastructures are limited or lacking. A cell phone can serve as the starting point for a microbusiness. Outsourcing of facilities such as call centers creates work in developing countries and encourages education—although it reduces opportunities in Western countries, where labor is more expensive. In a knowledge-based economy, however, the growing digital divide reinforces inequalities. For example, in 2008 only 5% of Africans had access to the internet, as opposed to 73% of North Americans.

IN 2008 ONLY 5% OF AFRICANS HAD ACCESS TO THE INTERNET, AS OPPOSED TO 73% OF NORTH AMERICANS

Viewed in social terms, IT permits access to information and education. The radio is a very accessible means—because of its low cost—of disseminating information in deprived areas. Cell phones, text messaging, and the internet are all important tools for the political organization of individuals. But they are also a way for governments to keep an eye on people.

Information technology thus reflects both the positive and the negative aspects of our world. It is not the technology itself but the way we use it that determines its impact.

International Telecommunication Union
www.itu.int

Satellite dishes on the rooftops in Aleppo, Syria (36°13′N–37°10′E) Aleppo is one of the oldest cities in the world, but not untouched by modern life, as we can see from the satellite dishes perched on its rooftops. Some of the dishes are new, others rusty and weathered by time, but they enable inhabitants to pick up TV broadcasts from around the world. Television is enormously accessible, since anyone can follow a TV show without necessarily knowing how to read and write.

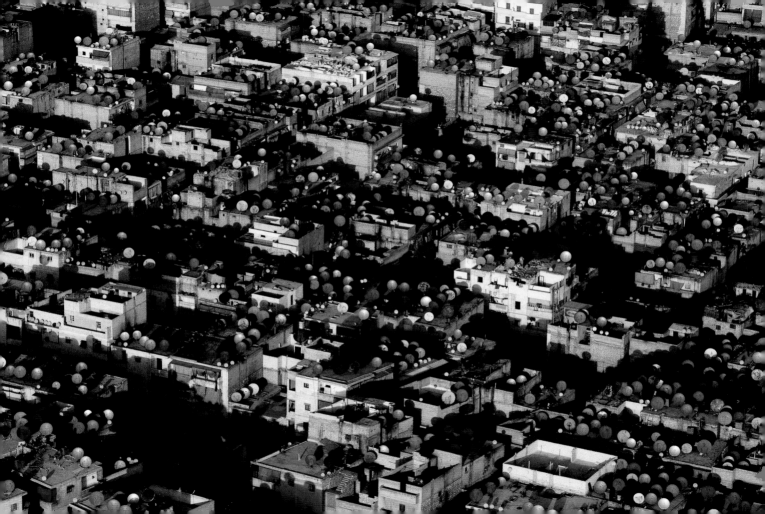

ECOLOGICAL FOOTPRINTS

A **Western lifestyle** has long been the preserve of a small minority. Today, with the growth of so-called "emerging countries," a burgeoning middle class is beginning to aspire to the same quality of life and the same levels of comfort. By communicating an idealized image of what is aptly termed the consumer society, television and cinema only serve to feed such aspirations.

Clearly, this is good news for hundreds of millions of people escaping destitution. But Western countries can only maintain their current standards of living if most of the rest of the planet continues to live in poverty: the planet cannot support everyone in the world following a Western lifestyle. This has been demonstrated by an indicator known as the ecological footprint, which measures the demands placed by an individual (or a group) on the planet's ecosystems by means of a single parameter—that of the surface area utilized: the land occupied by buildings, the agricultural lands required for food, the area of ocean used for fishing, the land used for producing materials, and the amount of energy consumed, etc. Interpreted as the equivalent surface area, the ecological footprint allows us to compare world consumption with planetary resources.

HUMANITY'S FOOTPRINT EXCEEDS THE CAPACITY OF OUR PLANET TO REGENERATE ITSELF AND TO ABSORB POLLUTION BY ABOUT 30%

If we divide the total extent of the planet's usable surface by the number of people in the world, we obtain the figure of approximately 4.4 acres (1.8 hectares) per human being. An American, however, "consumes" an average of 23.2 acres (9.4 hectares) and a European 11.8 acres (4.8 hectares). If the entire population of the world lived like the USA, we would need six planets. Applying the European model, we would need three planets, even though a large section of the population has a footprint that is lower than 2.4 acres (1 hectare). Humanity's footprint exceeds the capacity of our planet to regenerate itself and to absorb pollution by about 30%. And this global footprint is increasing each year.

The problem that faces us today, therefore, is how to ensure a decent standard of living for every human being without compromising the ability of future generations to do the same. This is the definition of sustainable development. And what sustainable development requires is a profound change in our social and political thinking, in the West, and in the rest of the world.

Global Footprint Network
www.footprintnetwork.org

Residential district of Changping, a suburb of Beijing, China (40°13′N–116°11′E) As host of the 2008 Olympic Games and a beneficiary of China's economic growth, Beijing has undergone profound transformations and major urban expansion. Changping lies some 20 miles (30 kilometers) northwest of the city center and is a suburban area characterized by rows of small houses. Expansion of this kind is occurring throughout China at the expense of its agricultural areas.

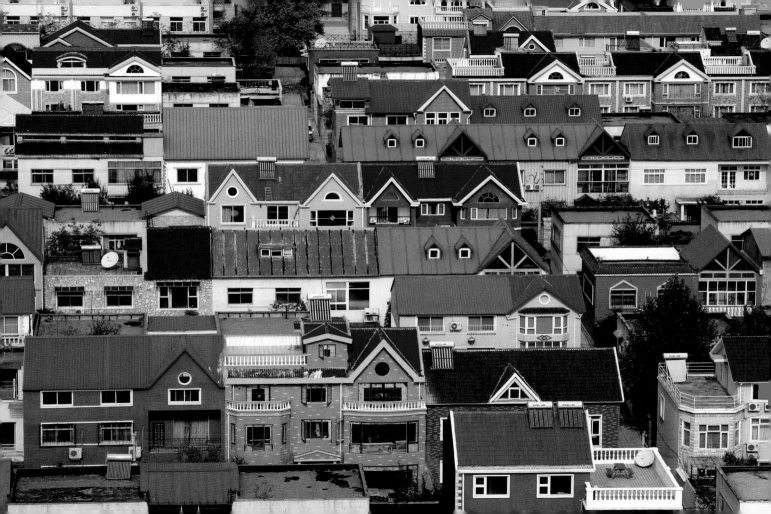

A US citizen produces 1,650 lb (750 kilograms) of household waste per year, and a city-dweller in India produces around 220 lb (100 kilograms). These figures are rising all the time. The waste that we produce is a reflection of our wealth; it is also a reflection of our society, based on overconsumption and disposability. For the most part, this waste is placed in land-fill sites where it creates many problems: odors, methane gases, and polluted discharges that leak into the ground or run into water supplies. Ecosystems can be damaged, and local populations poisoned. Waste can also be incinerated, which can generate energy, but its combustion leaves toxic residues.

Throwing garbage away is a waste of resources which are all the more valuable because they only exist in limited quantities. For this reason, increasing quantities of waste are now recycled. The composting of organic waste is a simple and ancient practice which is still widely used in rural areas. In urban zones, however, it forms only

CITIES AND REGIONS ARE SIGNING UP TO "ZERO WASTE" PROGRAMS, WITH A GOAL OF ELIMINATING LANDFILL AND ATTAINING 100% RECYCLING WITHIN 15 TO 20 YEARS

a tiny part of waste treatment. As for non-organic waste, recycling rates vary according to the materials involved. It is easy to recycle glass, aluminum, paper, and cardboard, but more difficult to recycle electronic components. It requires a large supply of manual labor (and therefore is often outsourced to poorer countries), is potentially dangerous to the health of workers, and can also be costly.

It is possible to go further in minimizing the environmental impact of products at source, from their conception onward, by reducing packaging and avoiding the use of toxic or non-recyclable materials, for example. From New Zealand to Japan, from Canada to the Philippines, cities and regions are signing up to "zero waste" programs, with a goal of eliminating landfill and attaining 100% recycling within 15 to 20 years. These are based on the 3R Initiative, which stands for Reduce, Reuse, and Recycle. The objective is to create a closed loop, imitating the behavior of a natural ecosystem.

The Mbeubeuss landfill, Malika district, Dakar, Senegal (14°48'N–17°19'W) Every day, almost 1,300 tons of waste arrive at Mbeubeuss, the largest landfill site in Senegal. It is a hunting ground for around a thousand "recyclers," men and women whose trade consists of gathering as much recyclable plastic and metal from the dump as they can. This exhausting and difficult task allows them to earn a steady income but has a very low social standing. The recyclers also run the risk of exposure to heavy metals such as zinc and lead, or to diseases such as salmonella.

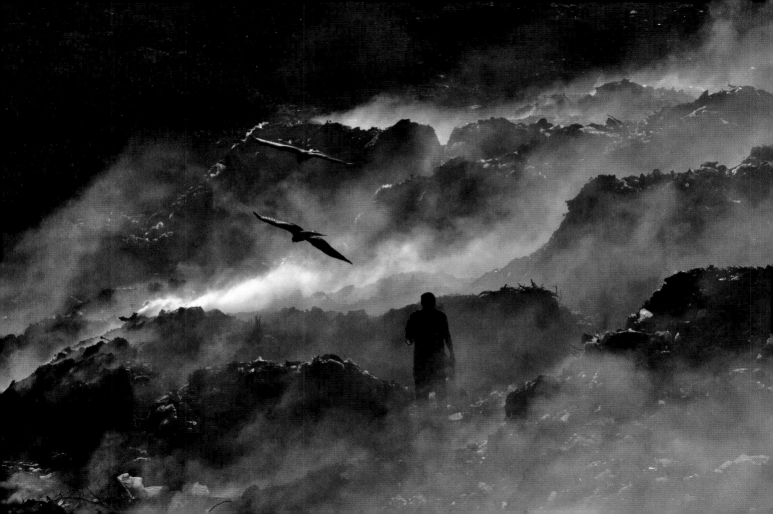

HAZARDOUS WASTES
HARMFUL SUBSTANCES & HAZARDOUS WASTES

How can we reduce the impacts of hazardous waste?

1 **Minimize the generation of hazardous waste.**
Use and repair electronics for as long as possible.

2 **Treat and dispose of hazardous wastes as close as possible to where they were generated.**
Be aware of where your recycler sends electronics. If donating to charity, make sure the program has a clear plan for recycling the electronics once they can no longer be used.

Source: (above) Basel Convention 2002, *Minimizing Hazardous Wastes*; (right) UNEP GEO Data Portal, compiled from UNSD

2003 Cell phones per 100 people		2005 Computers per 100 people	
Luxembourg	1,194	San Marino	91
Italy	1,018	Canada	87
Sweden	980	Switzerland	86
Iceland	966	Netherlands	86
Czech Republic	965	Sweden	84
Israel	961	USA	77
Finland	910	UK	77
Spain	909	Denmark	70

What hazardous materials are present in electronic appliances?

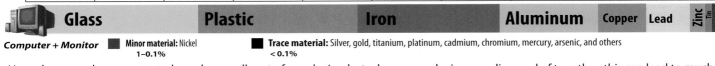

Glass **Plastic** **Iron** **Aluminum** **Copper** **Lead** **Zinc** **Tin**

Computer + Monitor
■ **Minor material:** Nickel 1–0.1%
■ **Trace material:** Silver, gold, titanium, platinum, cadmium, chromium, mercury, arsenic, and others < 0.1%

Hazardous metals may seem to be only a small part of any device, but when many devices are disposed of together, this can lead to much higher concentrations, and even small concentrations of these metals are sufficient to have serious health impacts.

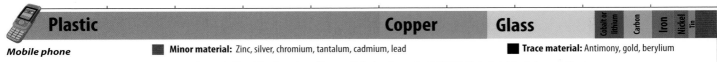

Plastic **Copper** **Glass** **Cobalt or lithium** **Carbon** **Iron** **Nickel** **Tin**

Mobile phone
■ **Minor material:** Zinc, silver, chromium, tantalum, cadmium, lead
■ **Trace material:** Antimony, gold, beryllium

Source: UNEP 2006, *Vital Waste Graphics 2*; Microelectronics and Computer Technology Corporation (MCC) 1996, *Electronics Industry Environmental Roadmap.*

Produced by UNEP/DEWA/GRID-Europe, Feb. 2009

What are some of the key hazardous wastes?

Clinical wastes

Construction
Asbestos

Electronics
(e-waste)
Arsenic
PCB chemicals
Cadmium
Lead
Mercury
Chromium

Pesticides
Cyanide
POP chemicals

Industry
Strong acids
and alkalis

Source: Basel Convention 2002, *Minimizing Hazardous Wastes: A Simplified Guide to the Basel Convention*

Which countries produce the most hazardous waste?

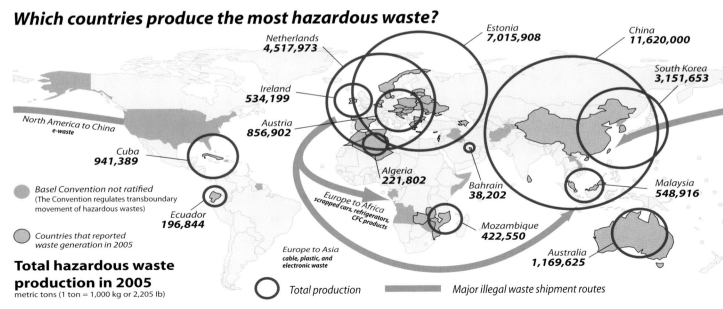

Estonia
7,015,908

China
11,620,000

Netherlands
4,517,973

South Korea
3,151,653

Ireland
534,199

North America to China
e-waste

Austria
856,902

Cuba
941,389

Algeria
221,802

Bahrain
38,202

Malaysia
548,916

Basel Convention not ratified
(The Convention regulates transboundary
movement of hazardous wastes)

*Europe to Africa
scrapped cars, refrigerators,
CFC products*

Ecuador
196,844

Countries that reported
waste generation in 2005

Mozambique
422,550

Total hazardous waste production in 2005
metric tons (1 ton = 1,000 kg or 2,205 lb)

*Europe to Asia
cable, plastic, and
electronic waste*

Australia
1,169,625

◯ Total production

Major illegal waste shipment routes

Source: Basel Convention 2005, National Reporting; UNEP 2006, *Vital Waste Graphics 2*.

OIL

Society has become dependent on oil, and it's easy to see why: after all, it's so convenient! One gallon of oil can propel a ton of metal (i.e. a car) over dozens of miles, for just a few dollars. Imagine the effort it would take to push the same vehicle over that kind of distance. It's been calculated that in terms of energy a gallon of oil is the equivalent of 8-80 weeks of human work.

Another advantage of this type of fuel is that it is highly concentrated, easy to use, and easy to transfer. It only takes a minute to fill a tank with fuel. It would take a whole night to transfer the equivalent amount of electricity. Coal, which has to be shoveled into a furnace, is even less practical.

The enormous quantities of energy contained in fossil fuels derive from organic matter which has decomposed over tens of millions of years. This matter originally captured solar energy, so you could say that oil is a pocketful of sunshine. But this is also why oil is not a renewable source of energy—not at least in terms of human lifespans.

IN TERMS OF ENERGY, A GALLON OF OIL IS THE EQUIVALENT OF 8-80 WEEKS OF HUMAN WORK

Oil is also remarkably cheap, considering the functions it performs. For a long time all you had to do was dig a hole in the ground (in the right place of course) to recover it. Today, the price of oil includes prospecting, extraction, refinement, distribution, and speculation. But it does not include the cost to the environment; nor the financial investment that will be required to produce an alternative energy source when it finally runs out.

Oil, and before it coal and other fossil fuels, have transformed our society and been fundamental to the development of modern chemistry, plastics, and fertilizers. Fossil fuels have enabled us to operate machines at a rate previously unimaginable, accelerating our way of life on a global scale. But we will have to wean ourselves off oil. Only a limited amount remains. And burning hydrocarbons releases large quantities of greenhouse gases, which are responsible for climate change.

International Energy Agency, www.iea.org

Gas flare on the Obagi oil field, Nigeria (5°14'N-6°37'E) Smoke rises over the Niger Delta as far as the eye can see as "gas flaring" is practiced. The flares burn off the natural gas present in an oil field, since it is not economical to retain. Each year, gas flares waste 5,000 billion cubic feet (150 billion cubic meters) of gas, equivalent to a third of the consumption of the European Union.

Oil will not run out suddenly. It will be a slow, agonizing decline. As oil becomes scarcer its price will rise, and what used to be very cheap will become expensive. Society will be wholly transformed.

The reason for this is simple: a finite planet has finite resources. Once we have consumed all of our oil and other primary materials, there will be nothing left. Oil is not a renewable resource on any timescale comparable to its rate of consumption. The chemical reactions which led to its formation occurred over millions of years.

There are, undoubtedly, oil deposits that remain to be discovered. But the easiest have already been found and exploited. Each year, we consume more oil than we find. This is clearly going to cause problems.

It is not only a question of when oil will run out, but how society will change as it does. A world in which oil is much rarer—and therefore costlier—will be very different from our own.

INTERNATIONAL TOURISM WILL RETURN TO WHAT IT USED TO BE IN PREVIOUS CENTURIES: A LUXURY FOR THE PRIVILEGED FEW

The modern petrochemical industry will have to change dramatically: everything from lipsticks to fertilizers and plastics of all types will either be made differently, or not at all. Transport will obviously become more expensive. This will spell the end of the West's huge retail and supermarket networks, since these rely on road transportation and economies of scale. The price of imported products will rise, and international tourism will return to what it used to be in previous centuries: a luxury for the privileged few. Competition for access to the last remaining oil deposits will increase, and may lead to conflict.

These developments are inevitable, and will only be temporarily delayed by the current recession which is slowing down the global economy. Developing renewable forms of energy and reducing consumption are the two most basic measures we can take to prepare ourselves.

Association for the Study of Peak Oil & Gas
http://aspofrance.org/ [www.peakoil.net]

Oil fields near Bakersfield, California, USA (35°28'N–119°43'W) The United States is the world's third-largest oil producer after Saudi Arabia and Russia, and also the number one oil importer. All developed countries depend on this form of hydrocarbon, especially for transport and the plastics industry. Today, the amount of oil remaining is roughly the same as the amount we have already burned or used to make other products.

Coal is an energy of the future. The fuel that powered the industrial revolution may have an outmoded image in the West, where it was replaced by oil and gas in the 20th century, but on a global scale it accounted for over 33% of the world's energy consumption in 2005. Over the coming years coal could make a comeback as the leading energy source, since worldwide reserves are much more plentiful than those of oil, which is becoming scarce. A further advantage is that coal reserves are better distributed across the planet and are located in industrialized regions which consume the most energy, such as Europe, Russia, North America, and China. In fact, China and India open one new coal plant every week. And while coal is less practical than oil, it can still be converted into gasoline, a process used by Germany during the Second World War and subsequently by South Africa.

Coal is relatively easy to extract but, as ever, the working conditions in mines worldwide are poor. Tunnel collapses, explosions, and respiratory disease cause numerous fatalities among miners every year. In China around 5,000 workers die annually in coal mines alone.

Coal power plants pump out high levels of pollution. They also have a greater environmental impact than oil-powered plants, emitting even more greenhouse gases. By burning coal, we will continue to contribute to climate change long after our "black gold"—oil—has run out. Slag heaps are also a huge environmental issue and scar the landscape. In the United States, new extraction techniques entail digging up entire hillsides to access the seams directly, generating millions of tons of rubble.

Various "clean coal" technologies are currently in development around the world, but none of them is truly practicable and none is truly clean. The most advanced involves storing released CO_2 underground: a process called "sequestration." But this almost doubles the cost of the energy produced and is only economically viable if systems are put in place to offset carbon emissions.

> OVER THE COMING YEARS COAL COULD MAKE A COMEBACK AS THE LEADING ENERGY SOURCE, SINCE WORLDWIDE RESERVES ARE MUCH MORE PLENTIFUL THAN THOSE OF OIL

International Energy Agency, www.iea.org

Open-pit coal mine near Delmas, South Africa (26°10'S–28°44'E) Coal continues to be a widespread source of energy worldwide. In South Africa, it generates 94% of the country's electricity. However, South Africa is still not able to meet its energy demands, and plans to open new coal plants in the coming years.

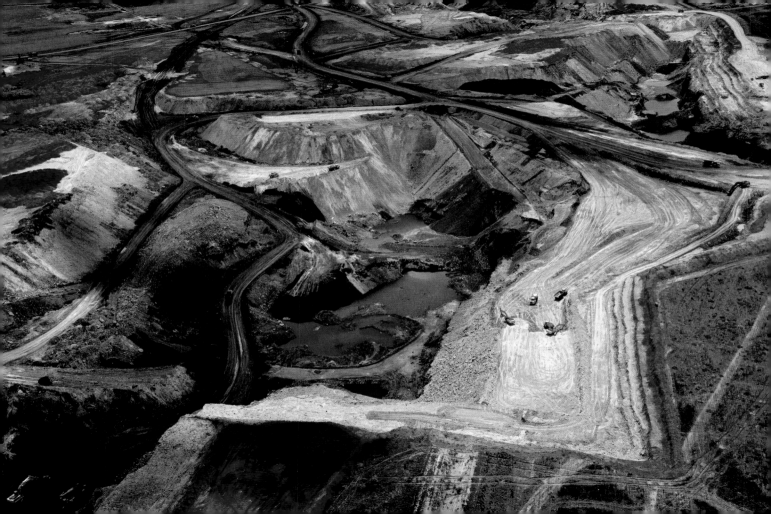

Faced with the inevitable exhaustion of our major oil deposits, researchers are looking into alternative sources of hydrocarbons. One of the main solutions is also one of the most damaging to the environment: "non-conventional oil." This term encompasses Venezuela's extra-heavy oil deposits and Canada's bituminous oil sands, where hydrocarbons are mixed with other residues. Extracting them is a complex process which creates pollution. One ton of oil sand produces only 26 gallons (100 liters) of oil.

Worldwide reserves of non-conventional oil are enormous—roughly 4 billion barrels, more than all known reserves of conventional crude oil. But the pollution they generate is also enormous. Canada is paying a high environmental price for extracting its vast deposits: forests cleared, soil destroyed, toxic waste products released, and water supplies contaminated. In Estonia, one of the few countries that uses oil sand bitumen to produce electricity, a study calculated that the energy sector was responsible for 97% of air pollution, 86% of waste products, and 23% of water pollution in 2002, not to mention huge greenhouse gas emissions. Oil sands are therefore not a real solution.

Rather than searching for ways to consume even more energy, we should be thinking about saving it. The American expert Amory Lovins introduced the concept of the "negawatt," a unit of saved rather than expended energy. Today, different energy-saving systems use this as a unit of calculation. However, they are battling against uninterrupted growth in consumption—a growth that mirrors the economy and is measured in GDP. Simply improving energy efficiency will not be enough if we continue to increase the amount of energy we consume. For example, the benefits of a car that is twice as efficient are canceled out if it is used twice as often or if twice as many are produced.

SIMPLY IMPROVING ENERGY EFFICIENCY WILL NOT BE ENOUGH IF WE CONTINUE TO INCREASE THE AMOUNT OF ENERGY WE CONSUME

Rocky Mountain Institute, www.rmi.org

The Athabasca Oil Sands, Fort McMurray, province of Alberta, Canada (57°01'N–111°38'W) The Athabasca River valley was once covered with boreal forest. To extract the bituminous sands, the land is drilled to a depth of more than 200 feet (60 meters). River water is pumped and used to separate the bitumen from the sand in large heated tanks. The bitumen is then converted to crude oil.

Once shunned because of its unpopularity with the public and its high investment cost, nuclear energy has experienced a resurgence in recent years, with 36 reactors currently under construction and a further hundred planned. In 2008 there were 439 active nuclear reactors, generating 6.3% of the world's energy in the form of electricity.

This resurgence is linked to the relative shortage in energy and the fact that nuclear power gives off very little CO_2. And while the construction of infrastructures, extraction and transportation of nuclear fuel produces its share of greenhouse gases, the sector's carbon footprint is substantially smaller than that of fossil fuels.

However, supplies of uranium—the principal fuel used in nuclear plants—won't last forever. According to the International Atomic Energy Agency (IAEA), existing stocks will only be able to meet the needs of the world's reactors for another century, although there is always the chance that new deposits will be found. But this does not take into account the increasing numbers of reactors. Unless the reactors of the future are able to turn to other, more abundant types of fuel, uranium may become scarce rather sooner.

The Chernobyl disaster in Ukraine in 1986 demonstrated the very real risks of a nuclear accident. Twenty years on, the consequences are still open to debate. The IAEA estimates that a total of around 4,000 people died as a result of the catastrophe, but other organizations argue that this figure does not account for the large number of victims among the 600,000 workers and soldiers sent in to extinguish the fire and build the new safe confinement structure. Uranium extraction can also be dangerous, both for miners and for the environment. It is still not known how to dispose of radioactive waste safely. And the risk of leaks or terrorist attacks is ever-present.

How should we address the pros and cons of nuclear energy? Some countries have consulted the public, such as Italy and Sweden, which have held referenda. In others, such as France—where 78% of electricity is produced by nuclear plants—the state has made unilateral decisions on nuclear policy.

IN 2008 THERE WERE 439 ACTIVE NUCLEAR REACTORS, GENERATING 6.3% OF THE WORLD'S ENERGY IN THE FORM OF ELECTRICITY

International Atomic Energy Agency (IAEA), www.iaea.org

Nuclear power station at Saint-Laurent-Nouan, Loir-et-Cher, France (47°42'N-1°35'E) Of the 443 nuclear reactors around the world, 59 are in France, generating roughly 80% of the country's electricity. This makes France the world's second-largest producer of electronuclear power, though still far behind the United States in first place. Other countries such as Germany and Sweden are treading more cautiously and are resolved to phase out nuclear power.

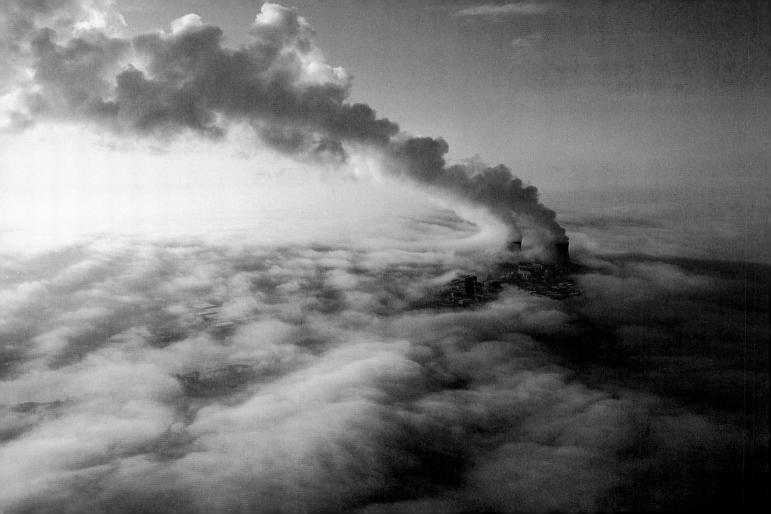

Almost all of us contribute to global warming, and we therefore share a collective responsibility. Transport is a prime example, representing 23% of global CO_2 emissions. Road and air transport represent, in essence, the movement of people: us.

Air travel is a case in point. On a single transatlantic flight, each passenger's carbon footprint is the equivalent of a year of travel by car. Aircraft emissions account for 3% of global greenhouse gases, more than the output of many entire countries including France. The true environmental impact of aviation is even greater, since greenhouse gases released at high altitudes have a more concentrated effect.

In 2007 a total of 2.2 billion journeys were made by air. The volume of air traffic is soaring, and may even double over the next 20 years.

International aviation emissions are excluded from Kyoto agreement targets, partly because they are extremely difficult to attribute to any particular country. As the French climate change and energy expert Jean-Marc Jancovici puts it: "to which country do you attribute the emissions of a Swiss passenger on a British Airways flight from Paris to Naples?" Various taxation alternatives are being considered. In 2012 the European Union plans to impose emission quotas on air carriers operating out of the continent.

What are the solutions? For trips under 400 miles (1,000 kilometers), taking a train is often faster and always more eco-friendly than taking a plane, although an air ticket may still be cheaper because kerosene is not taxed.

Overall, we must rethink the way we use transport. We don't have to travel to the ends of the Earth to have a good holiday. In the workplace, businesses can cut back on travel by encouraging meetings by conference call or video conferencing.

THE VOLUME OF AIR TRAFFIC IS SOARING, AND MAY EVEN DOUBLE OVER THE NEXT 20 YEARS

IPCC Special Report on Aviation and the Global Atmosphere, www.ipcc.ch

Terminal 2, Charles-de-Gaulle Airport, Paris, France (49°00'N–2°35'E) Some 60 million passengers used this airport in 2007, up 5.4% from 2006. In the same year more than 550,000 aircraft took off and landed at the airport, an increase of 2.1%. Charles-de-Gaulle Airport is located in a densely populated urban area (with around 6,500 inhabitants per square mile), and many residents complain about noise pollution.

Every year more than 7 billion tons of goods are imported and exported around the world. These international exchanges are made possible by cheap transport and cheap labor. It is often more cost-effective to import a product from the other side of the world than to make it locally.

These two factors may well change, however. Firstly, the cost of labor in emerging economies could rise with the appearance of a middle class. In China, for example, salaries in urban areas are increasing by more than 10% per year and in 2007 reached an official average of 3,500 USD per annum. Countering this trend, however, is the relocation of industries to poorer zones; China is now moving its factories to Bangladesh.

Secondly, the inevitable rise in oil prices will have a knock-on effect on the cost of imports, even though fuel often only accounts for a small percentage of the final price. Above all, international trade is only possible because prices do not take into account the environmental costs, or "externalities." Roads cut through ecosystems; ships, aircraft, and heavy duty vehicles emit greenhouse gases and other toxic substances; mineral and energy extraction processes create pollution. Numerous economists have tried to integrate such environmental costs into the price of goods, but while suitable models do exist, they have not been implemented for fear of upsetting the economic system.

Relocating production also means passing on its environmental costs to the manufacturing country. In 2008 China became the number one producer of greenhouse gases, with one third of its emissions coming from the industrial exports sector which notably produced goods bound for the United States and Europe. Environmental accountability, both on the part of suppliers and their clients, will soon become a burning question. Climate change is a global phenomenon which has repercussions no matter where energy is being consumed or greenhouse gases are being produced.

INTERNATIONAL TRADE IS ONLY POSSIBLE BECAUSE PRICES DO NOT TAKE INTO ACCOUNT THE ENVIRONMENTAL COSTS, OR "EXTERNALITIES"

United Nations Conference on Trade and Development, www.unctad.org

The CMA CGM "Medea" container ship, Ushant shipping lane, Finistère, France (48°46′N–5°36′O) Invented in the late 1950s, container ships quickly became the principal means of transporting freight. These specialist ships have become increasingly larger: the longest ship currently in service is a container ship, the "Emma Maersk." Measuring 1,302 feet (397 meters) in length, it can carry more than 11,000 standard containers and up to 200,000 tons, and requires a crew of just 13.

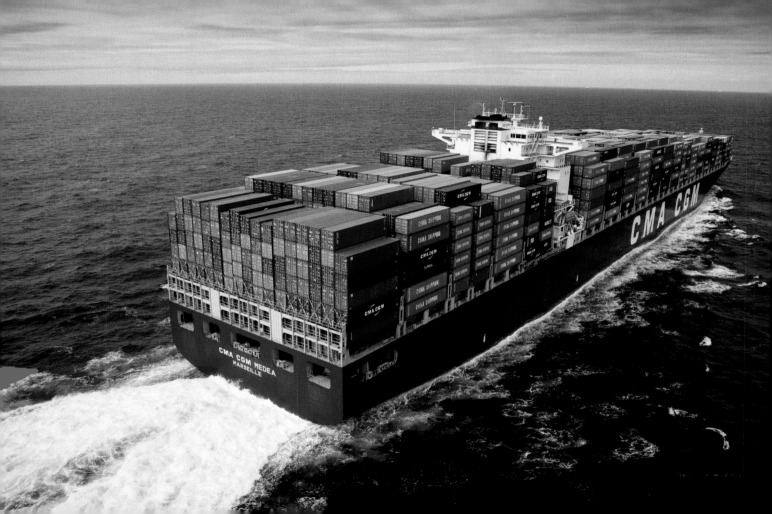

In a single hour, the sun transmits more energy to the Earth's surface than humans consume in a whole year. If we could find a way of harnessing this resource effectively, we could solve all of our energy problems.

Different solar power technologies already exist. Solar water heaters operate by heating up water in dark-coloured boxes or tanks covered with a plate pointed towards the sun. Today, 200 million Chinese people have solar water heating systems.

Photovoltaic cells generate electricity from the sun's rays. While still relatively marginal, solar power is the fastest-growing energy in the world. Production has increased nine-fold since 2000.

The latest way of harnessing solar energy is via solar power plants. Mirrors concentrate the sun's rays to heat a fluid; this in turn drives a turbine to produce electricity. In theory, with this technology 25,000 square miles (60,000 square kilometers) of desert could meet the entire world's electricity demands.

However, solar power plants are relatively inefficient: photovoltaic cells can only convert small amounts of sunshine, while producing them itself requires a lot of energy and creates pollution. Solar energy thus only represents 0.039% of global electricity consumption. But technology is evolving rapidly and some experts predict solar power will attain 25% of global consumption by 2040.

Photovoltaic cells do have one huge advantage: they can produce electricity independently of a grid. Today, 1.7 billion people live without an electricity supply. Even in the West, the production of energy off the grid—decentralized production—can have benefits. It enables different sources of energy (solar, wind, etc.) to be combined, avoiding wastage and other problems associated with high-tension electricity networks.

> WHILE STILL RELATIVELY MARGINAL, SOLAR POWER IS THE FASTEST-GROWING ENERGY IN THE WORLD. PRODUCTION HAS INCREASED NINE-FOLD SINCE 2000

European Commission site on solar energy
http://re.jrc.ec.europa.eu/pvgis/

Mirrored solar panels at Sanlucar la Mayor solar power plant, near Seville, Andalusia, Spain (37°26'N–6°15'W) The orientation of the 624 mirrors (called heliostats), each measuring 1,290 square feet (120 square meters), is regularly adjusted to concentrate the sun's rays to the receivers at the top of the plant's tower. Here they are not in operation and merely reflect the blue of the sky.

You don't have to live in Iceland to enjoy the benefits of thermal hotsprings, or to produce electricity or heat greenhouses with geothermal energy. Even in central Paris, where there isn't a volcano in sight, some buildings (such as the Maison de la Radio) are heated in this way. Other countries, from the United States to New Zealand and the Philippines, also use geothermal energy.

The Earth beneath our feet is hot, rising in temperature by 5.4ºF (3ºC) every 320 feet (100 meters) and reaching 7,000ºF (4,000ºC) at its core. Water circulates within the Earth's crust at different depths, and is heated by the surrounding rock. Some of this hot water breaks through to the surface in the form of hot springs or geysers.

This source of heat can be exploited in various ways. High-temperature underground water sources are used by geothermal power plants to produce electricity. At a depth of 1,650 feet (500 meters) beneath the Earth's surface, super-heated water between 300ºF and 650ºF (150ºC and 350ºC) turns into steam, creating a pressure-cooker effect. The steam is accessed and used to drive a turbine which generates electricity. Geothermal resources suitable for electricity production are common around the Pacific (accounting for 28% of the electricity produced in the Philippines), in Russia and Central and Eastern Europe. But on a global scale, geothermal power meets less than 1% of electricity demand.

Low-temperature geothermal sources are used for heating buildings. Hot water between 70ºF and 300ºF (20ºC and 150ºC) circulating around porous rocks in the ground is piped into buildings, greenhouses, and fish farms. Finally, very low-temperature geothermal waters from closest to the Earth's surface are used to power air conditioning units and heating systems of individual houses.

Today, technologies such as heat pumps and geothermal power plants are sophisticated and competitive enough to permit the development of this under-valued form of energy. With geothermal power, the Earth itself can provide us with a clean, renewable energy that is available night and day, and is completely safe for the environment.

WITH GEOTHERMAL POWER, THE EARTH ITSELF CAN PROVIDE US WITH A CLEAN, RENEWABLE ENERGY WHICH IS COMPLETELY SAFE FOR THE ENVIRONMENT

www.geothermie-perspectives.fr

Geothermal power station at Svartsengi, Blue Lagoon, Iceland (63º53'N-22º26'W) The Reykjanes peninsula in Iceland is a volcanic region with numerous natural hot springs which are widely exploited. More than 85% of the population now benefits from this heat source, compared with 25% in 1960. By using geothermal energy to produce hydrogen, Iceland even plans to make its economy oil-free before 2040.

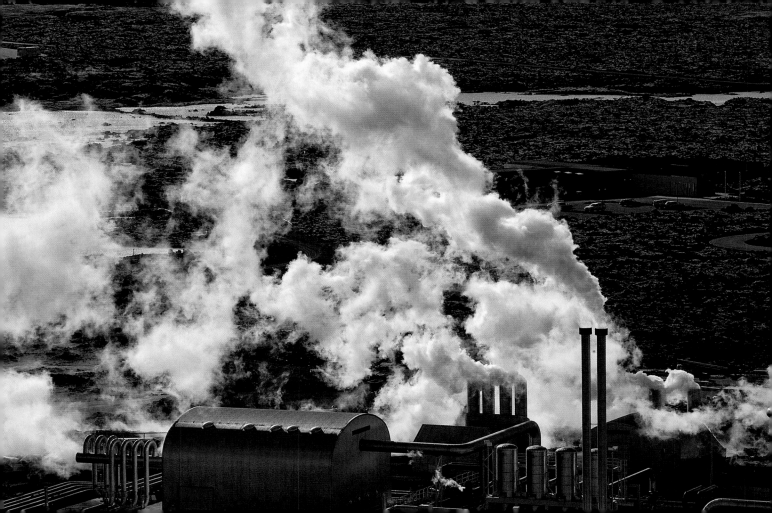

What alternative does wind power represent to fossil fuels? It is a renewable, clean source of energy, and when harnessed by windmills represents the epitome of eco-friendly energy. Thanks to advances in technology, windmills have grown considerably in size over the last few years, now reaching more than 320 feet (100 meters) in diameter; this has also made them more powerful. A large windmill can produce more than 1 megawatt of energy, enough to meet the demands of a thousand European inhabitants (excepting heating). This also saves around 2,000 tons of CO_2 emissions per year. The most powerful windmills are located out at sea, where the winds are stronger and more reliable, and where they don't impact the landscape. These models can generate 5 megawatts of energy.

Wind turbine installations are growing by 30% per year. They already account for around 20% of the electricity produced in Denmark, 10% in Spain and Portugal, and 7% in Germany and Ireland. However, on a global scale, power generated by wind is still rare and only represents 1.5% of electricity consumption.

WIND TURBINE INSTALLATIONS ACCOUNT FOR AROUND 20% OF THE ELECTRICITY PRODUCED IN DENMARK

How much further will it be able to develop? Probably no more than in Denmark, since wind power cannot completely supplant other sources of energy: after all, it is dependent on weather conditions. Windmills do not operate continuously, and cannot be relied on at times of peak consumption. They must be combined with other more versatile forms of energy. This, in fact, is true of all renewable energies. Individually, none of them can replace oil. But together they can create an "energy mix" that, alongside energy-saving measures, can help economies reduce their dependency on polluting fossil fuels.

With a rapid growth rate set to continue over the coming years, the wind power sector is also creating jobs: today it employs 150,000 people worldwide, potentially rising to over 300,000 by 2020. It's an excellent example of the additional benefits an environmental policy can bring in terms of economic development, technology, research, and jobs: these are "green careers."

Global Wind Energy Council, www.gwec.net

Windmills, San Gorgonio Pass wind farm, California, USA (33°55′N–116°42′W) Set on a hillside, the San Gorgonio Pass wind farm between Banning and Palm Springs is one of the most productive in the world. Air currents created by the Pacific ocean and the Mojave desert regularly blow through the site. The wind farm generates 2,400 megawatts of energy for the state of California. Wind-powered electricity now supplies 650,000 households.

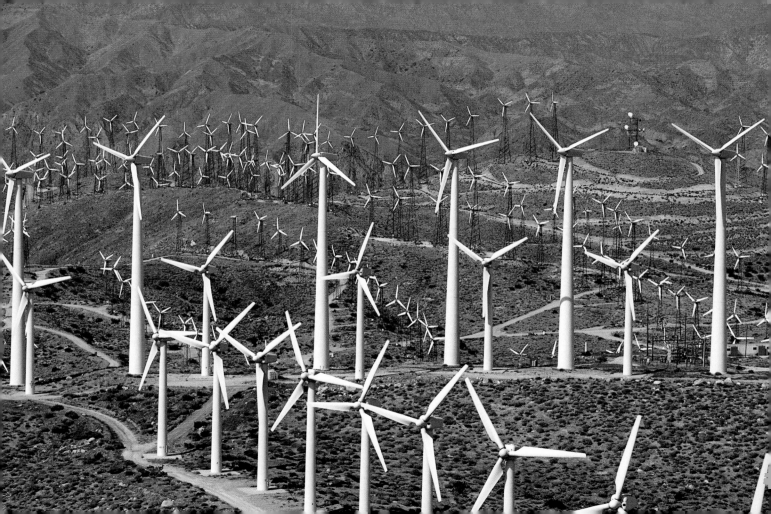

ELECTRICITY
ENERGY-HUNGRY SOCIETY CONSUMPTION

1 kWh

Electricity production and consumption are often measured in units of kilowatt hours (kWh). When a machine consumes 1 kWh, it has been running at a rate of 1,000 watts for a period of 1 hour. So the amount of electricity consumed is directly related to the wattage of appliances.

How much electricity do common household appliances consume?

Refrigerator
(300L capacity)

240–320
kWh / year

Washing machine
(5 kg / 11 lb load, 60 °C)

0.85–1.05
kWh / cycle

Dryer
(electric, 7 kg / 15 lb)

2.4–4.4
kWh / cycle

Stove / Oven
(electric)
Stovetop range
1–2.3kWh
145–180 mm (6–7 in.) diameter

Baking at 200 °C for 1 hour
0.9–1.1kWh

A watt (W) is a measurement of energy intensity at a single moment in time.
kWh = 1,000 W / hours used.

Coffee maker
(8–12 cups capacity)
0.8–1.2kWh

Computer
0.1–0.5kWh

Television
(82 cm / 32 in. LCD)
0.1–0.2kWh

Lightbulbs
Incandescent
60w

Compact fluorescent
16w

Switch to compact fluorescent lightbulbs

Switch to smaller and more energy-efficient appliances

Source: Based on a survey of product specifications from various manufacturers

Produced by UNEP/DEWA/GRID-Europe, Feb. 2009

What can I do with 1 kWh?

 Watch television for **6 and a half hours.**

 Bake a cake in the oven for **1 hour.**

 Keep 3 lightbulbs on for **5 and a half hours.**

 Wash **one 5 kg load** of laundry.

Calculations based on average wattage of appliances (see bottom of preceding page).

How much is the global consumption?

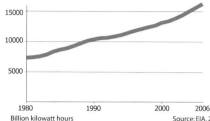

Globally, electricity consumption has doubled in less than 25 years.

Billion kilowatt hours

Source: EIA, 2006. *International Energy Annual, 2006*

How much electricity does the average person consume every year?

by sub-region

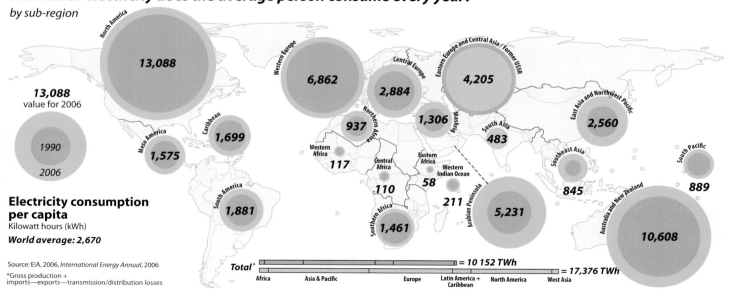

13,088
value for 2006

1990

2006

Electricity consumption per capita
Kilowatt hours (kWh)
World average: 2,670

Source: EIA, 2006, *International Energy Annual, 2006*

*Gross production + imports—exports—transmission/distribution losses

North America **13,088**

Western Europe **6,862**

Central Europe **2,884**

Eastern Europe and Central Asia / Former USSR **4,205**

East Asia and Northwest Pacific **2,560**

Caribbean **1,699**

Meso America **1,575**

Northern Africa **937**

Mashriq **1,306**

South Asia **483**

Western Africa **117**

Central Africa **110**

Eastern Africa **58**

Western Indian Ocean **211**

Southeast Asia **845**

South Pacific **889**

South America **1,881**

Southern Africa **1,461**

Arabian Peninsula **5,231**

Australia and New Zealand **10,608**

Total* = 10 152 TWh = 17,376 TWh

Africa | Asia & Pacific | Europe | Latin America + Caribbean | North America | West Asia

A 1.2°F (0.7°C) rise in temperature in the course of a century seems little enough: day-to-day fluctuations in temperature are often much greater. In fact, however, this represents a very significant increase, partly because it is measured on a global scale, and partly because it is a sign of even bigger changes to come. These will have major repercussions on many levels, which is why the term "climate change" is now generally preferred to "global warming."

Until recently, there were those who doubted that the phenomenon of climate change even existed. True, the facts have emerged in a piecemeal fashion, and it is only a few decades since experts were forecasting not global warming but a new ice age. Today, however, the debate is closed. Thousands of experts from more than 130 countries have rallied in support of the Intergovernmental Panel on Climate Change (IPCC), set up by the United Nations Environment Program. Through the efforts of the IPCC, which was awarded the Nobel Peace Prize in 2007, the existence of global warming is beyond doubt, as is its cause, which is principally linked to greenhouse gas emissions produced by human activities.

THE GREATEST UNCERTAINTY HAS NOTHING TO DO WITH SCIENCE. IT IS POLITICAL AND SOCIAL: WILL WE MANAGE TO REACT QUICKLY AND WILL IT BE ENOUGH?

There are still a number of details that need clarification and the experts envisage a variety of different scenarios for the end of the century, with temperature increases of between 3.6°F (2°C) and 10.8°F (6°C). But the greatest uncertainty has nothing to do with science. It is political and social: will we manage to react quickly and will it be enough?

Under the Kyoto Protocol, 38 industrialized countries pledged to reduce their greenhouse gas emissions by an average of 5.8% against 1990 levels. The pledge is a modest one, and inadequate, but there are still countries that fail to respect it. The protocol expires in 2012 and the challenge then will be to reach a new, more ambitious agreement and to enlist the support of the USA as well as newly industrial nations such as China and Brazil, which are not yet on board.

But governments are not the only ones who can take action. Local environmental groups, businesses and private individuals may all play a part at their own level. And with sufficient public support, policies can be influenced and pressure brought to bear on critical international negotiations in the future.

IPCC Fourth Assessment Report, www.ipcc.ch

Last traces of snow on Kilimanjaro, Tanzania (3°04'S-37°22'E) At its highest point, Kilimanjaro reaches 19,340 feet (5,895 meters). The glaciers at its summit have lost 80% of their surface area in less than a century, due partly to local climatic conditions and partly to global warming. Africa's highest peak reflects what is happening elsewhere in the world, where the majority of mountain glaciers are shrinking and receding.

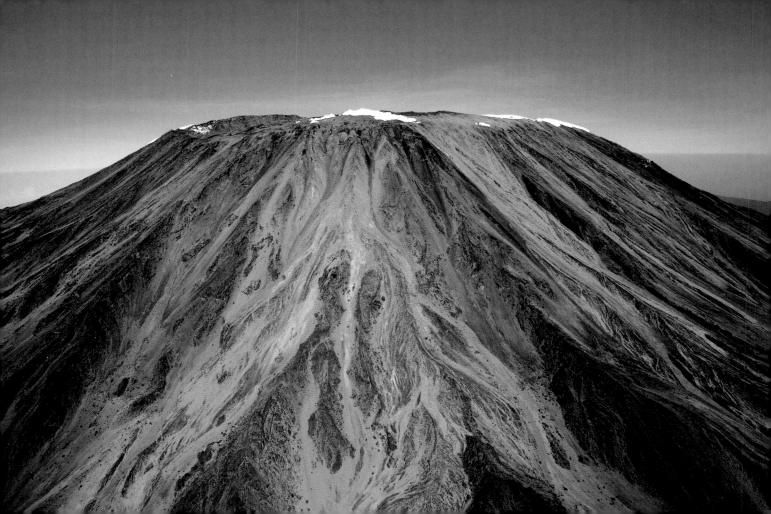

Put an ice cube in a glass filled to the brim with water and the water will not spill when the ice melts: this is the ice cube effect. Similarly, when ice floes melt they do not cause sea levels to rise.

And yet sea levels are rising. This is still at a modest rate: an average 0.07 in. (1.7 mm) per year during the 20th century, and by 0.12 in. (3.1 mm) more recently. There are two reasons why. The first is that oceans expand as they become warmer. The second is that the world's glaciers—the Andes and Himalayas, for example—are melting, and their water is flowing into the oceans via rivers. If these glaciers disappear completely, they will cause a rise in sea levels of around 19.5 in. (500 mm). But even that is nothing compared to what would happen if the ice of Antarctica and Greenland were to disappear: a rise of 183 feet (56 meters) and 19 feet (6 meters), respectively

Given that the temperature at the South Pole drops to –94°F (–70°C) in winter, there is no question that the whole Antarctic ice cover could disappear in the foreseeable future. But Antarctica is an immense continent, with greatly differing regions. In some regions, for local reasons, the snow cover is actually increasing slightly. In others, in the west (near Argentina and Chile), the glaciers are undoubtedly melting. But, for the moment, the continent is showing no clear signs of extensive change due to global warming.

The situation in Greenland is far more worrying. Until recently, experts thought that global warming would have only a modest impact here. This seems not to be the case. The melting of surface ice is causing flow at deeper levels, which in turn is having a lubricant effect, encouraging the movement of ice towards the sea and accelerating the melting process. These past few years, Greenland has thus been melting much faster than predicted.

The fate of Greenland and Antarctica, and of our oceans and coastlines, depends on greenhouse gas emissions occurring sometimes thousands of miles away, whether in Los Angeles, Beijing, or Paris. Global warming is a planetary phenomenon. Its global impact creates a new form of collective responsibility, since every single one of us is responsible for a part of these gas emissions. It calls for the emergence of a new form of solidarity.

IPCC Fourth Assessment Report: www.ipcc.ch

> ## THESE PAST FEW YEARS, GREENLAND HAS BEEN MELTING VERY MUCH FASTER THAN HAD BEEN PREDICTED

Meltwater stream on the Greenland ice sheet, near Nordlit Sermiat, Greenland, Denmark (61°05′N–46°27′W) Glaciers melt partly as a result of calving (slippage into the sea) and partly as a result of surface melting. In the latter case, the water accumulates to form lakes on top of the ice sheet and the run-off feeds into meltwater streams. These find their way down through vertical shafts in the glacier to reach the rocky substratum, where they act as a lubricant, accelerating the flow of the ice above.

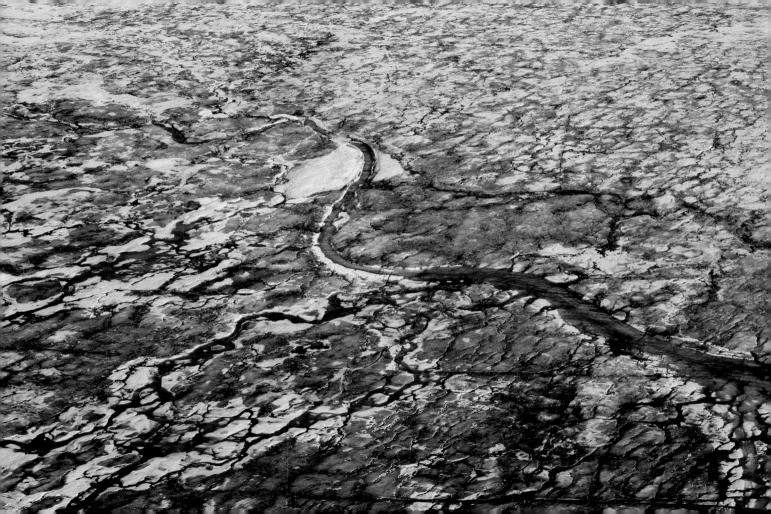

The first atolls submerged as a result of global warming, in 1999, were Tebua Tarawa and Abanuea in the Republic of Kiribati, situated in the Pacific Ocean. They were both uninhabited. With rising sea levels, many island states are at risk. Tuvalu, whose highest point is 13 feet (4 meters) above sea level, may be the first to see its entire population evacuated. The Maldives—highest point 11.5 feet (3.5 meters)—could be the next casualty, with nearly 800,000 people being forced to find a new home.

The majority of the world's major cities are situated on or near the coast, including New York, Shanghai, London.... The large deltas of the Nile, the Mekong and the Ganges are home to millions of people and are equally at risk. And the by-products of global warming will be more severe droughts, more frequent flooding and more lethal hurricanes. Even people living well inland may be forced to quit their homes and become environmental migrants. Climate change could lead to as many as 250 million people becoming "eco-refugees" by 2050.

CLIMATE CHANGE COULD LEAD TO AS MANY AS 250 MILLION PEOPLE BECOMING "ECO-REFUGEES" BY 2050

Today, these refugees are not recognized as such by international agreements such as the Geneva Convention. That complicates the case for their protection, as the Tuvalu situation demonstrated only too clearly. When the government sought to obtain immigration visas for the evacuees from Tuvalu's neighbors, New Zealand accepted, with certain conditions, but Australia refused. Yet Australia is responsible for high levels of greenhouse gas emissions and for years staunchly refused to sign the Kyoto Protocol. Small island states such as Tuvalu, on the other hand, produce the lowest emissions on the planet, but they are the first to suffer from the effects of climate change.

The question of the legal status of ecological refugees is intrinsically related to questions of the causes of their exile, and with whom responsibility should ultimately lie. Governments and international lawyers have been debating these issues, but thus far have failed to reach any clear conclusions.

IPCC Fourth Assessment Report, www.ipcc.ch

Island of Malé, Maldives (4°10'N–75°30E') Malé is the capital of the Republic of Maldives and its 70,000 inhabitants represent a little over a quarter of the total population. The population density of the Maldives is the world's seventh highest (2,300 inhabitants per square mile), with an additional 170,000 tourists visiting the archipelago each year. One island houses the capital, another the airport, a third an oil storage facility, while some 200 islands are inhabited and a further 90 reserved for tourists.

Plants and animals were already sensing the first signs of climate change before human beings were aware of its existence. Spring came earlier, bringing forward the moment when the buds burst, and milder conditions made it possible for a number of species to inhabit areas previously ill suited to their needs. The living world found itself changed in terms of both time and space.

In the face of global warming, living creatures seek out cooler zones, moving towards the poles or upwards, to higher altitudes. The range of a great many species will likely shift. But there are geographical limits to such migration: no species can keep climbing upwards or migrating towards the poles. Sometimes, there is simply nowhere left to go.

This is the case for the polar bear. With the ice floes melting earlier each year, the animal's hunting period is getting shorter and shorter. The result is that the bear cannot replenish its fat reserves before the winter and females find it increasingly difficult to feed their young. With the melting of the Arctic ice, the polar bear will eventually die out. And it is not alone: coral reefs bleach and eventually die when the temperature increases and humid tropical forests become too dry. Over forty years, an increase of just 5.4°F (3°C) would mean extinction for 30% of all living species.

And humanity could suffer direct consequences too: higher temperatures, for example, encourage swarms of insects that carry disease. This was the case with the tropical mosquitoes that appeared in the USA in 1999, carrying the potentially fatal West Nile fever. Dengue fever and malaria, other mosquito-borne diseases, could infect hundreds of millions of additional victims.

So what should we do? Animals are capable of learning and adapting, but only over generations. The current temperature increases are happening too fast. There is no one particular solution, other than redoubling our efforts to protect the living world, since the better the health of the planet's ecosystems, the better they will be able to tolerate climate disturbances. One possible way forward is to combat the fragmentation of ecosystems by creating contiguous protected zones, or "ecological corridors" between zones, so that animals can migrate towards areas better suited to their needs.

IPCC Fourth Assessment Report, www.ipcc.ch

OVER FORTY YEARS, AN INCREASE OF JUST 5.4°F (3°C) WOULD MEAN EXTINCTION FOR 30% OF ALL LIVING SPECIES

Herd of reindeer at the edge of the ice sheet southeast of Ivittuut, Greenland, Denmark (61°05'N–46°10'W) Both male and female reindeer (caribou in North America) have antlers. More than 100,000 of them have been recorded along the southern and western coasts of Greenland, where the ice sheet gives way to tundra. There are no wolves in southwest Greenland, unlike other Arctic regions, and so the reindeer's only predator here is mankind.

CONSERVATION AGRICULTURE

We sometimes joke about the idea of flatulent cows contributing to global warming, but the subject is more serious than it may appear, on two counts. Agriculture is the world's second largest producer of CO_2 emissions, only just behind transport, and the principal source of non-CO_2 greenhouse gas emissions: 50% of all methane emissions and 60% of all nitrous oxide emissions.

There are several reasons for this. The first is deforestation. Most deforestation occurs when land is cleared and converted to agricultural use. Deforestation contributes massively to the release of greenhouse gases into the atmosphere. The second is the spread of rice plantations. Rice farming is responsible for significant emissions of methane, a greenhouse gas 21 times more potent than CO_2. The third reason relates to the use of fertilizers, the principal source of emissions of nitrous oxide, a greenhouse gas 310 times stronger than CO_2.

Farming could also provide part of the solution in our fight against global warming. Some methods of farming—often inspired by age-old techniques—are more effective in protecting biodiversity and storing CO_2. Conservation agriculture, as it is known, does not as a rule require complex technology: rather it involves better use of traditional materials such as compost and pig manure, as well as techniques such as hedge-planting. It is also tillage-free agriculture, which prevents soil erosion, absorbs more carbon dioxide thanks to year-round vegetation cover and reduces the need for nitrate fertilizers, so preventing the release of nitrous oxide into the atmosphere.

By adapting our farming methods we could reduce our production of CO_2 equivalents by several billion tons annually, mainly in developing countries. If a global market for greenhouse gas emissions could be developed, with a price for each non-emitted ton of gas, this could provide a significant source of income for farmers in developing countries: the fight against global warming could thus also become a means of fighting poverty.

AGRICULTURE IS THE PRINCIPAL SOURCE OF NON-CO_2 GREENHOUSE GAS EMISSIONS: 50% OF ALL METHANE EMISSIONS AND 60% OF ALL NITROUS OXIDE EMISSIONS

IPCC Fourth Assessment Report, www.ipcc.ch

Small island of vegetation surrounded by rice terraces in Bali, Indonesia (8°22'S–115°08'E) Every Balinese farmer is a member of a local co-operative (*subak*) and grows rice, the staple food of over half the world's population. A vast irrigation system exploits the island's volcanic contours and 150 or so watercourses by directing water from the hills to the terraces via a network of man-made channels.

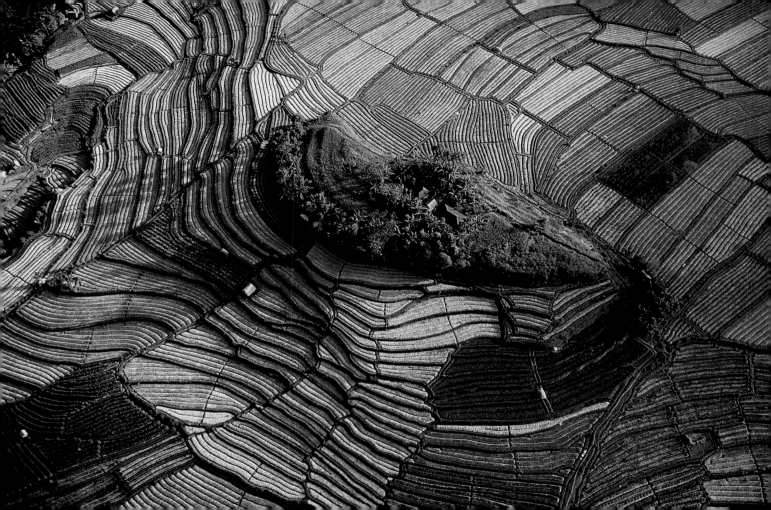

If there is perhaps an even more serious consequence of global warming than rising sea levels, it is the shortage of water that will follow the melting of the glaciers. Glacial meltwater feeds most of the planet's major rivers today. The Yellow River, the Mekong, the Ganges, and the Indus—which together irrigate areas inhabited by two billion people—all have their source in the glacial waters of the Himalayas.

As the glaciers melt, the first consequence will be too much water. Mountain regions will experience sudden and catastrophic flooding. At slightly lower altitudes, the arrival of the monsoon will precipitate flooding that is slower but more widespread. By about 2050, floods could reach a peak, with rivers overflowing and devastating the farmlands and communities that lie along their banks. Asia is not the only continent at risk: Europe has also seen catastrophic flooding—in France in 1999, and in Central Europe in 2002 and 2005. And developments are similar in South America, in Andean and neighboring regions.

At a later stage, water will start to become scarce. Global warming shortens winters and reduces the quantity of snow falling on high ground. Ice that traditionally melted in summer to feed lakes and rivers will no longer be replenished. According to a number of forecasts, India's major rivers could become seasonal during the second half of the 20th century. This despite the fact that the Brahmaputra, to mention only one, has a rate of flow 100 times greater than European rivers such as the Seine, the Ebro, and the Tiber.

Aside from agriculture and reserves of drinking water, water shortages also threaten energy production because of a reduction in the energy supplied by hydroelectric dams and because of cooling problems at thermal power stations.

Even if we take the radical measures that are needed to halt the process of global warming, the phenomenon has an in-built time lag. It will continue to get worse for several decades before the first measures take effect—and that is assuming that we do not just bury our heads in the sand. Either way, we are going to have to adapt to a different world. We may need to evacuate areas most at risk, change our farming practices, and put in place new methods of managing our water resources.

> BY ABOUT 2050, FLOODS COULD REACH A PEAK, WITH RIVERS OVERFLOWING AND DEVASTATING THE FARMLANDS AND COMMUNITIES THAT LIE ALONG THEIR BANKS

Mount Everest, Himalayas, Nepal (27°59'N–86°56'E) Mount Everest, at a height of 29,029 feet (8,848 meters), is the highest point on the planet. The regional rise in temperatures of 1.8°F (1°C) since 1970 is causing glaciers to melt throughout the Himalayas and high-altitude lakes are filling so rapidly that around 40 are in danger of bursting before 2010. At the current rate, all Himalayan glaciers—like all the planet's mountain glaciers—could disappear within 40 years.

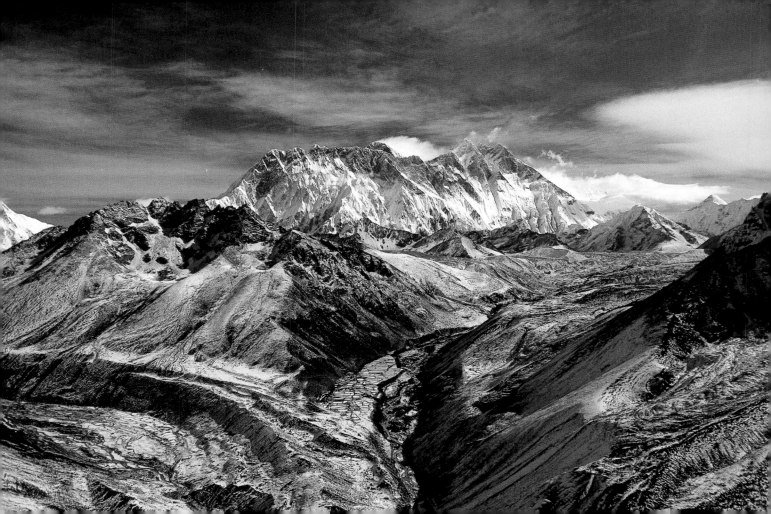

Not everyone will suffer from global warming. There will be winners as well as losers. The coldest, most inhospitable regions of the globe will benefit from a milder climate, and it will be possible to farm areas that were previously hard to cultivate. Canada, Russia, and southern Argentina could all see their agricultural productivity increase.

The Arctic typifies these future opportunities, in particular with the melting of the ice floes. Once all the ice has gone, it will be possible to navigate the entire region. The Northwest Passage will open and the dream of 19th-century explorers to sail from the Atlantic to the Pacific via the North will be a reality at last.

Sailing past northern Canada, the great ships voyaging between Europe and Asia will no longer need to use the Panama Canal. The journey between Tokyo and Rotterdam will be reduced from the current 14,300 miles (23,000 kilometers) to a mere 9,950 miles (16,000 kilometers). By sailing past northern Russia, via what is known as the Northeast Passage, the distance will be reduced still further, to 8,700 miles (14,000 kilometers).

THE NORTHWEST PASSAGE WILL OPEN AND THE DREAM OF 19TH-CENTURY EXPLORERS TO SAIL FROM THE ATLANTIC TO THE PACIFIC VIA THE NORTH WILL BE A REALITY AT LAST

The Arctic subsoil could contain the most extensive gas fields and oil, diamond, and gold reserves still to be discovered on the planet. Riches that were previously protected by a layer of hard ice and the harsh Arctic climate could become much easier to exploit.

For all these reasons, the Arctic is an area of increasing economic and strategic interest. Already, Canada, Russia, Denmark, the USA, and Norway are engaging in intense diplomatic maneuvers in an attempt to establish control over the region—a previously overlooked part of the world, whose frontiers have never been clearly delineated.

But for the traditional inhabitants of the Arctic—the Inuit, Sami, Nenets, and others—the influx of money and development brings its own challenges. Their way of life and their culture are threatened today by changes to both their physical and their political and economic environment.

IPCC Fourth Assessment Report: www.ipcc.ch

The Louis-Saint-Laurent icebreaker in Resolute Bay, Nunavut, Canada (74°42'N–95°18'W) With its specially designed bow, reinforced hull and powerful propulsion, an icebreaker can plow through ice floes, and is heavy enough to split and break them apart. In 2008, for the first time since records began, the Northwest and Northeast Passages were simultaneously free of ice.

Science has a special term for what is popularly known as a vicious circle: "positive feedback." Positive feedback describes how a phenomenon speeds up or slows down once it gets under way. In the case of global warming, at least three such patterns have been identified. The first is the melting of the Arctic. Ice reflects more of the sun's rays than any other surface. Water, on the other hand, absorbs more rays than any other. When ice floes melt, an area that previously reflected the sun's heat back into the atmosphere begins instead to accumulate it. The more the ice melts, the more the water heats up and causes remaining ice to melt. This explains in part why the temperature rise recorded for the Arctic region over the course of a century is approximately twice the global average: 3.6–5.4°F (2–3°C).

Another "positive feedback" cycle affects the permafrost, the permanently frozen ground of the Earth's far north. When permafrost melts, it releases methane, a greenhouse gas 21 times more powerful than CO_2. This effect could be accelerated if the methane trapped at the bottom of the oceans came to be released in the same way.

WHEN PERMAFROST MELTS, IT RELEASES METHANE, A GREENHOUSE GAS 21 TIMES MORE POWERFUL THAN CO_2

A third example relates to the behavior of the world's forests and oceans. Normally, they store billions of tons of CO_2 annually, in the soil, in the living trees, in the water, and in marine microorganisms. They are known for this reason as "carbon sinks." But global warming interferes with the way they function, so that they could end up absorbing much smaller quantities of greenhouse gas, or even releasing it, which would be catastrophic.

The precise mechanisms of these three effects are still the subject of debate, but one thing is sure: beyond a certain limit, the situation will run away with itself. This is why experts have set themselves the target of keeping global warming to within a fixed limit. This is calculated in terms of the quantity of CO_2 in the atmosphere and is set at 400 parts per million. The figure stood at 280 before the industrial age, and at 370 in 2000, and it could exceed 450 by the year 2020. A number of organizations have fixed this threshold (or even a threshold of 350 ppm) as a target figure not to be exceeded (or as yet to be achieved) and as a challenge for international campaigns.

Wetlands near Surgut, Siberia, Russia (61°36′N–73°07′E) Permafrost is ground that is permanently frozen. It covers an area of 10 billion square miles (25 billion square kilometers), some 20% of the planet's land mass. Its temperature has increased by 3.6–5.4°F (2–3°C) in Alaska, northern Russia, and eastern Siberia, and its maximum winter extent has decreased by 7% over a century. As it melts, permafrost could release large quantities of methane into the atmosphere.

Doing nothing is a luxury that humanity can no longer afford. Global warming has already begun to transform our planet, and it will continue to do so. It is going to cost us very dear.

Insurance companies were among the first to draw attention to the reality of climate change when they found themselves paying out increasing sums of money as a result of natural disasters such as Hurricane Katrina, the European heat-wave of 2003, and flooding in Central Europe and Asia. Experts have since attempted to give a global evaluation of the phenomenon. According to Nicholas Stern, an economist working for the British government, global warming will continue to cost approximately 5% of the world's annual GDP in the coming years. If we allow for a broader spectrum of risks and consequences, the damage estimates could rise to 20% of world GDP or higher. This is the equivalent of 5,000 billion US dollars, or the cost of the two World Wars plus the Wall Street Crash.

IT WILL BE THE POOREST PEOPLE ON THE PLANET, THOSE ALREADY WITH BARELY THE MEANS TO SURVIVE, WHO WILL BE LEAST ABLE TO DEAL WITH THE CRISIS

The measures we would need to put in place to halt global warming, according to Stern, would cost 10 to 20 times less—a massive saving! Despite the pressures of the current economic crisis, the investment is clearly worth making. Besides, the longer we put off doing something, the more radically we will have to act, and the more it will cost. According to the experts, we have about ten years to take action. After that, it will be very difficult to turn back.

It is not the existence of humanity that is threatened, but the way we live. Homo sapiens will probably survive, but as always it will be the poorest people on the planet, those already with barely the means to survive, who will be least able to deal with the crisis or change their way of life, and who will suffer most acutely. This is why the fight against global warming requires that we create new kinds of alliances, and why we will need to adopt measures such as technological co-operation and international emissions exchange mechanisms.

IPCC Fourth Assessment Report, www.ipcc.ch

House surrounded by floodwaters, southern Dhaka, Bangladesh (23°41'N–90°25'E) Since 1971, Bangladesh has been the victim of some 200 natural disasters (storms, tidal waves, cyclones, floods, earthquakes, and subsequent epidemics) that have claimed more than 500,000 lives. In 2004, the country was once again devastated by terrible floods, which submerged the capital, Dhaka.

CARBON DIOXIDE EMISSIONS
CLIMATE CHANGE

Which are the main GHGs?

		GWP*
Carbon dioxide	combustion of fossil fuels and biomass	1
Methane	livestock digestive systems, wetlands	25
Nitrous oxide	tropical soils, oceans, livestock, fertilizers	298

Which sectors emit the most GHGs?

Percent contribution to global greenhouse gas (GHG) emissions

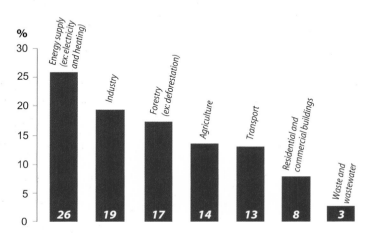

%
- Energy supply (ex: electricity and heating) — **26**
- Industry — **19**
- Forestry (ex: deforestation) — **17**
- Agriculture — **14**
- Transport — **13**
- Residential and commercial buildings — **8**
- Waste and wastewater — **3**

How do I contribute to GHG emissions?

Driving 20 km to work ------------------------- **5 kg (11 lb)**

Watching TV for 1 hour per day ---------------- **99 g (3½ oz)**

Microwaving my lunch for 5 minutes ----------- **43 g (1½ oz)**

Product carbon footprints (GHGs released during manufacture)

 275 kg (606 lb) Computer & monitor

 5 kg (11 lb) Hamburger

 490 g (17 oz) 1kg wheat flour

22 kg (49 lb) iPod touch

 9 kg (20 lb) 1kg tomatoes (greenhouse)

240 g (8 oz) 1kg potatoes

3 kg (7 lb) T-shirt

 4 kg (9 lb) 1kg gruyère

 27 g (1 oz) 1 egg

Food: Mostly UK growing conditions

* *Global warming potential is a measure of how much a given mass of GHG is estimated to contribute to global warming.*

Source: (left) IPCC, 2004. *Fourth Assessment Report*. (top) Apple Inc., 2008. *Environmental Performance*, 2008; UNEP, 2008. *Kick the Habit*; Coop Naturaline Website; Williams, Audsley, and Sandars, 2006. *Determining the environmental burdens and resource use in the production of agricultural and horticultural commodities.*

To reduce our emissions, we must reduce our consumption

Produced by UNEP/DEWA/GRID-Europe, Feb. 2009.

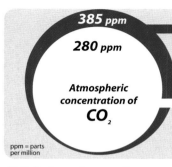

385 ppm

280 ppm

Atmospheric concentration of **CO$_2$**

ppm = parts per million

Present day (2008)

How much CO$_2$ is currently present in the atmosphere?

3,000 trillion kg

6,600 trillion lb

Pre-industrial (1750)

How much CO$_2$ is naturally present in the atmosphere?

2,200 trillion kg

4,900 trillion lb

Global mean temperature has increased by **0.74 °C** (1.33 °F) between 1906 and 2005. Temperatures are projected to increase by **1.8 °C to 4 °C** (3.2–7.2 °F) between 1980 and the end of the 21st century.

Source: IPCC, 2007. Fourth Assessment Report; CDIAC, 1990. Glossary: Carbon Dioxide and Climate

Which sub-regions emit the most CO$_2$?

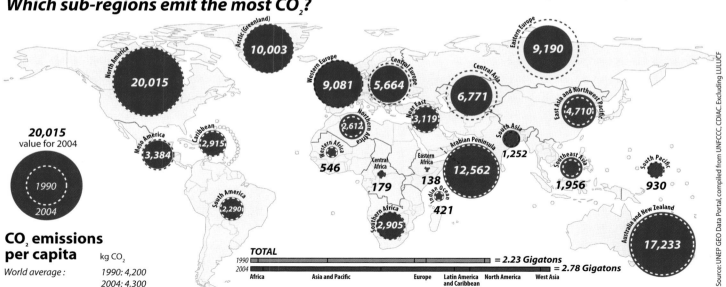

Arctic (Greenland) **10,003**

North America **20,015**

Western Europe **9,081**

Central Europe **5,664**

Eastern Europe **9,190**

Central Asia **6,771**

East Asia and Northwest Pacific **4,710**

Meso America **3,384**

Caribbean **2,915**

Northern Africa **2,612**

Near East **3,119**

South Asia **1,252**

Western Africa **546**

Central Africa **179**

Eastern Africa **138**

Arabian Peninsula **12,562**

Indian Ocean **421**

Southeast Asia **1,956**

South Pacific **930**

South America **2,290**

Southern Africa **2,905**

Australia and New Zealand **17,233**

20,015 value for 2004

1990

2004

CO$_2$ emissions per capita

kg CO$_2$

World average :

1990: 4,200
2004: 4,300

TOTAL

1990 = **2.23 Gigatons**
2004 = **2.78 Gigatons**

Africa Asia and Pacific Europe Latin America and Caribbean North America West Asia

Source: UNEP GEO Data Portal, compiled from UNFCCC, CDIAC. Excluding LULUCF

As we enter a period of major world food shortages, the food we are able to harvest from the sea will prove vitally important. According to the UN Food and Agriculture Organization (FAO), almost a billion men and women are undernourished and yet we are going to need to feed somewhere in the order of 50% more people in the next fifty years. Fish is rich in first-class proteins, fatty acids, and a whole range of other nutrients. Today already, 2.6 billion people receive at least 20% of their protein needs from fish. In many poor, densely populated countries, the figure exceeds 50%: this is the case in Bangladesh, Indonesia, Senegal, Thailand, and Guinea, for example.

The fishing industry also feeds, indirectly, the many families whose income depends upon it. The FAO estimates that there are 30 million people worldwide who live off fishing, 95% of them in developing countries. We have no statistics for other forms of employment indirectly connected with fishing, but it is important to take these into account too—jobs in the food industry, shipping and ship-building, commerce, transport, etc, probably totaling several hundred million. Fish exports from developing countries amount to some 20 billion dollars—a figure easily exceeding that of other major foodstuffs such as coffee, rice, and tea.

Whether viewed as a source of food or in broader economic terms, fishing is clearly an activity vital to humanity. This is why it needs to be sustainable and why we need to put a stop to particularly destructive practices, curb the mad scramble for ever more powerful boats and high-tech equipment, and promote fishing on a much smaller scale—such as is typically practiced in the southern hemisphere. While the latter should not be idealized, it is a richer source of employment than industrial-scale fishing and more economical in terms of fossil fuels. Above all, smaller, less powerful boats are more easily converted to "greener" fishing methods than the high-tech monsters used by the industrialized nations.

TODAY ALREADY, 2.6 BILLION PEOPLE RECEIVE AT LEAST 20% OF THEIR PROTEIN NEEDS FROM FISH

Food and Agriculture Organization of the United Nations, www.fao.org/fishery

The day's catch, Kayar, Senegal (14°55′N–17°07′W) Senegal's 430 mile (700 kilometer) coastline enjoys an abundance of marine life, benefitting from a seasonal alternation of cold currents rich in nutrients coming from the Canary Islands and warm equatorial currents. These local riches sustain the coastal fishing industry, 80% of which is practiced on a small scale from motorized wooden dugouts, using lines and nets; but they also attract European trawlers. Some 400,000 tons of fish are caught annually and fishing remains Senegal's primary economic resource, principally supplying the local market.

Reports by scientists are unanimous, and have been for several years now: the global fishing industry is in peril. A quarter of fish stocks are already overexploited and half are being exploited to the maximum. Some 90 million tons of fish are caught each year (four times the total of fifty years ago). Technology is still advancing, resulting in larger and more powerful vessels, superior equipment, and ultra-sophisticated detection systems.

Experts fear a global repetition of the Newfoundland cod drama. Cod was extraordinarily prolific off the coasts of Canada, but was heavily fished for four centuries, from 1550 to 1950. Then, over a period of barely 20 years, the annual catch rose steeply from 2–300,000 tons a year to 800,000 tons. The downturn was equally swift: cod populations were wiped out in the 1990s, signaling the end of the cod fishing industry and putting tens of thousands of people out of work. Twenty years later, cod stocks have failed to rebound and seem, in fact, to be dwindling again.

A QUARTER OF FISH STOCKS ARE ALREADY OVEREXPLOITED AND HALF ARE BEING EXPLOITED TO THE MAXIMUM

Fish are a natural resource that are constantly reproducing and ought therefore to be continuously available. But it is no easy task to create a global fishing industry that takes its environmental responsibilities seriously. Fishermen themselves are under pressure to compete and keep up with the technology, and are obliged to increase their takings to pay their debts. Governments are generally reluctant to impose unpopular restrictions such as quotas restricting the tonnage of fish caught. They are constantly pushing to increase their quotas, against scientific advice, and do not always enforce them even once they have been negotiated.

Effective and rigorous control of fishing activities, especially away from the coasts, is a costly and complicated business. Nevertheless, as the Newfoundland example demonstrates, the social and environmental cost of a collapse of the global fishing industry would be infinitely higher.

Food and Agriculture Organization of the United Nations, www.fao.org/fishery

Ukrainian-registered trawler off the Mauritanian coast, Mauritania (20°08'N–17°11'W) For forty days, four to six times a day, some thirty Ukrainian crewmembers haul in a trawl (a large fishing net) filled with 20 to 30 tons of fish (in this case, sardines). These are processed on board this 460 foot (140 meter) commercial trawler. On the deck, around a hundred workers freeze and box the fish, or turn it into fish meal if it spoils.

Industrial fishing does a great deal of damage to the planet's ecosystems. Its consequences tend to be underestimated by the general public because most of the damage is invisible, occurring beneath the surface of the oceans and often out on the open sea. Many fishing methods, whether they use lines or nets, impact numerous species that are of no interest to fishermen and result in what are described as "involuntary catches." Sea birds are drowned or strangled while feeding off bait or trying to snatch fish trapped in nets. Hundreds of millions of fish and hundreds of thousands of birds are lost each year, as well as a great many marine mammals (seals, porpoises, dolphins, and sea turtles), though there are no precise global figures.

Trawling is a particularly destructive practice, which consists in dragging weighted nets along the sea bed. It is also the most heavily used fishing method in the world thanks to the increased power of fishing vessels (itself the fruit of government subsidies): trawling is responsible for 50% of global catches and 80% of all catches in the open sea. As they rake over the rocks, trawlers' nets stir up clouds of sediments and turn the sea bed into a wilderness. Fishing trawlers are like marine bulldozers, plowing half the surface of the world's continental shelf each year, and no doubt reducing its productivity (although studies are lacking). They are also greedy consumers of fossil fuels.

Everything interconnects in the living world: the disappearance of a single species can destabilize entire ecosystems. The disappearance of fish stocks threatens all the creatures that feed off them—not just mankind, but birds and marine mammals too.

Part of the solution—even though it may not solve all the problems—lies in the creation of an international network of marine parks, where fishing would be banned or subject to severe restrictions. Only 0.7% of the ocean's surface is protected in this way today. The international target periodically mentioned is 20%, and if this were to be achieved, the damage caused by fishing would be considerably reduced, while still leaving fishermen sufficient space to pursue their activity.

> ## FISHING TRAWLERS ARE LIKE MARINE BULLDOZERS, PLOWING HALF THE SURFACE OF THE WORLD'S CONTINENTAL SHELF EACH YEAR

Food and Agriculture Organization of the United Nations, www.fao.org/fishery

Colony of northern gannets, island of Eldey, Iceland (63°43′N–22°58′W) Iceland is situated at the crossroads of three geographical regions, the Arctic, North America, and Europe, and gives sanctuary to a varied bird population: 70 species come to nest here regularly and 300 others are migrant visitors. The island of Eldey is a 230-foot-high (70-meter) rock situated 9 miles (14 kilometers) off the coast of southern Iceland. Classified as a nature reserve, the island gives sanctuary each year to almost 40,000 northern gannets (*Morus bassanus*), one of the world's largest gannet colonies.

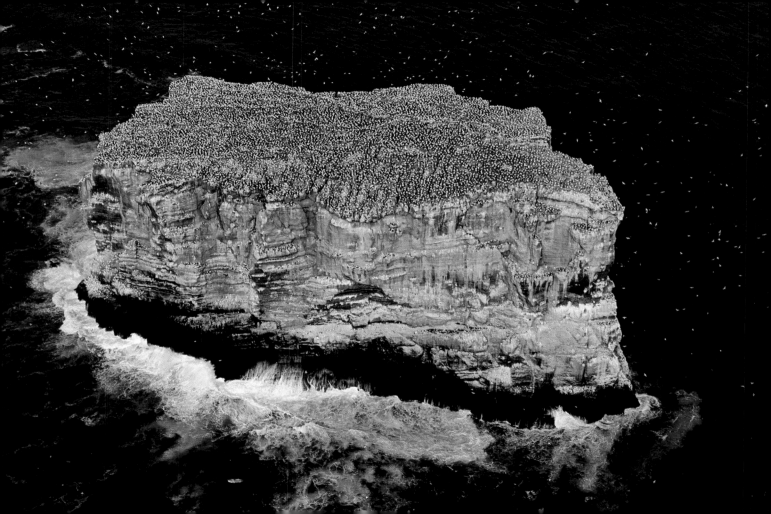

Cetaceans are an order of aquatic mammals that includes whales and dolphins. They are exceptional creatures. Equipped with lungs, they can remain under water for over an hour and swim to depths of 6,500 feet (2,000 meters). Most use a sophisticated system comparable to sonar for orientation. Many migrate across the globe each year. The blue whale is the largest animal that has ever lived on Earth, weighing up to 190 tons.

Whales and dolphins are unusually intelligent, the only animals to compare with primates in this respect. They form hierarchical social groups similar in size and organization to those of great apes—groups which depend, among other things, on sophisticated systems of communication. Their nervous system is similar to our own—a fact often invoked to denounce the particularly cruel methods by which whales are hunted. Wounds inflicted by harpoons are rarely fatal in themselves but lead to a protracted and painful death from blood loss.

The intergovernmental body that regulates whaling is known as the International Whaling Commission. The Commission adopted a moratorium on commercial whaling in 1986—which is still in force—and created a whale sanctuary in the Southern Ocean in 1994. But several member countries of the IWC are demanding a partial reintroduction of whaling, in addition to an extension of the existing exceptions. This has prompted a great deal of angry debate.

Whaling is by no means the only danger faced by cetaceans, of which some thirty or so species (almost half) are at risk. Fishing nets trap and drown tens of thousands of them, and although special nets have been designed to enable the creatures to break free, these are more expensive than standard nets and not widely used. Chemical pollution is also causing significant damage: being at the top of the food chain, whales and dolphins are particularly susceptible to increased contamination. Sound pollution—especially ultra-powerful military sonar—also disorientates them. And finally there is the problem of collisions with shipping vessels, which wreak havoc among the larger species.

THE WOUNDS INFLICTED BY HARPOONS ARE RARELY FATAL IN THEMSELVES BUT LEAD TO A PROTRACTED AND PAINFUL DEATH FROM BLOOD LOSS

International Whaling Commission, www.iwcoffice.org

Humpback whale in the Gulf of Guinea, off Port-Gentil, Ogooué-Maritime province, Gabon (0°31′S–8°52′E) The humpback whale (*Megaptera novaeangliae*) migrates between the krill-rich waters of Antarctica and the Gulf of Guinea, where females give birth, and where males and females mate. It is during courtship that male humpbacks make their most spectacular leaps. They propel their 30-ton weight out of the water before falling back with a tremendous splash that is visible from a great distance.

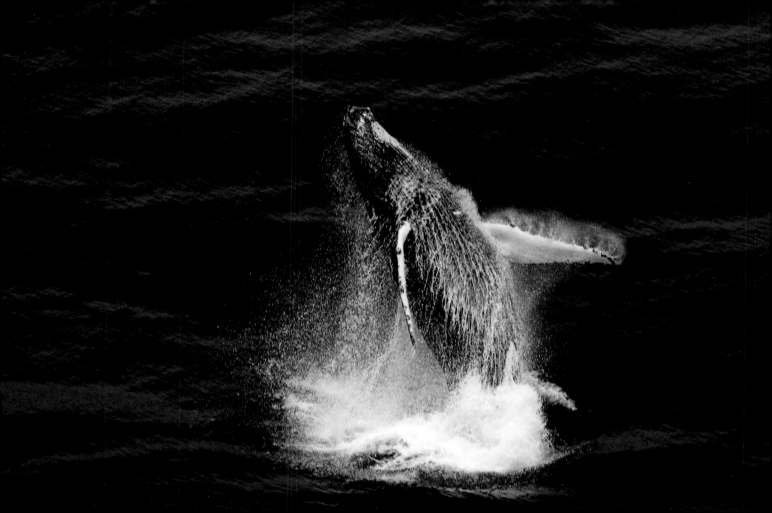

The principal resource human beings have harvested from the sea to date is fish. But the sea contains other riches with enormous but often neglected potential. One of these is seaweed. In countries such as China, Korea, and Japan, seaweed is commonly eaten, currently making up 10% of each person's daily intake. Seaweed tends to have a very high protein content, more than 25% of its dry weight in the case of many varieties of laminaria, and can be efficiently farmed: global production is estimated at almost 10 million tons annually.

Marine algae also have other potential uses. Some coastal populations have been using seaweed as an organic fertilizer for centuries. With chemical fertilizers threatened by the shortage of petroleum, seaweed could offer an alternative for the future. Traditional Chinese medicine also makes extensive use of seaweed, though in the West its pharmaceutical potential is still largely untapped outside the cosmetics and beauty industry.

IN COUNTRIES SUCH AS CHINA, KOREA, AND JAPAN, SEAWEED IS COMMONLY EATEN, CURRENTLY MAKING UP 10% OF EACH PERSON'S DAILY INTAKE

Most importantly, for some years now researchers have been looking into the possibility of using lipid-rich seaweed as a substitute for fossil fuels. Tests have been carried out on a number of varieties with promising results: these are generally unicellular species, with a rapid growth rate, capable of growing in water laden with organic matter, such as the discharge from a water purification plant. Studies are also being carried out to see if these seaweeds can be used to consume industrial emissions of CO_2, the main greenhouse gas.

Finally, plankton—which is a floating mix of unicellular algae and the microorganisms that feed off them—is another potentially colossal food source from the sea. Some 100,000 tons of krill—small, shrimp-like organisms that are a type of plankton—are farmed each year, mainly for aquaculture purposes. But the krill to be found in the Southern Ocean alone (admittedly difficult to harvest) has an estimated biomass of 500 million tons.

Food and Agriculture Organization of the United Nations, www.fao.org/fishery

Nets used for drying seaweed, Wando archipelago, South Korea (34°19'N–127°05'E) This archipelago lies to the southwest of the Korean peninsula and encompasses more than 200 islands of varying size, some of them inhabited, others deserted. Aquaculture, and seaweed farming in particular, is the dominant activity here. At one time, seaweed was just gathered from the sea, but large quantities of it are now specially farmed. The Koreans, along with the Chinese and the Japanese, are the biggest consumers of seaweed in the world.

Since the 1970s, the practice of aquaculture has been the focus of a worldwide surge of interest and has been growing at an annual rate of more than 7%. Today, the sector produces almost 50 million tons of fish, shellfish, and crustaceans annually, making up a third of all fish products to reach the market.

Unfortunately, aquaculture generates the same sorts of problems as any other form of intensive breeding: it produces organic and nitrous waste, as well as chemical waste (antibiotics and fungicides), and the concentration of living organisms is associated with increased risk of disease. But does it at least help to ease the pressures on wild fish? Not always, by any means. Shrimp, for instance, are usually farmed on sites that have been cleared of mangroves which previously provided a habitat for numerous species of marine life. And fish farming often focuses on the large carnivorous species particularly favored by consumers: salmon, sea bream, and turbot, for example. These predators require the inclusion of certain amino acids in their diet that are only to be found in fish and fish derivatives such as meal. It is estimated that between 2.5 and 5 lb of wild fish are needed to produce 1 lb of carnivorous farmed fish.

Happily, plant-eating fish can be farmed too. These often live in freshwater and not only pose fewer challenges in terms of farming, but could also provide human beings with precious supplies of animal proteins in years to come. Whereas 7 lb of cereals are needed to produce 1 lb of beef, 2 lb of grain are enough for 1 lb of carp, tilapia, or catfish. In China, a great many small-scale farmers have incorporated aquaculture into a highly efficient system of polyculture, using liquid pig manure, for example, to increase the production of algae in their ponds, which in turn makes their carp grow more rapidly. The promising practice of breeding fish in rice plantations (rice being the world's most widely grown grain) is also increasing.

> # WHEREAS 7 LB OF CEREALS ARE NEEDED TO PRODUCE 1 LB OF BEEF, 2 LB OF GRAIN ARE ENOUGH FOR 1 LB OF CARP, TILAPIA, OR CATFISH

Food and Agriculture Organization of the United Nations, www.fao.org/fishery

Salmon farming near Mechuque, in the Chauques Islands, Chile (42°17'S–73°34'W) The cold waters of the Chauques Islands are free of pollution and ideal for salmon farming. The region is the second-largest producer of farmed salmon in the world after Norway and has profited from the global rise of aquaculture since the 1970s. Nevertheless, in 2008 and 2009, recurring epidemics killed millions of salmon, and thousands of jobs were lost as a result.

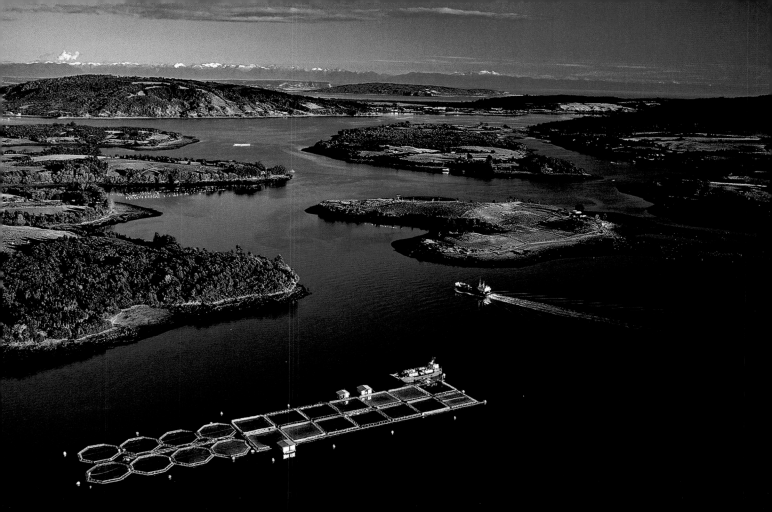

When we think of the seas being polluted, what we tend to picture are oil spills. Even today, oil tankers are still responsible for an average of some twenty spills a year—and some of these have been so massive (exceeding 250,000 tons) that they have found their way into the history books. But pipelines, oil rigs, and refineries are by far the biggest source of oil spills, such spillages representing on average 5 times the volume of hydrocarbons spilled by tankers. The largest oil spill in history occurred in 1991, as a result of the Gulf War, and is said to have exceeded a million tons.

Oil spills, however, represent just a fraction of the harmful human waste that finds its way into the marine environment. A high proportion of all our waste products, from the most toxic to the most benign, end up in the ocean. This is firstly because rivers are mankind's natural drains and rivers flow into the sea; and secondly because airborne pollutants have a high chance of being deposited in the world's oceans, given their huge surface area. Coastal ecosystems are the most badly affected: agricultural pesticides and fertilizers, industrial waste, and domestic organic pollution flow into their waters faster and faster as coastal populations (already 40% of humanity) increase. But even the heart of the ocean is a rubbish dump: an estimated (but conservative) figure of 3 million tons of plastic is slowly revolving in the middle of the Pacific, covering an area the size of Texas.

There is no strictly maritime solution to the pollution of our seas. Certainly, regulations controlling the maritime transportation of harmful substances need to be tighter and, above all, to be better enforced. This was the stated objective of the international marine environmental convention known as Marpol (short for "marine pollution"), which has in fact succeeded in gradually reducing the number of serious accidents occurring at sea. The phasing out of the last single-hull tankers by 2015 is an initiative along similar lines. But the fundamental question relates to the waste itself: we need above all to reduce the amount produced, and we need to increase recycling. We also need to improve our systems for filtering fluvial and atmospheric waste and to make these more widespread, especially since we already have the necessary technology.

International Maritime Organization, www.imo.org

PIPELINES, OIL RIGS, AND REFINERIES ARE BY FAR THE BIGGEST SOURCE OF OIL SPILLS

Euronav tanker, the Namur, Ushant shipping lane, Finistère, France (48°53'N–5°20'W) Oil tankers transport some 2 billion tons of hydrocarbons annually (2.4 billion tons in 2005, or 36% of maritime transport tonnage). The largest are several hundred yards long and carry more than 500,000 tons. Between 1974 and 2007, they caused 9,351 "accidental spillages," releasing some hundred million tons a year into the sea at the end of the 20th century—though more recently this figure has been almost halved.

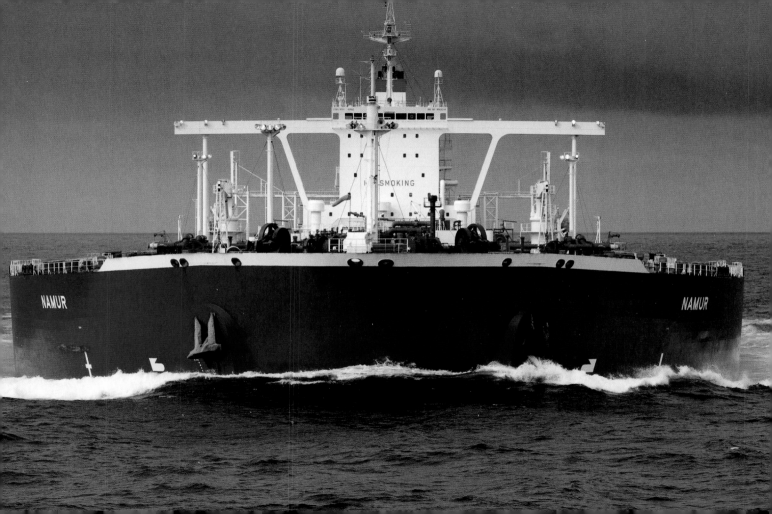

If awards were given to nature's greatest masterpieces, coral reefs would surely be a prizewinner. These ecosystems display a staggering degree of biodiversity: they are home to more than 93,000 recorded species, or 33% of all marine species—species whose variety of forms and colours is unequalled anywhere on the planet. And yet the area covered by coral reefs represents only 0.02% of the surface area of the world's oceans.

Corals are extremely fragile organisms. The product of a complex relation between single-cell algae and colonies of small fixed organisms known as polyps, they are vulnerable to the slightest changes in their environment. Human coastal populations are getting ever bigger, and the quantity of waste products (domestic, agricultural, and industrial) ending up in the sea is rapidly increasing. The ocean, too, is becoming warmer, and also more acid as a consequence of our CO_2 emissions, threatening the growth of coral. And, finally, coral reefs—mainly situated in developing countries—are coming under increasing pressure from fishing, particularly illegal and destructive practices that include the use of explosives and cyanide poisoning. What's more, there is nothing marginal about these practices: they are said to be affecting 80% of all corals, and more than 1,000 tons of cyanide has been used in the Philippines alone.

The result is that 27% of all coral reefs have vanished and another 30% are at risk. And yet these marine ecosystems are valuable to mankind in a number of ways. Their potential as a food source is enormous: a single square mile of coral, if well managed, can produce an estimated 375 tons of fish a year. Coral reefs are also a major tourist attraction: Australia's Great Barrier Reef generates 1 billion dollars of income a year. And coral reefs protect our shores from costly damage wreaked by storms and hurricanes.

All of this more than justifies the protective measures required to save coral reefs, including—as a matter of urgency—the construction of filtering plants, changes to farming methods in coastal regions, and the regulation of fishing and tourism. Corals are adapted to stable tropical conditions and are highly sensitive to changes in temperature: steps to halt global warming are therefore another urgent priority.

International Coral Reef Action Network (ICRAN), www.icran.org

> ## THESE ECOSYSTEMS ARE HOME TO 33% OF ALL MARINE SPECIES... AND YET THE AREA REPRESENTS ONLY 0.02% OF THE SURFACE AREA OF THE WORLD'S OCEANS

Great Barrier Reef, Queensland, Australia (16°55'S–146°03'E) The Great Barrier Reef lies off the northeast coast of Australia. It is the largest coral formation in the world, and home to more than 400 species of coral. Listed as a UNESCO World Heritage Site since 1981, this rich sanctuary of underwater life is a refuge for more than 1,500 species of fish and 4,000 shellfish, as well as the dugong, an endangered marine mammal, and six of the world's seven species of sea turtle.

FISHERIES
AN OVEREXPLOITED RESOURCE

What is the current state of world fisheries?

State of fishery stocks (percent, average 1997–2004)

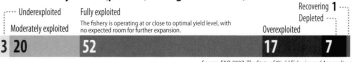

Underexploited	Fully exploited			Recovering	1
Moderately exploited	The fishery is operating at or close to optimal yield level, with no expected room for further expansion.		Overexploited	Depleted	
3	20	52		17	7

Source: FAO 2007, *The State of World Fisheries and Aquaculture*

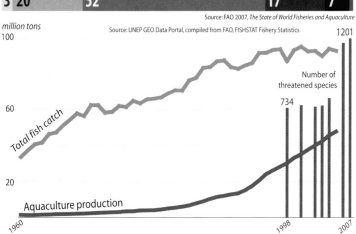

Source: UNEP GEO Data Portal, compiled from FAO, FISHSTAT Fishery Statistics

million tons

Number of threatened species

1201

734

Total fish catch

Aquaculture production

Sources: FAO 2006, Yearbooks of Fishery Statistics, Summary Tables, Capture Production 2006, Fish, crustaceans, molluscs, etc.; FAO 2005, *Review of the State of World Marine Fishery Resources*.
Right: MSC.org Website

What are some of the threats to fisheries?

Coral reef bleaching • Mangrove destruction • Erosion
Climate change • Bottom trawling • Pollution

How are fisheries managed sustainably?

Some basic principles of MSC sustainable fisheries certification:

➡ **Sustainable fish stocks:** The fishing activity must be at a level which is sustainable for the fish population.

➡ **Minimizing environmental impact:** Fishing operations should be managed to maintain structure, productivity, function, and diversity of the ecosystem.

➡ **Effective management:** The fishery must meet all local, national, and international laws.

The challenge is to manage fisheries in a sustainable way

 Look for an eco-label on products to make sure you are purchasing fish from a sustainably managed fishery. The Marine Stewardship Council is a major accredited certification body.

Produced by UNEP/DEWA/GRID-Europe, Feb. 2009

Why preserve fisheries?

Food
Fish is an important part of daily nutrition in many countries.

Linking parts of the ecosystem
Fish link different parts of the ecosystem via transport of nutrients and energy.

Recreation
In many areas of the world fishing is considered a form of relaxation and can improve one's sense of wellbeing.

Other services: Medicine · Spirituality · Regulation of the populations · Habitat engineering

How important is fish to the average diet?

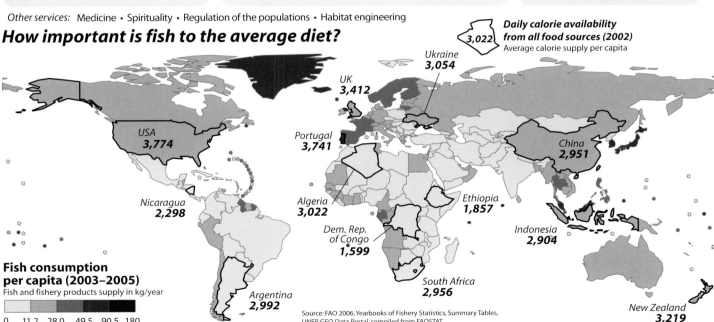

3,022

Daily calorie availability from all food sources (2002)
Average calorie supply per capita

Ukraine
3,054

UK
3,412

USA
3,774

Portugal
3,741

China
2,951

Nicaragua
2,298

Algeria
3,022

Ethiopia
1,857

Indonesia
2,904

Dem. Rep. of Congo
1,599

Argentina
2,992

South Africa
2,956

New Zealand
3,219

Fish consumption per capita (2003–2005)
Fish and fishery products supply in kg/year

0 11.2 28.0 49.5 90.5 180

Source: FAO 2006, Yearbooks of Fishery Statistics, Summary Tables, UNEP GEO Data Portal, compiled from FAOSTAT

Water is essential to human life. The human body is composed of more than 60% water in an adult and 70% in a baby. To compensate for the loss of water (through respiration, perspiration, and urine), a single adult needs to consume on average 4-6 pints (2-3 liters) of water per day. According to the United Nations, governments should supply a minimum of 5 gallons (20 liters) of safe water per day for each inhabitant. Water also plays a major role in food production; for example, between 500 and 1,300 gallons (2,000 and 5,000 liters) are needed to produce the daily food of a single person living in a Western country.

More than a billion people in the world do not have access to clean water, a fact that makes them vulnerable to many diseases and increases poverty and social injustice. But how can the meeting of this vital need be made into a human right? Recognizing water as a common resource of humankind and its use as a fundamental human right would not only be a symbolic act, it would make the provision of clean water a priority for governments and local authorities. But although it is regularly discussed, the right to water has not yet been included in the Universal Declaration of Human Rights.

Debate rages between those who support a right that guarantees every human being a quantity of water that is sufficient for personal and domestic use, at an acceptable quality and at a low cost, and those who see water as a commodity that should be governed by market forces. According to the latter, giving water an economic value is the best way to control waste and protect this limited resource.

In fact, the privatization of public water services in many countries has resulted in intolerable price rises for the poorest section of the population. On the other hand, in many places where water supplies remain a public service, governments and local authorities have not always succeeded in fulfilling their responsibilities to their citizens, even within countries with cultures that recognize water as a sacred resource.

UN Water, www.unwater.org

ALTHOUGH IT IS REGULARLY DISCUSSED, THE RIGHT TO WATER HAS NOT YET BEEN INCLUDED IN THE UNIVERSAL DECLARATION OF HUMAN RIGHTS

Camels drinking at a well in Ti-n-Tehoun, Timbuktu region, Mali (16°58'N–2°57'W) The territory of every group of Tuareg herdsmen is mapped out by water sources. A well can become a meeting place for several tribes who all make use of it. The bulk of their livestock consists of camels, which fulfill many roles: they are a means of transport and a source not only of food (milk and meat) but of wool and leather, as well as a store of wealth that can be bought and sold en route.

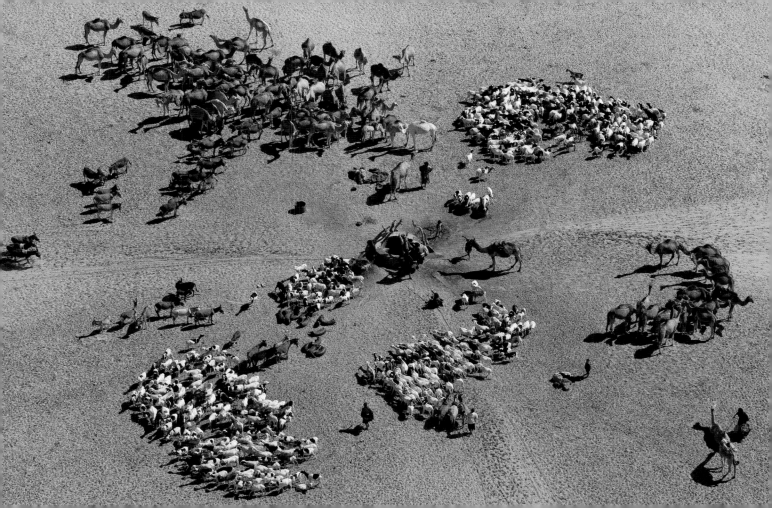

The water cycle, along with the carbon cycle, is an essential requirement for every form of life. Water is present within the cells of our bodies, and even at this level it is in perpetual motion. It is water that gives the cell its volume, allows it to breathe, and to obtain nourishment. This simple molecule is needed by everything that lives. The living water cycle is repeated again and again, not just within each plant or animal, but on a planetary scale.

Among these constant changes, there is a visible circulation of water in the form of clouds and rain, the water that fills springs, feeds wells, runs into rivers, and rejoins the oceans of the world. This is called blue water. But water can also be invisible to human eyes, in the form of evaporation from the surface of oceans and land, and plant transpiration from the surfaces of leaves. This is called green water because it creates biomass. The water cycle and the carbon cycle come together inside the living tissues of plants.

> UNLIKE OIL, WATER IS NOT DESTROYED WHEN IT IS CONSUMED. BUT WE ARE DISTURBING ITS NATURAL CYCLE

Here this interdependence is complete, because it is water that erodes rocks, allowing plants to obtain the minerals they need.

It is not the case that water is running out. Unlike oil, water is not destroyed when it is consumed. But we are disturbing its natural cycle. For example, the deforestation of huge areas of land has doubled the quantity of blue water—water that flows through streams and rivers and ultimately empties into the oceans. We have thereby altered the frequency and intensity of rainfall, mostly with the effect of making the air drier. But what we have done can still be undone. For example, on J. David Bamberger's 5,500-acre (2,220-hectare) ranch in Texas, there was formerly no water and no usable pasture. After the replanting of native grasses that had disappeared through over-grazing, dry springs and streams began to flow once again, creating enough water to run the ranch and several households in the area.

United Nations Environment Program, www.unep.org

Iguazú Falls, Argentina and Brazil (25°41'S–54°26'W) On the border of Brazil and Argentina, the Iguazú (or Iguaçu) Falls are 230 feet (70 meters) high and form a semicircle 1.7 miles (2.7 kilometers) long. The average flow of the Iguazú river at this point surpasses 50,000 cubic feet (1,400 cubic meters) per second. Visited by 1.5 million tourists every year, the falls are protected and were designated a UNESCO World Heritage Site in 1984.

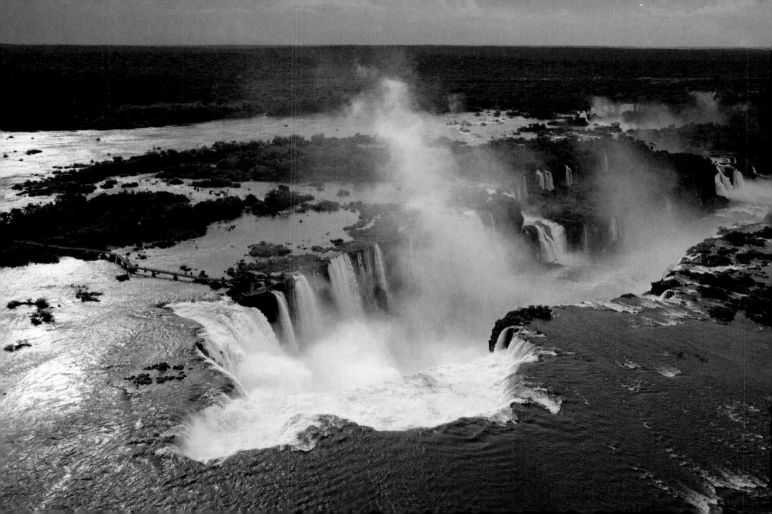

On a global scale, agriculture absorbs 70% of all freshwater supplies, a figure that rises to 95% in some developing countries. Irrigation allows food production to be increased, combating hunger and improving living standards. However, irrigation is not without drawbacks. It uses up a resource that is only available in limited quantities: since 1950, irrigated areas have doubled, while the use of water for agricultural, domestic, and industrial purposes has more than tripled. Two examples illustrate the problems of large-scale reliance on irrigation.

Egypt and its 82 million inhabitants are totally dependent on the water provided by the Nile: 100% of agricultural land is irrigated and 96% of this with river water. Thanks to the Aswan Dam, irrigation has been ensured, but salinization—a consequence of intense irrigation in areas where evaporation is high—is now threatening the soil and reducing crop yields.

In Central Asia, the diversion of the Syr-Daria and Amu Darya rivers to allow large-scale irrigation of cultivated areas—predominantly for growing cotton—has resulted in the shrinking of the Aral Sea, which since the 1960s has lost 60% of its surface area and 80% of its volume of water. Its ecosystem has been destroyed, and the local fishing industry has collapsed. Salts and pesticides that have accumulated on the dried sea bed are blown by the wind and are contaminating drinking water supplies, endangering the health of the region's population.

Is there any way to reduce water consumption and protect freshwater ecosystems while still increasing agricultural production? In regions where rainfall is insufficient or barely sufficient, drip irrigation or micro-irrigation is a method that delivers water directly to the roots of plants through a system of pipes and small sprinklers, reducing evaporation, deep drainage, and contamination. Drip irrigation can create a saving of 40-60% of water compared to traditional systems. Despite the set-up costs, the United Nations Food and Agriculture Organization supports the promotion of this technique in developing countries.

DRIP IRRIGATION CAN CREATE A SAVING OF 40-60% OF WATER COMPARED TO TRADITIONAL SYSTEMS

United Nations Food and Agriculture Organization, www.fao.org

Center-pivot irrigation, Wadi Rum, Ma'an, Jordan (29°36′N–35°34′E) This self-propelled irrigation machine draws water from deeply buried layers of rock for use in agriculture. Production of 1 ton of grain requires about 1,000 tons of water, and because of their growing need for food supplies, the countries of the Middle East have begun to use modern technologies to tap the underground aquifers in the region. This non-renewable resource will be drained within just a few years.

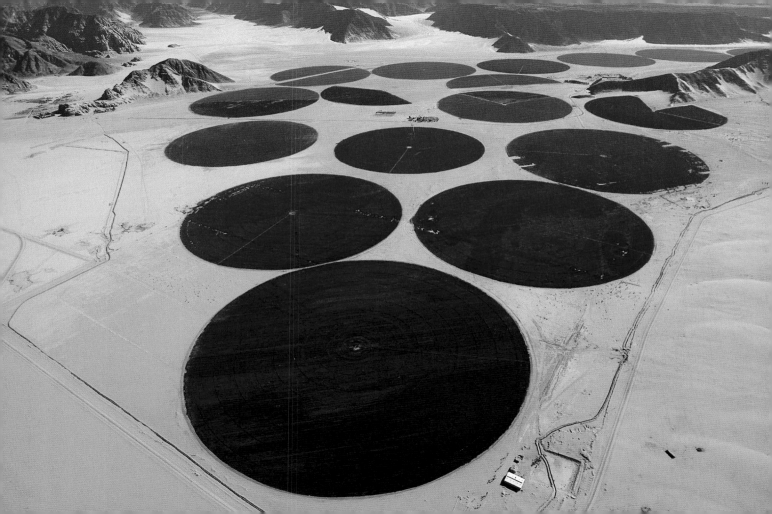

Today a third of humanity is suffering from water scarcity. Specialists use the term "water stress" when the demand for water exceeds the available freshwater supply by 10%. Although 10% of a renewable resource may not seem like much, we should not forget that before mankind's intervention, 100% of this water was used by ecosystems. This extra demand is enough to dry a water course, drain a spring, or prevent the replenishment of groundwater.

While the populations of Canada and the Amazon or Congo basin have a plentiful water supply, the people of the Mediterranean basin, Central Asia and Mexico are at greater risk of scarcity. The particular problem with water is that it is difficult to transport in large quantities over great distances.

One solution is to use the same water several times. An increasing number of industries are reusing water, retreating it up to 30 times in some cases. Domestic wastewater, known as "greywater," can be reused to water a garden or flush a toilet, reserving drinkable water for human consumption, cooking, or washing. In countries where water is scarce, wastewater from cities is retreated for use in agriculture. In Israel, for example, where the average rainfall is 1 inch (250 mm) a year, 70% of wastewater is recycled, allowing 49,000 acres (20,000 hectares) of land to be watered.

There are many other ways of saving water, especially by being aware of how much of it we consume. Some of this water is invisible: it is used to make a product, but is not present in the product itself. This is called virtual water. One pound of grain means hundreds of gallons of irrigation water; a pair of cotton jeans require 2,860 gallons (10,850 liters) of water; a cup of coffee 9 gallons (35 liters); a sheet of paper 2.5 gallons (10 liters). A single tomato contains 3.5 gallons (13 liters) of virtual water, which is more than many people use in a day. Paradoxically, some countries that face water scarcity are actually exporting some of their limited water resources in the form of agricultural or manufactured products.

A SINGLE TOMATO CONTAINS 3.5 GALLONS (13 LITERS) OF VIRTUAL WATER, WHICH IS MORE THAN MANY PEOPLE USE IN A DAY

UN Water, www.unwater.org

Moshav (co-operative village) farm at Nahalal, Jezrael plain, Israel (32°41'N–35°13'E) Moshavim are collective farms that were inspired by socialist and Zionist ideology and created during the second wave of Jewish immigration during the 19th century. They played an important part in the creation of the state of Israel. Unlike the principles of the kibbutz, the moshav farmers keep ownership of their own goods, but share labor and natural resources (water, for example), and the profits from their activities are returned to the community.

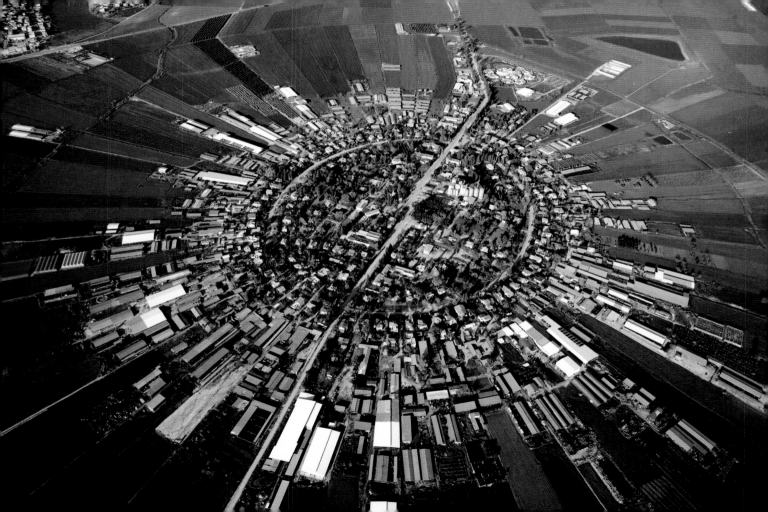

Almost 40% of the world's population is concentrated in 263 river basins shared between two or more countries. The inhabitants who must share these precious water resources often become rivals, and these situations can escalate into conflict. When a river crosses a border, water becomes an instrument of power and the country situated upstream, whether or not it is more powerful in other ways, gains the advantage because it can theoretically control the water supply of its downstream neighbor. More recently, conflicts have broken out over the sharing of water from large cross-border groundwater supplies, an increasingly exploited resource.

Today, disputes over water are too numerous to list. Many are in the Middle East, Africa, and Asia. Fortunately, however, there are also many unexpected examples of co-operation between countries on the issue of water. Why is

this? Perhaps because water is too crucial a resource to fight over. One of the most encouraging examples is the co-operation between India and Pakistan: despite other tensions between the two countries, they have continued to share financing for projects to manage the Indus river.

THERE ARE MANY UNEXPECTED EXAMPLES OF CO-OPERATION BETWEEN COUNTRIES ON THE ISSUE OF WATER

Conflicts over water resources are often conflicts about water use at a local level, within the same country, between farmers, cities, industries, and dam-builders. To resolve this, there is a need all over the world for basin water management systems and co-operation between upstream and downstream populations on issues such as water quantity and quality, fish migration patterns, and flood defenses. Indeed, basin water management is not only a sound ecological principle but a democratic principle that the United Nations wishes to promote across all continents.

UN Water, www.unwater.org

Salt formations on the west coast of the Dead Sea, Israel (31°20′N–35°25′E) The landlocked Dead Sea is the lowest point on the planet, 1,370 feet (418 meters) below sea level. Its surface is punctuated by white patches, an effect of its high salt content, which is nine times higher than the ocean average. Since 1972, the Dead Sea has lost 30% of its surface area, and its level is dropping by nearly 3 feet every year: the waters of the river Jordan which feed it are being diverted to irrigate neighboring lands.

In developing countries, both in urban and rural areas, the collection of water is often the responsibility of women. Many must walk for miles to the nearest well or stream, and must devote a large portion of each day to this chore. In some cases, girls stop going to school at a young age in order to help with the task. In Subsaharan Africa, 58% of the population lives 30 minutes away on foot from a drinking water supply and only 16% have a piped water connection at home, according to UNICEF.

The relationship between water and poverty is marked. On a global scale, 2.6 billion men and women—half of the population of the world's developing countries—live without a basic standard of sanitation, and 1.1 billion people—17% of the world's population—do not have access to safe drinking water. Diseases such as diarrhea, cholera, and dysentery, which are transmitted through poor quality water in the absence of proper sanitation, cause the deaths of 3,900 children under the age of five every day. Behind this death toll lie millions more children who are sick, disabled, or unable to attend school. Simple hygiene measures (washing the hands after using the toilet and before preparing food) would prevent many of these deaths, so education also has a vital role to play.

1.1 BILLION PEOPLE—17% OF THE WORLD'S POPULATION—DO NOT HAVE ACCESS TO SAFE DRINKING WATER

In developed countries, almost 100% of people have access to drinking water. Nonetheless, the quality of this water is threatened by the presence of pesticides, chemical residues, and nitrates. In France, for example, 25% of groundwater and 15–20% of water courses are polluted and of poor quality.

Worries about water quality have led to a rise in consumption of bottled mineral water. However, in Western nations, this is often of no better quality than tap water and is certainly not eco-friendly. Its transportation, refrigeration, and plastic packaging consume a great deal of energy: the equivalent of a tenth of a gallon of oil for one bottle.

The United Nations Children's Fund (UNICEF), www.unicef.org/wes/mdgreport

Women at a well near Pali, Rajasthan, India (25°57'N–73°19'E) In India, the intensification of agriculture, improvements in drilling techniques and the use of motor pumps have allowed farmers to create and use millions of small wells, freeing themselves from the vagaries of the monsoon climate. Today more than 50% of water used for irrigation comes from groundwater sources which are now being depleted at a disturbing rate. They have been reduced by 3-10 feet (1-3 meters) across more than 75% of India.

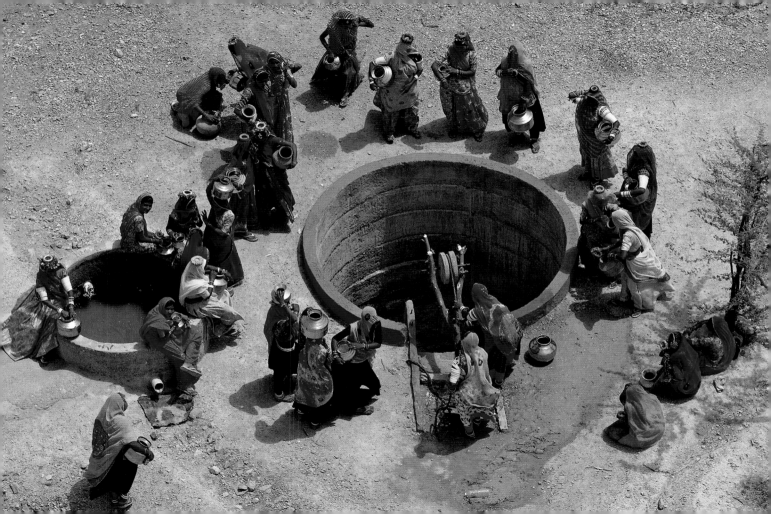

Most people in industrialized countries take water for granted: they simply have to turn a faucet. But this attitude now lies at the root of some increasingly irresponsible behavior, of which there is no better illustration than the growth of desert cities in the very heart of arid regions.

The population of Las Vegas, for example, grows by more than 50,000 people annually, despite its very low rainfall of less than five inches (around 100 mm) a year. This situation is problematic because the people of the US are insatiable consumers of water, at an average rate of 600,000 cubic feet (17,000 cubic meters) per person, per year—30 times more than the people of Tanzania, for example. In tourist towns, water is also needed for visitors (40 million a year in Las Vegas), who are attracted by infrastructure such as swimming pools, parks, and golf courses. The watering of a golf course requires more than 175,000 cubic feet (5,000 cubic meters) of water per day, the average consumption of a town of 12,000 people.

THE WATERING OF A GOLF COURSE REQUIRES MORE THAN 175,000 CUBIC FEET (5,000 CUBIC METERS) OF WATER PER DAY, THE AVERAGE CONSUMPTION OF A TOWN OF 12,000 PEOPLE

To feed the demands of these parched cities, huge quantities of water generally need to be imported, requiring costly infrastructure (dams, canals, pumping stations), often at the expense of taxpayers, and taking a heavy toll on the environment. The flow of the Colorado river, which feeds the southwest of the USA, has now been severely reduced, causing serious damage to the ecosystems of the river and its delta. For coastal cities, the construction of seawater desalination plants may seem to offer an alternative, but such plants require a huge amount of energy to run.

Part of the solution must involve reducing consumption: adapting agriculture for a dry climate, replacing lawns with "desert gardens" that do not require watering, and increasing the range of water-saving measures within homes. Water tariffs have proved an efficient strategy: when water prices rise more quickly than water demand, tariffs create an incentive to use water more sparingly, and therefore more responsibly.

Hotel development near Arrecife, Lanzarote, Canary Islands, Spain (29°00'N–13°28'W) A popular destination for both short summer vacations and longer-term visits, the Canary Islands have been heavily developed. Acutely aware of the impact of tourist infrastructure on the landscape and ecology of the islands, Lanzarote has hosted two world conventions on sustainable tourism. Dealing with this industry's environmental impact is all the more urgent because over the next 20 years the sector is expected to grow at an average of 4.3% per year, and the number of tourists to increase by 300%.

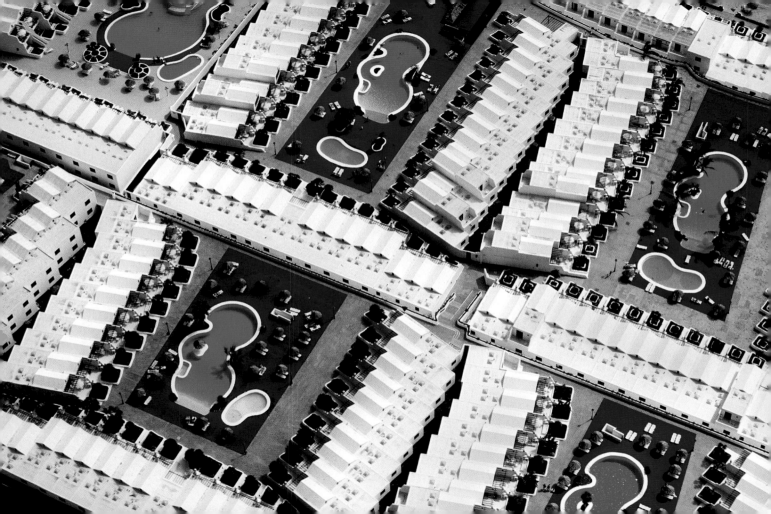

It is hard to think of a better symbol of mankind's mastery over nature than dams and barrages, which hold back the power of water. More than 50,000 dams over a height of 50 feet (15 meters) have been built across rivers of the world, causing unprecedented changes to the planet's hydrology.

The benefits of dams are well known. They are a relatively "clean" source of electricity that can adapt to demand. They also enable irrigation, allowing a considerable rise in crop yields: the 20% of irrigated crops worldwide represent 40% of production. The majority of the world's dams are used for agricultural rather than hydroelectric purposes.

But dams also have a darker side, as has been demonstrated by an international group of experts—the World Commission on Dams. The issue was examined from three major perspectives. From an economic point of view, the planned costs of dam development, which are almost always supported by taxpayers, are regularly underestimated. At the same time, the economic benefits are frequently overestimated, particularly in developmental terms. On a social level, dam-building projects, especially in the countries of the South, are rarely profitable to all. Rural farmers are often forced off the land and into overcrowded cities. From an ecological perspective, finally, the trapping of sediment by dams has had destructive consequences for the deltas of almost all the world's major rivers, causing them to deepen, and increasing erosion. Many wetland areas with rich biodiversity have been flooded, water quality has been affected and fish migration disturbed. In tropical zones, dams can also lead to an increase in methane, which adds to global warming.

As a result, a more reponsible attitude to dam construction is taking hold. The desire to tame nature is now being replaced by a wish to "collaborate" with it. An era of smaller-scale dams, based on more thorough studies of environmental impact, may come to supersede the day of the all-powerful civil engineer.

THE MAJORITY OF THE WORLD'S DAMS ARE USED FOR AGRICULTURAL RATHER THAN HYDROELECTRIC PURPOSES

The World Commission on Dams, www.dams.org

Lake Powell, San Juan River, Utah, USA (37°25'N–110°45'W) Created by the construction of the Glen Canyon Dam in 1956, Lake Powell is one of the largest artificial lakes in the world, with its surface area of 160,000 acres (65,000 hectares), depth of 560 feet (170 meters), length of 185 miles (300 kilometers), and 2,200 miles (3,500 kilometers) of shoreline. Before it was lost under Lake Powell, the land here belonged to the Navajo people, who were forced to swap it for another territory in southern Utah of the same size.

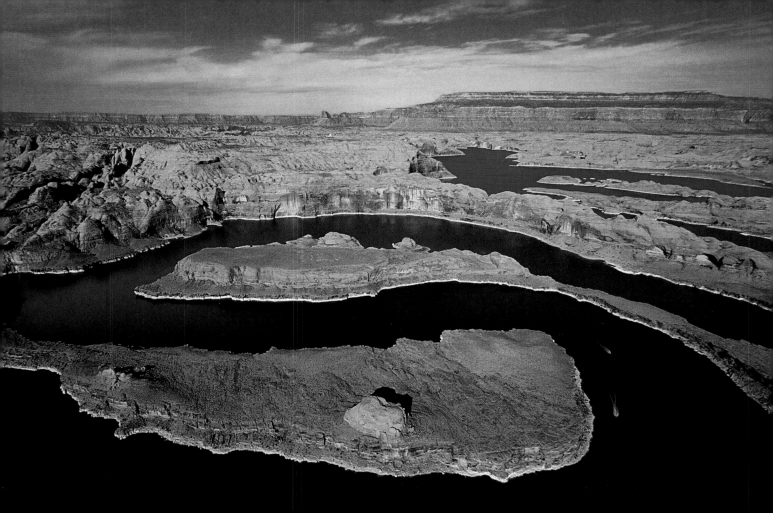

For a long time, they were regarded by mankind as sterile, unhealthy, even dangerous places. Now, however, it is understood that wetlands are home to amazing ecosystems and a biological diversity that is almost beyond compare. Whether they take the form of salt marshes, mangroves, deltas, or peat bogs, these stretches of land shaped and dominated by water occupy some 6% of the planet's continental landmass, an area of almost 2.3 million square miles (6 million square kilometers). They are found in the polar regions (the enormous Hudson Bay, for example) and in the tropics (the Okavango delta lies close to the Kalahari desert).

The density of species in wetland areas is very high. The Pantanal region of Brazil, at 77,000 square miles (200,000 square kilometers) is one of the largest in the world and is comparable to the nearby (and much more famous) Amazon rainforest. Some 3,500 species of plants, 400 fish, 300 mammals, and nearly 500 different reptiles have been identified here, with many as yet unrecorded, and the beauty of the landscape attracts naturalists from all over the world.

These places where land and water meet and mingle are under serious threat from human activity: they are being drained for farming, invaded by intensive aquaculture, redeveloped into industrial or commercial properties, and their area is shrinking at a startling rate. An international agreement known as the Ramsar Convention was signed in 1971 to protect wetlands, but as is often the case, there have been many obstacles to putting it into practice. Nevertheless, the last few years have seen a rise in awareness of the importance of wetlands to mankind, albeit primarily on an economic level. When well managed, these rich ecosystems can fulfill many functions: as well as being a potential source of fish and fodder, they can be developed into lucrative areas for eco-tourism. Wetlands are also able to store water—reducing the risk of drought—and can filter it too, acting as natural depollutants. All good reasons for ensuring their future protection.

WETLANDS ARE ABLE TO STORE WATER—REDUCING THE RISK OF DROUGHT—AND CAN FILTER IT TOO, ACTING AS NATURAL DEPOLLUTANTS

The Ramsar Convention on Wetlands, www.ramsar.org

Cattle in a swamp in the Pantanal region, Mato Grosso do Sul, Brazil (17°36'S-57°30'W) Intensive cattle-ranching was for a long time the only major economic activity in the Pantanal, the world's largest wetland region. Now, agriculture—sugar cane, soya, rice, and maize—is taking up an increasing area of land that has been deforested and drained. Although it became a UNESCO World Heritage Site in 2000, the Pantanal and its biodiversity are still under threat.

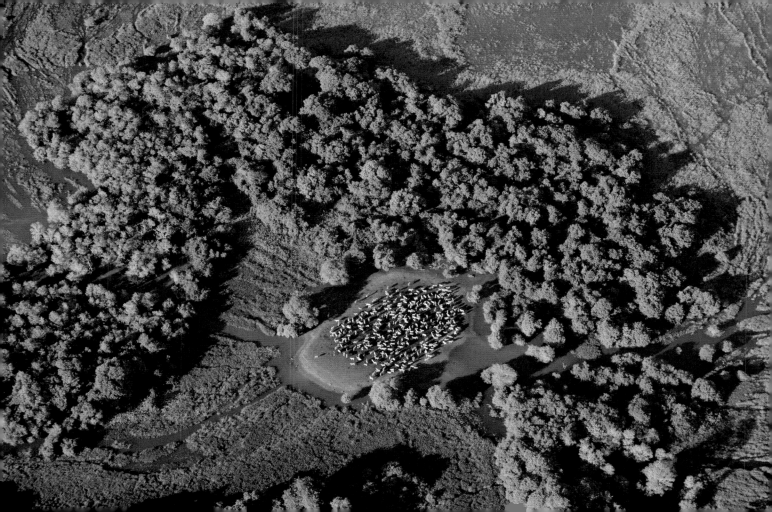

A CORE SET OF GLOBAL

Variables that are worsening

Variables that are improving

Data unavailable

Notes

Energy supply: This index is a measurement of energy intensity and efficiency, with a lower value indicating higher efficiency.

Renewable energy: This supply index is calculated by comparing the current value to 1990. The index for 1990 is 100, so a current index of 125 indicates that renewable energy use has grown by 25%.

Red List Index: This index represents whether the conservation status of a group of species is getting better or worse, where the index for 1988 is 100.

ODP (Ozone Depletion Potential): CFCs have a potential of 1, HCFCs a potential of 0.005–0.2, and methyl bromide a potential of 0.51.

CFCs and HCFCs: Chemicals used in refrigerants and aerosol sprays.

Methyl bromide: A gas used mainly for pest control.

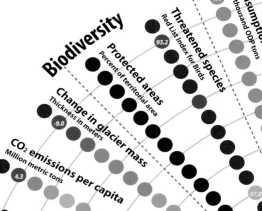

Ozone Depletion

Consumption of CFCs
Ten thousand ODP tons — 3.1

Consumption
Ten thousand ODP tons — 4.4

Biodiversity

Threatened species
Red List Index for Birds — 93.2

Protected areas
Percent of territorial area

Change in glacier mass
Thickness in meters — -9.0

Atmosphere

CO_2 emissions per capita
Million metric tons — 4.3

Total CO_2 emissions
Trillion metric tons — 27.8

Renewable energy
Renewable Energy Supply Index — 125

Energy

Energy supply per $1,000 GDP
Energy Supply Index — 198

97.8 · 78 · 9.8 · -2.2 · 4.2 · 22.3 · 100 · 240

2004 · 2002 · 2000 · 1998 · 1996 · 1994 · 1992 · 1990

Produced by UNEP/DEWA/GRID-Europe, Feb. 2009

ENVIRONMENTAL INDICATORS

1990–2005

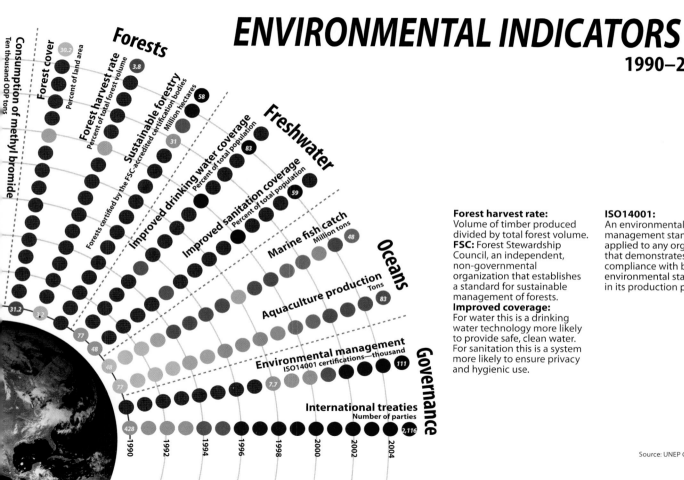

Forests

Consumption of methyl bromide — Ten thousand ODP tons

Forest cover — Percent of land area — 30.2

Forest harvest rate — Percent of total forest volume — 3.8

Sustainable forestry — Forests certified by the FSC-accredited certification bodies — Million hectares — 58 — 31

Freshwater

Improved drinking water coverage — Percent of total population — 83

Improved sanitation coverage — Percent of total population — 59

Oceans

Marine fish catch — Million tons — 48

Aquaculture production — Tons — 83

Governance

Environmental management — ISO14001 certifications—thousand — 111 — 7.7

International treaties — Number of parties — 2,116 — 428

31.2 — 3.2 — 77 — 48 — 48 — 77

1990 — 1992 — 1994 — 1996 — 1998 — 2000 — 2002 — 2004

Forest harvest rate:
Volume of timber produced divided by total forest volume.
FSC: Forest Stewardship Council, an independent, non-governmental organization that establishes a standard for sustainable management of forests.
Improved coverage:
For water this is a drinking water technology more likely to provide safe, clean water. For sanitation this is a system more likely to ensure privacy and hygienic use.

ISO14001:
An environmental management standard applied to any organization that demonstrates compliance with basic environmental standards in its production processes.

Source: UNEP GEO Data Portal

What is a forest? There is no simple answer to this question. But the question is crucially important to an understanding of the current crisis. In order to answer it, we need first to answer two other questions. When does a group of trees make a forest? And how do we define a tree? The FAO provides the answer to both of these questions. According to its definition, a forest is a surface area of over 1.2 acres (0.5 hectares) composed of adjacent trees at least 16 feet (5 meters) tall when fully grown and whose foliage covers at least 10% of the ground surface. This definition gives us a starting point at least, although environmental organizations argue that it fails to distinguish between plantations and primary forests, and between forests that are in good health and those that have suffered significant damage.

Depending on the definitions, the total forested area of the planet's surface varies between 5.7 billion and 15 billion acres. Using the FAO's definition gives us a total of a little less than 10 billion acres, the equivalent of 30% of the Earth's land mass. Between 1990 and 2005, the planet lost 3% of its forest cover, which corresponds to 50,000 acres (20,000 hectares) a day. While forests are dwindling fast in certain countries such as Brazil and Indonesia, in others, especially in Europe, areas of woodland are increasing as a result of people moving away from the countryside, and China is witnessing the same phenomenon thanks to a massive tree-planting program.

BETWEEN 1990 AND 2005, THE PLANET LOST 3% OF ITS FOREST COVER, WHICH CORRESPONDS TO 50,000 ACRES A DAY

The diversity of the situations is equaled only by that of the forests themselves. The first important distinction relates to primary forests, which are free of any evident impact by man and occupy only a third of the planet's total forest cover, and secondary forests, which have been modified by human interference and are often less species-rich as a consequence. Forests are also classified in terms of ecosystems. A third of the world's forest is taiga or boreal forest, associated with cold climates and extending from Alaska to Quebec, and from Scandinavia to Siberia. This type of forest is dominated by conifers (larch, pine, fir, spruce). Moist tropical forests occupy 6% of the planetary land mass and are associated with hot climates; they are the most productive and species-rich of our forests, home to two thirds or three quarters of all terrestrial species.

State of the World's Forests 2007, United Nations Food and Agriculture Organization (FAO), www.fao.org/forestry/home/en

Saint-Hyacinthe forest in Montérégie, Quebec, Canada (45°37′N–75°57′W) Bathed by the waters of the Saint Lawrence River to the north and bounded to the south by the border with the USA, Montérégie has suffered extensive deforestation. Forest now covers only a third of its surface area. This is mixed woodland with a predominance of broad-leaved trees typical of temperate regions (red maple, sugar maple, poplar, birch, ash, oak, lime, hickory) interspersed with boreal conifers.

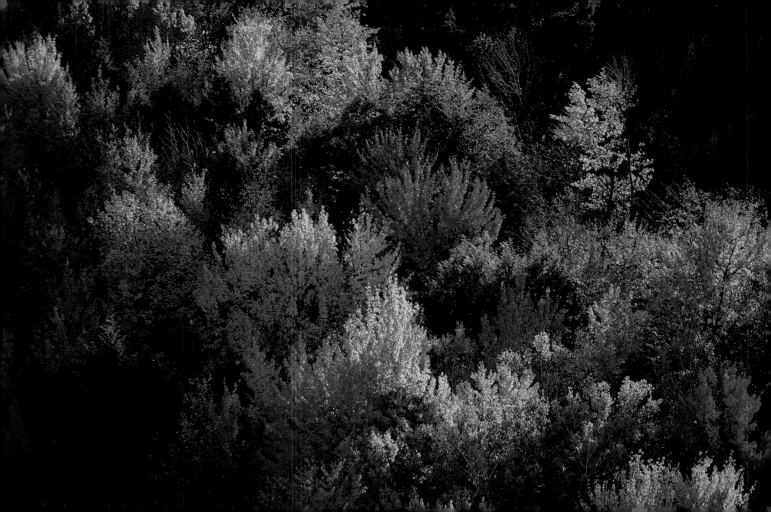

Wood is a renewable material and a renewable source of energy provided that consumption does not exceed the forests' capacities for self-regeneration. It is a resource that has been used since the dawn of mankind, but its use has risen sharply, with human beings now extracting 120 billion cubic feet (3.4 billion cubic meters) of wood from the world's forests each year. A little more than half of all wood harvested serves as fuel, whether for heating or cooking purposes. In Africa, for example, wood and charcoal are by far the most important forms of energy consumed (a usage that corresponds to 89% of the wood harvested). Wood is thus at the global level our principal source of renewable energy. But it is developed countries that use the most wood, in the form of building and furniture materials and paper.

Sustainable forest management is not a new idea. At a time when naval ships were still being built of wood, the state kept a watchful eye on the forests destined to furnish the material for their construction. With our consumption of forest resources constantly increasing, however, we need to develop new approaches to sustainable use. The best example of such an approach is the Forest Stewardship Council (FSC), which was

IT IS DEVELOPED COUNTRIES THAT USE THE MOST WOOD, IN THE FORM OF BUILDING AND FURNITURE MATERIALS AND PAPER

established in 1993 and promotes a system of forest management certification. This means that the consumer who purchases products bearing the FSC label knows that they have come from forests which have been responsibly managed in social, environmental, and economic terms. The chain of accountability stops with the user himself—a system that has proved pretty effective in this case. To date, more than 250 million acres (100 million hectares) of forest in seventy-nine countries have been certified, and annual sales of FSC-certified products amount to some 20 billion dollars. But this is actually less than a tenth of the global market, and a smaller share of the total than the traffic in illegally cut tropical woods, which probably account for half the market.

We could make more use of some of our secondary forests, such as those in western Europe, especially since burning them does not increase the quantity of greenhouse gases in the atmosphere, and the wood could be used to advantage in place of other materials—plastic and concrete, for example.

State of the World's Forests 2007, United Nations Food and Agriculture Organization (FAO), www.fao.org/forestry/home/en

Port-Gentil wood depot, Ogooué-Maritime province, Gabon (0°43'S–8°47'E) These logs will be taken by road and rail, and then via the Ogooué River, to the coast, where they will be loaded onto ships bound for China and Europe. Gabon is the main exporter of gaboon (*Aucoumea klaineana*), a forest species used in the manufacture of plywood.

Forests can be "cultivated" just like crops. The process is known as silviculture. More and more trees are being planted across the globe, and the area covered by such plantations is increasing by 6.9 million acres (2.8 million hectares) a year. These plantations—which are mainly to be found in China, Russia, and the USA—only represent 5% of the planet's total forest cover, but they supply 35% of all wood harvested.

Plantations of fast-growing trees, all of similar age and all belonging to the same species, do not make a forest, however. They do not sustain the same level of biodiversity or ensure the same level of soil protection as a natural forest. Such plantations are also vulnerable to fire and storm damage, and they are less resistant to epidemics. Species poorly adapted to the environment may leach water from the soil—as the eucalyptus does—and others, like the pine, may alter the pH of the soil, making it unduly acidic. In addition, some systems of silviculture use chemical fertilizers, weed killers, and pesticides; others use trees that have been genetically modified.

PLANTATIONS OF FAST-GROWING TREES, ALL OF SIMILAR AGE AND ALL BELONGING TO THE SAME SPECIES, DO NOT MAKE A FOREST

These vast monoculture plantations are generally designed to meet the needs of the highly polluting and energy-hungry paper industry. Our global consumption of paper and cardboard has quadrupled in the space of forty years and now stands at a million metric tons a day—an increase that is clearly problematic. In 2005, each inhabitant of the USA used 655 lb (297 kilograms) of paper. The figure for China was 98 lb (44.5 kilograms), and for India 10 lb (4.5 kilograms), while in Somalia it was only 1 ounce (30 grams). The global average was 120 lb (54.5 kilograms), which makes the discrepancy even more telling.

Not all paper industries use wood as their raw material. In China, the world's second-largest paper manufacturer, 45% of the paper is made from agricultural waste products and 40% from recycled paper. But only a reduction in the consumption of paper (wrapping paper, printed materials, office paper, newspapers, etc.) by the world's major consumers, linked with higher levels of recycling, will enable us to extricate ourselves from the current impasse.

State of the World's Forests 2007, United Nations Food and Agriculture Organization (FAO), www.fao.org/forestry/home/en

Lone tree in a eucalyptus plantation, Indonesia (1°54'S–112°29'E) In 1950, Indonesia's primary forests covered an area of almost 400 million acres (160 million hectares); today, the figure is only 120 million acres (48 million hectares). More and more of the natural forest is being replaced by eucalyptus plantations, and more recently oil palms. Thanks to a law passed in 1992, a 60-mile (100-kilometer) radius of forest around a paper factory may be subjected to clearcutting to make way for fast-growing trees.

Between 1990 and 2005, the planet lost 3% of its total forest cover, a net loss of 18 million acres (7.3 million hectares) of forest a year, or 50,000 acres (20,000 hectares) a day—a loss that is all the more considerable because it takes into account the positive role played by plantations and natural regeneration. In fact, 32 million acres (13 million hectares) are deforested each year, an area equivalent to the surface area of Nicaragua or Greece. Between 2000 and 2005, fifty-seven countries recorded an increase of wooded areas, and eighty-three a decrease. Since 2000 the pace of defor-estation has been accelerating in Southeast Asia, while the biggest reduc-tion of forest was recorded in Africa, where 9% has been lost in fifteen years.

It is difficult to determine the primary cause of global defor-estation: whether non-sustainable exploitation of wood resources or forest clearance for the benefit of animal rearing and agriculture. These two causes can be closely linked. Forests are also cleared in order to make way for mining activities and to build towns, roads, and dams. There are also indirect causes for

deforestation, such as the absence of regulation and controls, the high demand of developed countries for forest or agricultural resources, and also the poverty of developing countries.

The consequences of the disappearance of trees are multiple. Forest soils become fragile and impoverished, especially in a tropical environment, and after a few years they may turn out to be agricultur-ally unproductive. The regeneration of the forest cover is then, at worst, compro-mised or, at best, will only occur over decades. The water cycle is also disturbed. In deforested regions, rivers experience more dramatic fluctuations in their water levels. Populations face catastrophic flooding and also episodes of more marked drought. Often, the absence of trees triggers various phenomena associated with erosion, the most spectacular being landslides. But, without doubt, the most alarming factor is the loss of biodiversity. Tropical forests are home to more than half of all terrestrial species. And it is esti-mated that one in ten plants contains an active substance potentially useful to medicine.

> ## SINCE 2000 THE PACE OF DEFORESTATION HAS BEEN ACCELERATING IN SOUTHEAST ASIA, WHILE THE BIGGEST REDUCTION OF FOREST WAS RECORDED IN AFRICA

State of the World's Forests 2007, United Nations Food and Agriculture Organization (FAO), www.fao.org/forestry/home/er

New plantation of oil palms near Pundu, Borneo, Indonesia (1°59′S–113°06′E) Between 2000 and 2005, Indonesia lost 4.7 million acres (1.9 million hectares) of forest a year. Once the ground has been cleared, it is terraced and covered with young oil palms (we can see their green shoots in the photograph), which start producing fruit after three years. If the current rate of deforestation continues, Borneo's old forests will all have disappeared fifteen years from now.

Deforestation and poverty are part of a vicious circle, each feeding into the other. In Haiti, for example, the destruction of the forests has put a strain on the country's water supplies and agricultural productivity, aggravating the problems of malnutrition and extreme poverty as well as those relating to health and infant mortality.

But we need to beware of this kind of simplification. The link between poverty and deforestation is an ambiguous one. Across the globe, there are some 800 million people living within or on the edge of an area of tropical forest which supplies part of their food and energy needs, and is also therefore a source of income. In very many countries, the poor may be cutting down trees, but the most serious damage is done by the extractive industries and the major companies associated with forestry or agriculture, acting in response to demands from wealthy countries.

This is the case in the Brazilian rainforest, where 80% of the deforested areas are in parcels of 50 acres (20 hectares) or more —deforestation on a scale well beyond the means of poor farming families. Brazilian society is characterized by extreme

THERE ARE SOME 800 MILLION PEOPLE LIVING WITHIN OR ON THE EDGE OF AN AREA OF TROPICAL FOREST WHICH SUPPLIES PART OF THEIR FOOD AND ENERGY NEEDS

inequalities: on the one hand, there are a handful of wealthy land owners, farming and rearing livestock with an eye to the export market; on the other, there are the millions of small family-run farms and landless workers. And these inequalities are mirrored in the process of deforestation.

In Indonesia, the government has granted a number of huge concessions: while the big companies and their employees see their revenues increasing, part of the local population has no access at all to the forest and its resources and is sinking further into poverty. To many people, deforestation seems inevitable, and the link between industrial advances in Europe and the destruction of all its primary forests offers an unfortunate precedent.

Development policies can play a part in the phenomenon of deforestation. Whereas projects for constructing roads and dams have frequently contributed to the destruction of forests, policies aimed at reducing levels of poverty, which prioritize health, education, and the environment, could slow down the process.

State of the World's Forests 2007, United Nations Food and Agriculture Organization (FAO), www.fao.org/forestry/home/en

Cargo of charcoal, Haiti (18°35′N–72°00′W) Haiti's primary forests have been extensively felled for charcoal and to make way for agricultural land, and less than 3% remains. Half the arable lands have been lost through soil erosion. Deforestation has reduced the water vapor in the atmosphere above Haiti, and in many places annual precipitation is down to 40% of what it was, thus reducing the flow of rivers and opportunities for irrigation.

Healthy forests are indispensable to a healthy planet. Forests regulate the water cycle and protect the soil. By absorbing and trapping large quantities of carbon dioxide and recycling the oxygen in the atmosphere, they contribute to climate balance. They offer a habitat for flora and fauna and supply wood, food, and medicinal products for human use. Attempts have been made to evaluate these "environmental services" in economic terms, not in order to exploit or profit from them, but to ensure that our economic activities do not destroy these natural and free infrastructures. According to Pavan Sukhdev, an Indian economist and principal author of a study on the economics of natural ecosystems and biodiversity, each year the destruction of forest ecosystems alone and the loss of their services to humanity would cost 6% of global Gross National Product (GNP), which is equivalent to 2 trillion euros or 2 trillion US dollars.

All these environmental services are compelling reasons to protect our forests, but to whom should we entrust the task? This question is inextricably linked with the question of ownership.

THE TOTAL AREA OF FOREST MANAGED BY INDIGENOUS COMMUNITIES DOUBLED BETWEEN 1985 AND 2000

Across the globe, 84% of all forests are the property of individual states or public organizations, and 16% are in private ownership. Governments shoulder a huge responsibility in the matter, therefore. But the indigenous peoples of the Amazon rainforest and the forests of the Congo Basin and South and Southeast Asia—people who live off the forests, and in close association with them, and who can play a vital role in safeguarding them—have had their right to own, or even use, the land repeatedly ignored.

The situation is changing gradually and more and more indigenous communities are gaining the right to their lands, often with the help of non-governmental organizations. The population of the Amazon rainforest has increased from 5 million to 33 million inhabitants in forty years. And yet, despite demographic and economic pressures, the total area of forest managed by indigenous communities—which doubled between 1985 and 2000—now represents 22% of the forests in developing countries.

State of the World's Forests 2007, United Nations Food and Agriculture Organization (FAO), www.fao.org/forestry/home/en

Djidji Falls, Ivindo National Park, Ogooué-Ivindo province, Gabon (0°01'N–12°27'E) Gabon is one of the most heavily forested countries in the world: 85% of its surface area is forest. In 2002, the Gabonese government decided to create thirteen national parks, occupying 11% of its surface area. In addition to conserving biodiversity, the purpose of these parks is to promote the development of nature tourism—and, thereby, increase revenue for the population.

The Earth's forests help to maintain our atmosphere. Firstly, because they recycle much of the oxygen that we breathe (the phytoplankton in the oceans does the same) as a result of photo-synthesis. Secondly, because they absorb large quantities of water (several hundred liters per day in the case of a tropical tree), which they release into the atmos-phere through a process known as transpiration, and in so doing contribute to the humidity in the air and to precipita-tion. And, finally, because they trap significant quantities of CO_2, which is transformed into organic matter such as starch in plants and lignin in trees by means of photosynthesis.

What is the scale of this phenome-non? Forest ecosystems store more than half the carbon accumulated by terrestrial ecosystems; the figure for 2005 was 638 billion tons, according to the FAO, which is more than all the carbon in the atmosphere. But this stockpile is declining. This is logical since the surface area of our forests is dwindling as a result of deforestation—itself a potent source of CO_2 emissions.

FOREST ECOSYSTEMS STORE MORE THAN HALF THE CARBON ACCUMULATED BY TERRESTRIAL ECOSYSTEMS

Each year, the world's forests continue to stockpile more carbon than they release. The surplus is still in the region of 0.7 billion tons a year. But the role they play as a carbon sink is increasingly endangered. So, what are we to do? The logical solu-tion is to leave this carbon store well alone and to suspend the destruction of primary forests across the globe. The international community is currently discussing the possibility of introducing a compensation mechanism for countries that avoid destroying their forests and maintain them in good condi-tion. Such a system would be difficult to put in place, but the World Bank, with the support of the United Nations, has already set up a fund that prefigures a system for financing avoidance of deforestation. The aim is also to show the communities that live in or near forested areas that the use of renewable sources such as fruit, nuts, and essential oils can be financially more rewarding than cutting down trees or converting forests into fields and grazing lands.

State of the World's Forests 2007, United Nations Food and Agriculture Organization (FAO), www.fao.org/forestry/home/en

The Orinoco near La Esmeralda, Amazonas, Venezuela (3°10'N–65°33'W) The absence of proper means of communication has helped to preserve the Amazon rainforest from excessive human interference. Lying near the Equator, the forest is a product of heavy rainfall—but also a source of it, since rain clouds form from water vapor tran-spired by the vegetation. If all the moist tropical forest of the Amazon basin were to disappear, rainfall in the region would be halved.

We have tended in the past to regard mangrove swamps as being of little use to humans. They occupy muddy coastlines in tropical regions, tend to be infested with mosquitoes, and are easily flooded by the sea or inland waters. But the mangrove swamp is a transitional ecosystem, as productive as it is biologically rich. It is composed of one or several species of mangrove, a tree that has aerial stilt-like roots which support the main trunk like flying buttresses, and is home to a large number of fish, mollusks, and crustaceans, which begin life in these mangrove nurseries before rejoining the open sea. By trapping the sediments carried by the rivers and the tides, mangrove swamps also protect tropical coastlines from erosion and the assaults of storms, cyclones, and tsunamis, while ensuring that the waters remain clean enough to sustain their coral reefs.

Humid zones and mangrove swamps are the two environments that suffered the worst damage during the course of the 20th century. Between 1980 and 2005, according to the FAO, 20% of mangrove swamps were destroyed, and they now occupy a surface area of no more than 37.6 million acres (15.2 million hectares). Traditionally exploited for wood, these forests have been subjected more recently to vast clearance schemes linked to the development of shrimp farming in Southeast Asia and Latin America. Extension of agricultural land, harbor installations and seaside developments, and the general urbanization of coastlines are also causes of decline.

BETWEEN 1980 AND 2005, ACCORDING TO THE FAO, 20% OF MANGROVE SWAMPS WERE DESTROYED

Experts have succeeded in establishing figures relating to the economic and social value of mangrove swamps. A hectare of mangrove swamp in the Gulf of California, for example, would generate some 37,500 US dollars a year, principally in the form of fish and crabs, commercial species whose life cycle is linked to the presence of the mangroves. Mangrove swamps would also help to limit the more dramatic effects of climate change and rising sea levels, while acting as effective carbon sinks.

Awareness of the environmental and also economic and social value of these forests has undoubtedly helped to slow the pace of destruction in a number of countries. In Bangladesh, the surface area of mangrove swamps is even increasing. But this is still the exception.

State of the World's Forests 2007, United Nations Food and Agriculture Organization (FAO), www.fao.org/forestry/home/en

Koh Pannyi, Phang Nga Bay, Thailand (8°20′N–98°30′E) Thailand is the world's number one producer of farmed shrimp, and the area occupied by its mangrove swamps has shrunk from 690,000 acres (280,000 hectares) in 1980 to its current level of 600,000 acres (244,000 hectares). When the tsunami struck on December 26, 2004, the low-lying shores of the Andaman Sea whose mangrove swamps were still intact suffered less damage than those areas that had been robbed of their protective belt.

FORESTS
SUSTAINABLE MANAGEMENT

Which countries have the greatest area of sustainably managed forest?

Countries with the highest % of FSC-certified forests (2005)

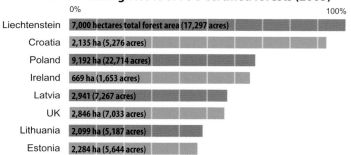

	0%	100%
Liechtenstein	7,000 hectares total forest area (17,297 acres)	
Croatia	2,135 ha (5,276 acres)	
Poland	9,192 ha (22,714 acres)	
Ireland	669 ha (1,653 acres)	
Latvia	2,941 (7,267 acres)	
UK	2,846 ha (7,033 acres)	
Lithuania	2,099 ha (5,187 acres)	
Estonia	2,284 ha (5,644 acres)	

Countries with the most forest area (2005)

	Million hectares of forest	% FSC accredited
Russian Federation	809	0.6
Brazil	478	0.7
Canada	310	2.5
USA	303	2.5
China	197	0.2
Australia	164	0.3

Source: UNEP GEO Data Portal, compiled from FSC

What are some of the threats to forests?

Legal and illegal logging • Conflicts • Natural hazards • Climate change • Pollution • Conversion to agricultural land • Urban development • Fire • Diseases and insects

How are forests managed sustainably?

Some basic principles of FSC sustainable forestry certification:

➡ Comply with all international laws.

➡ Respect the rights of indigenous peoples.

➡ Respect workers' rights and support local communities.

➡ Share benefits from use of the forest.

➡ Reduce the environmental impact of logging, and maintain the ecological functions of the forest.

➡ Regularly assess the condition of the forest and impacts of environmental and social management plans.

Wood cannot be a renewable resource unless forests are managed sustainably.

Look for an eco-label on products to make sure you are purchasing wood and paper products from sustainably managed forests. The Forest Stewardship Council is a major accredited certification body.

FSC

Produced by UNEP/DEWA/GRID-Europe, Feb. 2009

Why preserve forests and plant trees?

Carbon storage and oxygen—CO_2 cycling

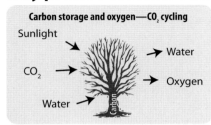

Sunlight

CO_2

Water

Carbon

Water

Oxygen

Prevent desertification

This prevents the loss of fertile topsoil and helps retain moisture.

Tree roots hold soil together and prevent erosion.

Preserve habitats and ensure ecosystem services

Many animal species and human communities depend on forests for survival.

Other services: Food · Heating · Air purification · Recreation · Spirituality · Protection of watersheds · Conservation of gene-pools · Plant pollination

How has global forest cover changed over time?

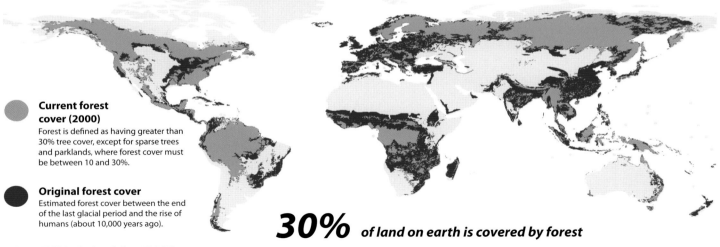

Current forest cover (2000)
Forest is defined as having greater than 30% tree cover, except for sparse trees and parklands, where forest cover must be between 10 and 30%.

Original forest cover
Estimated forest cover between the end of the last glacial period and the rise of humans (about 10,000 years ago).

30% of land on earth is covered by forest

Source: UNEP GEO Data Portal, compiled from UNEP–WCMC

Sooner or later, societies disappear and are replaced by new ones. As our own society enters a critical phase, what lessons can be learned from those that preceded us? One example that has been extensively studied is Easter Island in the Pacific Ocean. The island was once home to a flourishing civilization, which reached its peak in around 1500, but it subsequently experienced a rapid decline, losing four fifths of its population in just one century. According to the American expert Jared Diamond, the explanation lies principally in the fact that the people deforested their entire land. Without trees, they were no longer able to build fishing boats, and crucially the soil was eroded. As the situation worsened, the people began fighting among themselves, and developed bizarre religious practices. In an effort to erect increasingly gigantic statues, they cut down more and more trees, accelerating their demise.

Diamond also studied a number of other civilizations that vanished largely as a result of environmental factors, such as the Maya and Babylonians, who exhausted their land, and the Greenland Vikings, who could not adapt to the cooler climate. While these societies did not vanish because of environmental damage alone, it certainly weakened their economic and social structures and created vicious cycles that ultimately proved fatal. The same pattern could easily be applied to modern society.

In Diamond's analysis, the factors leading to a society's collapse seem to be quite clearly set out every time. But for political, religious, or social reasons, the society is incapable of reacting and taking adequate measures to ensure its survival. What would the Easter Islander who cut down the last tree have been thinking? Another expert in the history of civilizations, the British historian Arnold Toynbee, wrote that "civilizations die from suicide, not by murder"—in other words, from their inability to resolve their internal crises.

Today most people agree that we are facing an environmental catastrophe. We need to change the course in which our society is heading, and remove the obstacles to that change. It is too late to bury our heads in the sand. It is also too late to be pessimistic.

ARNOLD TOYNBEE WROTE THAT "CIVILIZATIONS DIE FROM SUICIDE, NOT BY MURDER"

Jared Diamond, *Collapse: How Societies Choose to Fail or Succeed*, London and New York, 2005

Volcano of Rano Kau, Easter Island, Chile (27°11′S–109°26′W) It is hard to believe that this island of 66 square miles (171 square kilometers) located in the middle of the Pacific was once covered by a forest of giant palms. Colonized by Polynesians some time between the 5th and 6th centuries, the island was progressively deforested. Once set in motion, erosion stripped the surface layers of the soil creating ravines several meters in depth and revealing the volcanic substratum.

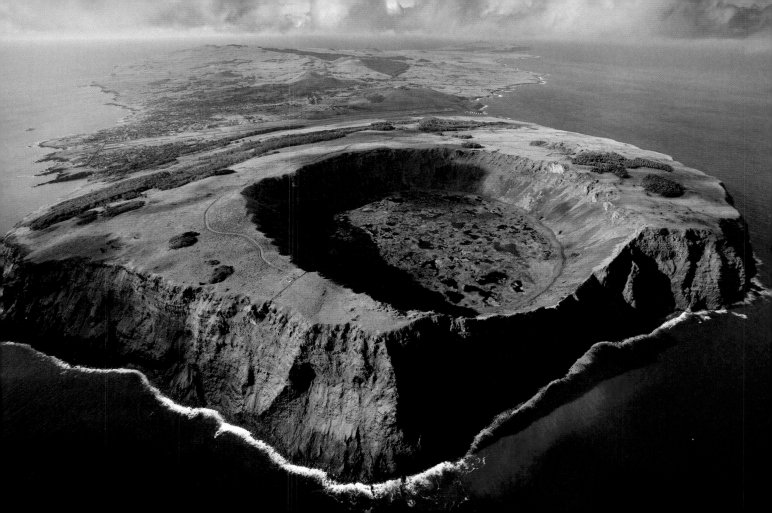

The world is divided: by religion, by the gap between rich and poor, by nationalism and prejudice, and by humanity's desire for land and natural resources belonging to others... Sometimes these conflicts lead to violence, but they don't always end in war. Following the fall of the Berlin Wall in 1989, the term "globalization" has increasingly been used to describe the interdependent relationships between nations, economic activities, political systems, and individuals on a worldwide scale. However, while international exchanges are developing in all directions—goods, labor, knowledge-sharing, and culture—not everyone is benefiting from globalization.

Nonetheless, the idea that the future of humanity and our environment is a collective global concern is gaining momentum. And this is supported by the number of important international conventions on the environment which have been held in recent times, including the Antarctic Treaty of 1959, the Ramsar Convention on

THE IDEA THAT THE FUTURE OF HUMANITY AND OUR ENVIRONMENT IS A COLLECTIVE GLOBAL CONCERN IS GAINING MOMENTUM

Wetlands of 1971 (for the protection of migratory birds), the London Convention on the Prevention of Marine Pollution of 1972, and the Washington Convention on International Trade in Endangered Species of Wild Fauna and Flora of 1973.

One of the most recent and influential was the United Nations Conference on Environment and Development of 1992, which culminated in the Kyoto Protocol in 1997. Even though the Earth only has one atmosphere, not everyone agrees on the urgent need to reduce greenhouse gas emissions. Often the compromises required are at the cost of efficiency. The commitments made at Kyoto, which are rarely enforceable, are not being met: global emissions of CO_2, the main greenhouse gas, have risen by 16% since 1990 and continue to increase. The first set of targets for the Kyoto Protocol will expire in 2012 and the international negotiations to replace them have already begun. It is a painstaking yet essential process.

United Nations Environment Program, www.unep.org

Israeli West Bank barrier, Israel and Palestinian Territories (31°50'N-35°14'E) In 2002 Israel decided to build a wall along the "Green Line" which used to demarcate the border between Israel and its neighbors before the Six-Day War of 1967. Although the wall has become part of the landscape and daily lives of the West Bank inhabitants, it has failed to resolve security issues, and the forty-year-old battle over the territories continues to rage on. In 2004 the International Court of Justice in the Hague declared the wall to be illegal and called for it to be knocked down.

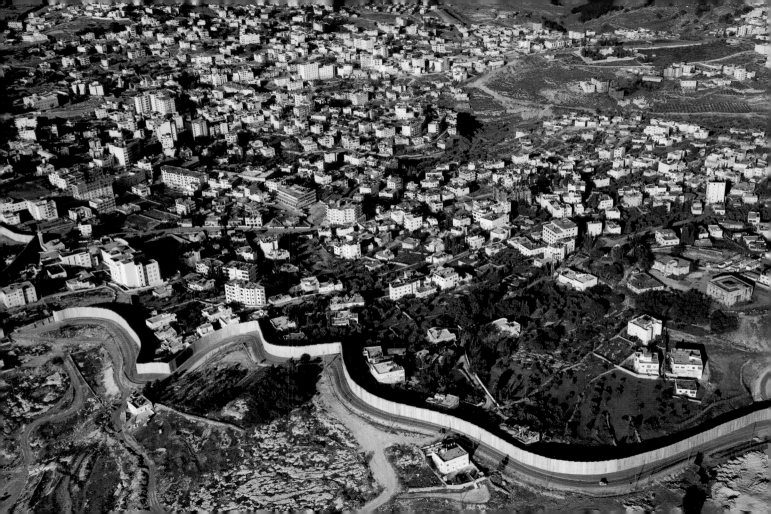

There are almost 200 million global migrants, representing roughly 3% of the world's population. The figure was only 75 million forty years ago. Their personal backgrounds and motivations vary, but the majority of migrants are looking for a better quality of life. They hope to escape poverty, find education, or live in different types of societies. However harsh their living conditions may be, they are still better off than those of the world's 33 million displaced persons or refugees, who have been forced to leave their homes or countries.

Humans have migrated throughout history, but today it is occurring on unprecedented levels, and it is on the increase. Climate change will cause flooding in certain areas and droughts in others. Living conditions everywhere will change, and some studies have predicted that this will create 250 million refugees over the coming decades. Economic instability in less developed countries and the rapid urbanization of the planet is set to displace hundreds of millions of people.

THE WEST HAS A ROLE TO PLAY THROUGH INTERNATIONAL COOPERATION AND AID POLICIES, FOR EXAMPLE

Immigration can play an important demographic role for countries whose history is linked to the phenomenon, such as the USA, or for nations whose birth rate is in decline. But it can also upset the social equilibrium: in times of social and political tension, it can give rise to xenophobia. Emigration can also dismantle a country's social structure by depriving it of its most skilled workers, of entrepreneurs, or simply of an entire generation of families, as in the case of the North Africans who sought work in Europe in the 1960s, or the people of the Philippines who are leaving to find jobs in other areas of South Asia.

The obvious solution is for countries to share the burden of migration. The West has a role to play through international cooperation and aid policies, for example. But faced with the inevitable rise of human migration, we must also remember that it encourages diversity, openness, and cultural richness, and helps to create a more unified world.

The UN Refugee Agency, www.unhcr.org

Sudanese refugee camps at Goz Amer near the Sudanese border, Chad (12°00'N–21°23'E) Sudan, an African giant with no fewer than nine borders, has experienced only eleven years of peace since it gained its independence in 1956. The origins of the civil war lie in the conflict between the dominant north, which is Arab and Muslim, and the black African south, with a Christian and animist majority. Since 2003 the war has intensified and changed in the region of Darfur, pitting Muslims of Arab origin against Muslims of black origin.

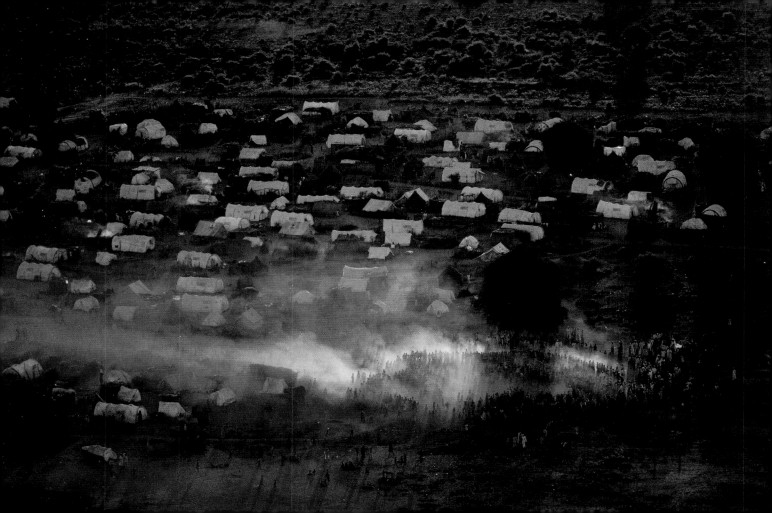

Consumption is also a political and social act. Sometimes public awareness is all that is needed to create change. The boycott of British textiles spearheaded by Gandhi in the 1920s, that of bus companies practicing racial segregation in the USA in 1955, and more recently the Greenpeace protest campaign against Shell's plans to sink a North Sea oil platform are proof of the power consumers wield. Over the last few decades, a similar approach has been used by the fairtrade movement.

Fairtrade is a trading partnership that seeks greater equity in international trade. Its umbrella organization, Fairtrade Labelling Organizations International (FLO), unites a group of labeling initiatives, the best-known of which is Max Havelaar. They operate by paying producers fixed minimum prices which usually exceed the market equivalent, permitting workers a decent standard of living without being subject to market fluctuations. This trading system also guarantees decent working conditions: forced labor and child exploitation are banned. For a company to receive Fairtrade certification it must meet International Labour Organization standards and report transparently on its workforce, manufacturing processes, prices, and profit margins.

FAIRTRADE IS RAISING CONSUMER AWARENESS OF THE INJUSTICE OF THE CURRENT TRADE SYSTEM AND ENCOURAGING COMPANIES TO IMPROVE THEIR ETHICAL STANDARDS

In spite of this, a substantial portion of the cost mark-up is not passed on to the producers themselves; and the higher price of fairtrade products places them in a niche market. One could go so far as to say that fairtrade is not fair in the sense that the social welfare systems and salaries of the producers are substantially inferior to those of the consumers. Furthermore, fairtrade does not always respect the environment.

Fairtrade is therefore by no means a perfect way of bringing about change. Today it represents only a tiny fraction of world trade (less than 1%). But although it has limitations, it is raising consumer awareness of the injustice of the current trade system and encouraging companies to improve their ethical standards. You can vote with your credit card just as effectively as in the ballot box.

Fairtrade Labelling Organizations International, www.fairtrade.net

Tea plantation, Kericho region, Kenya (0°20'S–35°15'E) Global production of tea reached 3.6 million metric tons in 2006, a world record. Kenya produced 328,000 tons, which is less than China (1.05 million tons) and India (945,000 tons); however, unlike these two countries, Kenya consumes only 5% of the tea it produces and exports the rest.

Almost half of the human population is under the age of twenty-five, the largest generation the world has ever known. It is also the best educated: the figure for primary school attendance has now reached 88%. Despite this, 73 million children do not have a basic education and 158 million children under fifteen have to work, often in the worst conditions. This generation also has the longest life expectancy, 67 on average, although that figure varies widely from country to country. However, the falling birth rate also means that these young people will grow in an ageing society.

The demographic group aged between fifteen and twenty-four is 1.2 billion strong, and is already shouldering its share of the burden: 200 million live on less than 1 US dollar per day, 130 million are illiterate, 88 million are unemployed, and 10 million are HIV positive. How will they face up to adulthood in a changing world? What does the future hold in store for them on a planet whose limited resources have been all but exhausted by humanity?

ALMOST HALF OF THE HUMAN POPULATION IS UNDER THE AGE OF TWENTY-FIVE... IT IS ALSO THE BEST EDUCATED: THE FIGURE FOR PRIMARY SCHOOL ATTENDANCE HAS NOW REACHED 88%

We are only just beginning to address these questions. Although the younger generation may aspire to bring about radical change, this is mitigated by their need to fit into an existing social structure. Even in democratic societies, young people must have reached the legal voting age to express their opinions on civil issues. This means that in countries with a particularly young population, the electorate may be at odds with a substantial portion of the people.

The younger generations are often disaffected and their future appears uncertain. At the 1992 Earth Summit in Rio de Janeiro, a 12-year-old adolescent, Severn Suzuki, spoke for the first time: "I'm only a child yet I know we are all in this together and should act as one single world towards one single goal. ... Parents should be able to comfort their children by saying 'Everything's going to be all right', 'It's not the end of the world', and 'We're doing the best we can'. But I don't think you can say that to us anymore. Are we even on your list of priorities?"

The United Nations Children's Fund (UNICEF), www.unicef.org

Children playing in a school yard in Hlatikulu, Shiselweni region, Swaziland (26°58'S–31°19'E) Official statistics report that 80% of children in Swaziland attend school, but many children are forced to interrupt their education either temporarily or permanently due to poverty. At least 70% of the country's 1.1 million inhabitants live below the poverty line and almost 35% of adults—the highest number on Earth—are HIV positive. Poor school attendance seems to be rising with the pandemic.

In the course of the 20th century, the women's movement made a number of extraordinary advances: women won the right to vote, gained access to birth control and abortion, rose to high-ranking jobs and even to top political positions. However, only a small minority of women enjoyed these new benefits. And while the laws may have changed, common practice has not.

In the new millennium, women's rights vary greatly depending on their country, social rank, and religion. In certain places women are practically invisible in public, or are obliged to wear veils. Eighty-two million young women are married before they reach the age of eighteen. Many girls are still not educated, and are consigned instead to household chores or even collecting water. Female circumcision is still unacceptably common.

The infanticide of baby girls epitomizes the lack of status women have in many cultures. In India and China, female fetuses are aborted or the newborns left to die or even killed, because the birth of a girl simply represents another mouth to feed and, above all, a dowry to find.

Female illiteracy is at 600 million, as opposed to 320 million among men. Women who do have a basic education can achieve a greater level of autonomy enabling them to question the decisions imposed on them by their family or social structure. There is a clear correlation between increasing school attendance for girls and lowering birth rates.

For millennia, our political, social, and economic history has largely been written by men. How might it have been different had both sexes worked together with complete equality? Sociological research has shown that men and women solve problems in different but complementary ways, and that sexual equality benefits both parts of this alliance. The environmental crisis calls for a change in the way society has historically tackled issues, including the full recognition of the role women play in the decision-making process.

SOCIOLOGICAL RESEARCH HAS SHOWN THAT MEN AND WOMEN SOLVE PROBLEMS IN DIFFERENT BUT COMPLEMENTARY WAYS

Millennium goals
www.un.org/millenniumgoals

Cotton harvest near Banfora, Burkina Faso (10°48′N-3°56′W) Burkina Faso has the largest cotton industry in Africa, employing three million people of which two million are producers. The sector accounts for 25% of the country's GDP and 60% of exports, which make it vulnerable to fluctuations in the global markets. After having rejected GM cotton for years, the government officially authorized its growth in 2008, arguing that this would guarantee regular production.

Will we ever be able to eradicate war altogether? In modern times, wars continue to rage: since the end of the Second World War there have been over 130 more wars or violent conflicts across 80 different countries. If anything has changed at all, it is in the technology of war which is becoming more advanced.

During the 20th century the First World War claimed tens of millions of lives. The death toll for the Second World War rose to 60 million. The power struggles culminated in the nuclear arms race: today more than 10,000 nuclear warheads are on standby to annihilate the entire planet. Paradoxically, it is the 639 small arms currently in circulation that are causing the most fatalities. Civilians have become the principal victims of conflict, both during and after combat. Civilian losses during the First World War represented roughly 10% of total deaths, but this figure rose steadily over the course of the century to reach 90% in the Cambodian, Rwandan, and Lebanese conflicts.

Even away from the battlefield, war is causing damage. Military spending is constantly on the increase, reaching 1,339 billion US dollars in 2007, an average of $200 per person per year. Not only do wars utilize and waste enormous natural and economic resources, but they undermine the trust required to foster cooperation and solidarity among countries.

Following the Second World War and the disbanding of the League of Nations (the first international peace-keeping organization), the United Nations was set up to safeguard world security. Its jurisdiction is limited. Some of its resolutions have led to military intervention, for example in Korea in 1950 and in Iraq in 1991. But the UN has also been criticized for taking sides, and many of its actions have not been effective, such as those taken with regard to the Israeli-Palestinian conflict which has been raging for over half a century. However, opponents of the organization have not come up with a better alternative, and in spite of its shortcomings, the UN continues to assist victims and act as a peace-keeping force in many of the world's warring regions.

Stockholm International Peace Research Institute, www.sipri.org

SINCE THE END OF THE SECOND WORLD WAR THERE HAVE BEEN OVER 130 MORE WARS OR VIOLENT CONFLICTS ACROSS 80 DIFFERENT COUNTRIES

B-52s at Davis-Monthan air force base near Tucson, Arizona, USA (32°10′N–110°52′W) Several hundred American B-52 Stratofortress bombers are being kept for spare parts at the Davis-Monthan air force base in the heart of the Arizona desert. Used intensively as a conventional bomber during the Vietnam and Gulf Wars, the B-52 was originally designed (in 1952) to carry nuclear weapons.

The wave of support that came in the wake of the Asian Tsunami of December 2004 revealed, once again, humans' capacity for generosity. A total of 7 billion US dollars was raised, financing the largest humanitarian operation in history. Hundreds of organizations distributed aid money which had come from all four corners of the globe.

The first international relief agency, the International Committee of the Red Cross (ICRC), was founded in 1863. The Red Cross provides assistance to victims and prisoners of war, and is underpinned by a statute drawn up by the Geneva Convention. The majority of organizations are non-governmental (NGO) and are not just active in emergency situations: they operate in a variety of fields including the environment, reconstruction projects, education, development aid, and human rights. According to the United Nations, there are 6,000 international NGOs and five million NGOs worldwide, some of which receive extensive international support: Amnesty International counts 2.2 million members, while the World Wildlife Fund (WWF) has 4.7 million. There is such a wide range of NGOs nowadays that there is a cause to suit every interest.

NGOs are increasingly large, numerous, and well-organized, and are playing a growing role in politics. They also participate in the drawing up of international legal conventions: as in the case of the Red Cross and the Geneva Conventions of 1949 and 1972, Amnesty International and the Convention Against Torture, and Survival International who work for the rights of tribal peoples.

Working alongside nations, sometimes in areas that have been overlooked for lack of money or other resources, NGOs propose alternative organizational models and advocate other values over power and profit. By doing this they offer everyone the opportunity to help effect social change and make an impact on their town, region, or the world, something that can give them a sense of pride and satisfaction.

ACCORDING TO THE UNITED NATIONS, THERE ARE 6,000 INTERNATIONAL NGOS AND FIVE MILLION NGOS WORLDWIDE

Union of International Associations (UIA), www.uia.be

Aviation Without Borders mission, Senegal (12°29'N–16°33'W) The isolated region of Casamance in southwest Senegal has few medical facilities. The area is patrolled by ambulance planes operated by the NGO Aviation Without Borders, which helps evacuate patients to the local hospital in Tambacounda, or in more serious cases to Dakar.

Sometimes, one person's courage can make all the difference and a few seconds can save a life. A quick reaction or a carefully chosen word can deflect a crisis. When a group of brave individuals who share the same goals and ideals form a movement, they can change the world.

Nelson Mandela did not bring down apartheid single-handedly. But he set an example to several generations of political activists. Incarcerated for twenty-seven years, eighteen of them on Robben Island, he was able to give hope to those who were fighting for their rights, who were being tortured, and who were becoming disheartened by the difficulties they faced. The victory against apartheid is one of the finest examples of how people can join forces to overturn an unjust system.

After the fall of apartheid, Nelson Mandela and Bishop Desmond Tutu set up a new legal system based on "Truth and Reconciliation," which tried to find out the truth for the victims and their families and to identify those who were guilty. The object was not to forgive—a personal affair which does not concern the state—but to enable people to start all over again and to build a new society. Bloody reprisals between black and white were largely avoided. Not giving in to hatred was an important lesson in courage.

Today, as we face a global environmental crisis, we all need courage more than ever: the courage to think differently, to reject certain things in favor of fewer material possessions, the courage to come together with others, the courage to admit when we are wrong, the courage to reject injustice around the world, and the courage to stand up against ideologies which put us on a collision course with disaster.

The coming years will be crucial for humanity. We have reached a pivotal point at which society can veer in one way or another, and we can all influence the future outcome. This is both disturbing and exciting. Those who have already seized fate in their own hands are aware of the difficulties, but this makes us stronger. In this battle, which must be won without hatred or rancor, everyone has a role to play.

> # WHEN A GROUP OF BRAVE INDIVIDUALS WHO SHARE THE SAME GOALS AND IDEALS FORM A MOVEMENT, THEY CAN CHANGE THE WORLD

Nobel Prize, http://nobelprize.org

Portrait of Nelson Mandela on a cooling tower at Orlando Power Station, Soweto, South Africa (26°15′S–27°56′E) Nelson Mandela joined the African National Congress (ANC) in 1942 at the age of twenty-four, and soon played a crucial role in the party. He was arrested for the first time in 1956, and again in 1962, and was subsequently sentenced to life imprisonment. He was released in 1990 and in 1993 was awarded the Nobel Peace Prize. In 1994 Mandela became the first black president of the Republic of South Africa to be elected after the fall of apartheid.

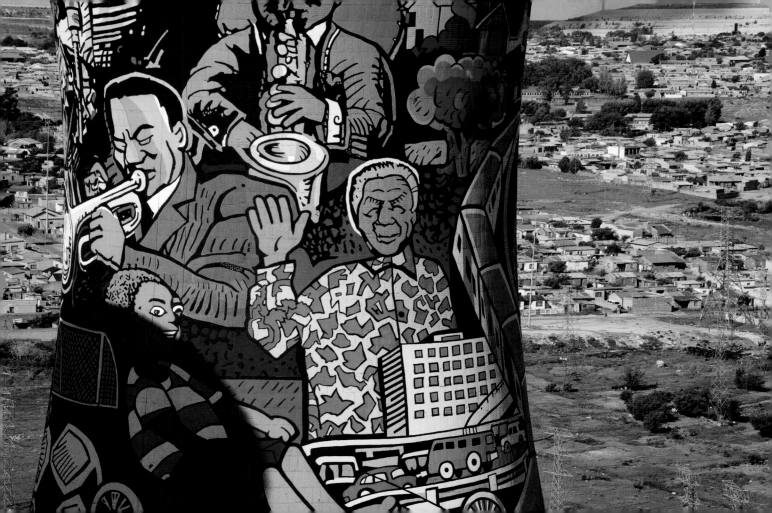

GLOBAL ENVIRONMENTAL TREATIES
ENVIRONMENTAL GOVERNANCE

Climate Change

Montreal Protocol (1987)
Aims to stop ozone depletion by regulating emissions of pollutants such as CFCs.

UN Framework Convention on Climate Change (UNFCCC) (1992)
Encourages all countries to reduce GHG emissions to combat global warming.

Kyoto Protocol (1997)
Requires industrialized countries to reduce GHG emissions.

Ecosystems Management

Ramsar Convention on Wetlands (1971)
Promotes the conservation and wise use of wetlands and their resources.

Convention on International Trade in Endangered Species of Wild Fauna and Flora (CITES) (1973)
Regulates trade in endangered plants and animals.

Bonn Convention on Conservation of Migratory Species of Wild Animals (1979)
Preserves migratory species and their habitats.

UN Convention on Biological Diversity (CBD) (1992)
Preserves biodiversity by promoting conservation methods.

UN Convention to Combat Desertification (UNCCD) (1994)
Slows the process of desertification by making changes at the community level.

World Heritage Convention (WHC) (1972)
Identifies and protects sites of great natural and cultural value.

Hazardous Substances

Basel Convention (1989)
Regulates the movement and disposal of hazardous wastes, such as e-waste.

Rotterdam Convention (1998)
Regulates the import and export of hazardous chemicals, such as pesticides.

Stockholm Convention on Persistent Organic Pollutants (2001)
Reduces and eliminates the release of dangerous chemical pollutants that remain in the environment for long periods of time.

How is an international treaty formed?

1 Research leads to identification of a major or emerging world problem.

2 Member states or non-governmental organizations (NGOs) propose a solution at an international conference.

3 The terms and text are negotiated and rewritten until a certain percentage of member states vote "Yes" to adopting the treaty. This majority is usually 2/3 of voters.

4 Adoption of the treaty has no immediate effect. Member states must sign and then ratify the treaty after getting approval from the national government.

5 Treaty comes into force a set period of time after a certain number of countries have ratified it. For example: 3 months after the 15th ratification of the treaty.

6 Regulation of international treaties is mostly dependent on the good will of the ratifying members. In some cases methods such as "inducements, disincentives, environmental levies, and even fines or criminal sanctions" can be used.

 Sources: (above) United Nations University, 1992. *Environmental Change and International Law;* (opposite) UNEP GEO Data Portal, compiled from secretariats of the respective conventions.

Produced by UNEP/DEWA/GRID-Europe, Feb. 2009

Ratified (as of 2007) Not ratified

	Ramsar	WHC	CITES	Bonn	Montreal	Basel	UNFCCC	CBD	UNCCD	Kyoto	Rotterdam	Stockholm
Afghanistan												
Albania												
Algeria												
Angola												
Argentina												
Armenia												
Australia												
Austria												
Azerbaijan												
Bahrain												
Bangladesh												
Belgium												
Benin												
Bhutan												
Bolivia												
Botswana												
Brazil												
Bulgaria												
Cambodia												
Cameroon												
Canada												
Chad												
Chile												
China												
Colombia												
Congo												
Cote d'Ivoire												
Croatia												
Cuba												
Czech Republic												
North Korea												
Denmark												
Djibouti												
Dominica												
Dominican Republic												
Ecuador												
Egypt												
El Salvador												
Equatorial Guinea												
Eritrea												
Estonia												
Ethiopia												
Fiji												
Finland												
France												
Gabon												
Gambia												
Georgia												
Germany												
Ghana												
Greece												
Grenada												
Guatemala												
Guinea												
Guyana												
Haiti												
Hungary												
Iceland												
India												
Indonesia												
Iran												
Iraq												
Ireland												
Israel												
Italy												

	Ramsar	WHC	CITES	Bonn	Montreal	Basel	UNFCCC	CBD	UNCCD	Kyoto	Rotterdam	Stockholm
Japan												
Jordan												
Kenya												
Kuwait												
Laos												
Lebanon												
Libya												
Luxembourg												
Malaysia												
Mali												
Mexico												
Moldova												
Mongolia												
Morocco												
Mozambique												
Nepal												
Netherlands												
New Zealand												
Nicaragua												
Niger												
Norway												
Oman												
Pakistan												
Panama												
Papua New Guinea												
Paraguay												
Peru												
Philippines												
Poland												
Portugal												
Qatar												
South Korea												
Romania												
Russia												
Rwanda												
Saudi Arabia												
Senegal												
Serbia												
Singapore												
Slovenia												
Somalia												
South Africa												
Spain												
Sri Lanka												
Sudan												
Suriname												
Swaziland												
Sweden												
Switzerland												
Syria												
Tajikistan												
Thailand												
Tunisia												
Turkey												
Uganda												
Ukraine												
UAE												
UK												
Tanzania												
USA												
Uzbekistan												
Venezuela												
Vietnam												
Yemen												
Zambia												
Zimbabwe												

The UNEP GEO Data Portal:

Much of the information presented on the poster pages is accessible and can be seen and studied at UNEP's online GEO Data Portal (http://geodata.grid.unep.ch). The GEO Data Portal is the authoritative source for data sets used by UNEP and its partners in the Global Environment Outlook (GEO) report and other integrated environment assessments. Its online database holds more than 450 different variables, as national, subregional, regional, and global statistics, or as geospatial data sets (maps), covering themes like Freshwater, Population, Forests, Emissions, Climate, Disasters, Health, and GDP. This data can be consulted in real time through maps, graphics, and images, or downloaded in different formats.

Disclaimer:

Although every effort has been made to ensure that the content of this book is factually correct and accurately attributed, UNEP takes no responsibility for the accuracy and exhaustivity of the content and cannot be held responsible for any loss or damage created directly or indirectly by the use of the content of this book or by the attribution of this material.

On the cover: Pascal LESOING for YDEO—Illustration: CALOU
Design: Bruno Morini / Ami-Images

Photographs:

All photographs are by Yann Arthus-Bertrand
with the exception of p. 61 © Dorothée Martin and p. 119 © Charles Pottier
Picture research: Isabelle Bruneau
All photographs by Yann Arthus-Bertrand are distributed by the agency
Altitude, Paris, France

Maps and graphics:

Graph design: Eric Le Miere
Graph design for pages 26, 50, 72, 94, 114, 132, 152, 170 and 190:
Stefan Schwarzer, UNEP owns the rights but makes these freely available

UNEP

ABRAMS
THE ART OF BOOKS SINCE 1949
115 West 18th Street
New York, NY 10011
www.abramsbooks.com